TO

2019

Schilt Publishing

Lars Boering
Managing Director, World Press Photo Foundation

Always Something New

This book brings you the results of the World Press Photo Foundation's 2019 contests, showcasing the choices of the independent juries who worked so hard to review this year's entries. It is integral to our work as a global platform, connecting professionals and audiences through high-quality reporting and storytelling that can be trusted.

Being such a platform involves more than the contests. With our worldwide exhibitions and festival we showcase stories that make people stop, feel, think and act. Our Develop programs encourage diverse accounts of the world that present stories with different perspectives. Through our Explore program, we foster debate and research. Witness, our online magazine, publishes new talent and new thinking in visual journalism and storytelling. All this means we are active year round.

For more than sixty years, our annual photo contests have rewarded the best in visual journalism, and we have done the same for digital storytelling since 2011. This year, to give greater recognition to the importance of storytelling and digital productions, we introduced three new awards to complement the World Press Photo of the Year. The World Press Photo Story of the Year award honors the photographer whose visual creativity and skills produced a story which captures an event or issue of great journalistic importance in that year. In the Digital Storytelling Contest, we now have the World Press Photo Interactive of the Year award and the World Press Photo Online Video of the Year.

These awards recognize a new trend in visual journalism—a shift from spot news moments to longer-term projects. This is a welcome move from single images to the stories that matter. Sometimes, though, this is accompanied by a stylization of news photography, a trend that involves imposing a visual look on a scene. Since reality is already amazing, colorful and impressive, no one needs to exaggerate those elements just to please the eye.

The shift to longer-term projects also bridges the divide between photography and digital storytelling, as photography is often stitched into a broader context. Photography might be the centerpiece, but it can no longer be the whole story. This also means the one-person 'shooter' could be replaced by a collaborative team in which the photographer might be a director.

All this means contemporary photography and digital storytelling is in great shape and able to give us, in many different ways, the stories that matter.

Whitney Johnson
Chair of the 2019 Jury

It's a daunting task to choose the best photos taken in the world. Think of the numbers: three weeks, 17 jurors, 4,738 photographers, and 78,801 photographs.

What were we looking for? Images that were relevant, unique, memorable. Images that represent the most significant issues of our time, such as the changing climate and the mass migration of people across the globe. As chair of the general jury I also felt a great responsibility, with so much scrutiny of the visual media, to ensure we weighed questions about representation, the treatment of women, and 'fake news'.

Though all the members of the jury are part of the visual industry, we don't often have the opportunity to spend weeks looking at pictures. But that's what we did, in a process that kept the names of the photographers a secret. All we had to work with was caption information submitted by the photographers and the photos themselves. As chair, it was my job to listen to my peers, elicit their feelings, make sure they were all heard, and then call for a decision. My vote didn't count for more than those of my colleagues, and I didn't have a veto.

The World Press Photo Foundation presented the jury with a statement about representation that asked us to keep questions about consent, dignity, the use of graphic imagery, and stereotypes at the top of our minds. This jury was especially diverse, with people from 12 countries and six continents; nine women, eight men, and a wide array of experiences as producers, photo editors, curators, photographers, and artists.

For all of us, issues of representation were central to the conversation. Whether we were speaking about photographing a Muslim in America, an AIDS patient, or a former captive of Boko Haram, we considered whether the image portrayed the subjects in an accurate way, whether it took advantage of the less privileged or was exploitative, whether it furthered the story, and whether it put the subject in danger.

Last year was also a year when women in the United States, and around the world, vigorously asserted demands for equality and an end to sexual harassment and abuse. We wondered whether that would be reflected in the competition. In the end, it's represented through two stories about women being able to make choices about their own bodies. Though we have a way to go before reaching gender equality in visual journalism, it's gratifying that, in an anonymous contest, an increasing number of women photographers are winning.

As a jury, we didn't always agree. In fact, we disagreed quite a bit. But we talked, and listened, and talked some more. And then we voted. The pages ahead won't show a complete picture of 2018. Rather, they reflect a great diversity of content.

Now you, the audience, can decide what you think.

Contents

Environment

Spot News

General News

Contemporary Issues

Sports

Nature

Portraits

Long-Term Projects

Digital Storytelling Contest

The 2019 World Press Photo of the Year Nominees

Catalina Martin-Chico
France/Spain,
Panos
→ page 66

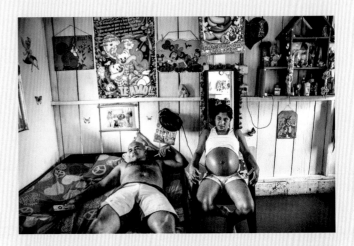

John Moore
United States,
Getty Images
→ page 18

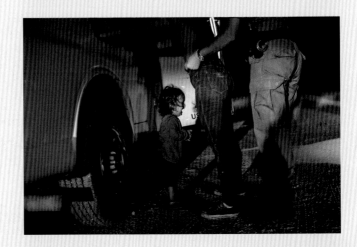

Mohammed Badra
Syria,
European Pressphoto
Agency
→ page 90

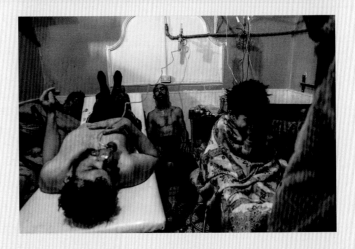

Brent Stirton
South Africa,
Getty Images
→ page 12

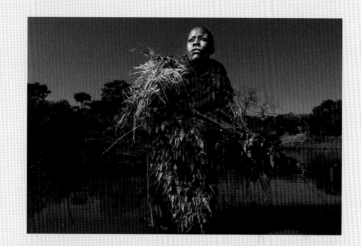

Chris McGrath
Australia,
Getty Images
→ page 24

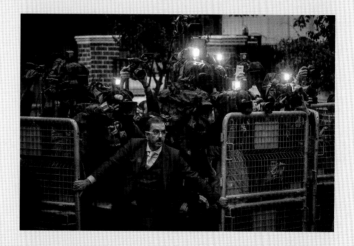

Marco Gualazzini
Italy,
Contrasto
→ page 134

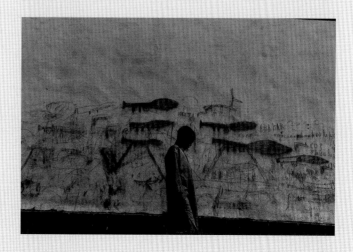

The 2019 Singles

Brent Stirton

South Africa, Getty Images /
1st Prize Environment

Petronella Chigumbura (30), a member of
an all-female anti-poaching unit called
Akashinga, participates in stealth and
concealment training in the Phundundu
Wildlife Park, Zimbabwe.

Akashinga ('The Brave Ones') is a ranger
force established as an alternative conser-
vation model. It aims to work with, rather
than against local populations, for the
long-term benefits of their communities
and the environment. Akashinga comprises
women from disadvantaged backgrounds,
empowering them, offering jobs, and helping
local people to benefit directly from the
preservation of wildlife. Other strategies—
such as using fees from trophy hunting to
fund conservation—have been criticized
for imposing solutions from the outside
and excluding the needs of local people.

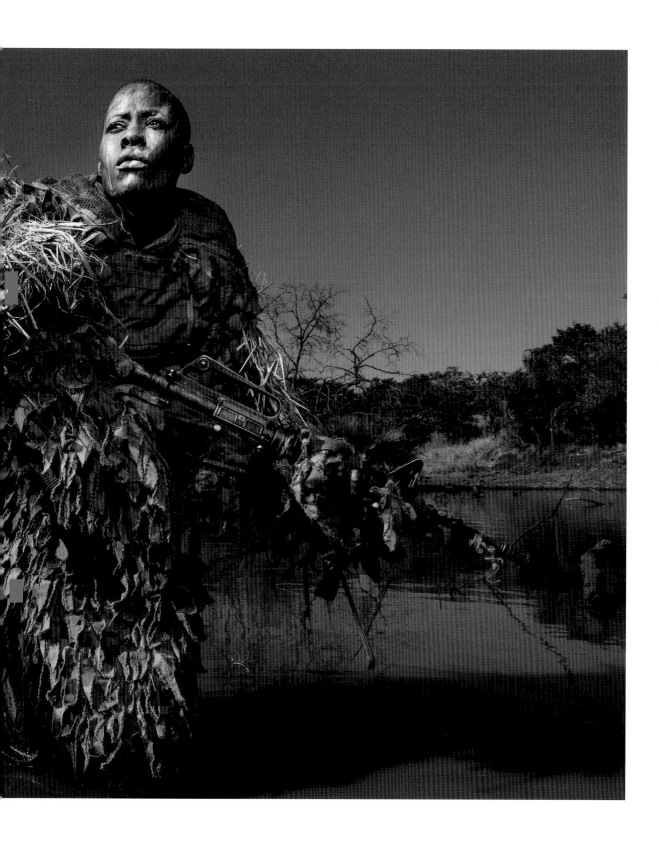

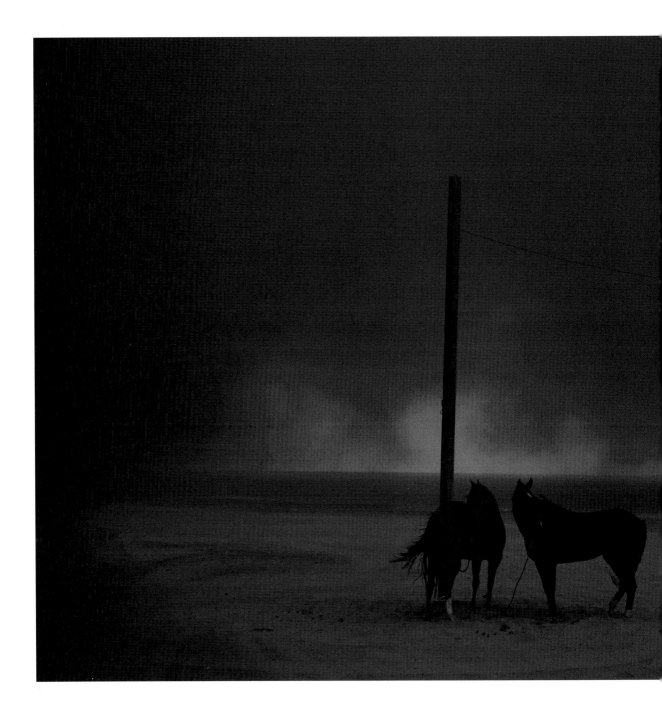

Wally Skalij

United States, *Los Angeles Times* / 2nd Prize Environment

Evacuated horses stand tied to a pole, as smoke from a wildfire billows above them, on Zuma Beach, in Malibu, California, USA, on 10 November.

 The 2018 wildfire season in California was the deadliest and most destructive on record, burning an area of more than 676,000 hectares. While scientists pointed to the effects of climate change as a cause, US President Donald Trump blamed forest management.

Mário Cruz

Portugal / 3rd Prize Environment

A child who collects recyclable material lies on a mattress surrounded by garbage floating on the Pasig River, in Manila, Philippines.

The Pasig River was declared biologically dead in the 1990s, due to a combination of industrial pollution and waste being dumped by nearby communities living without adequate sanitation infrastructure. A 2017 report by Nature Communications cites the Pasig as one of 20 most polluted rivers in the world, with up to 63,700 tons of plastic deposited into the ocean each year. Efforts are being made to clean up the Pasig, which were recognized by an international prize in 2018, but in parts of the river the waste is still so dense that it is possible to walk on top of the garbage.

→

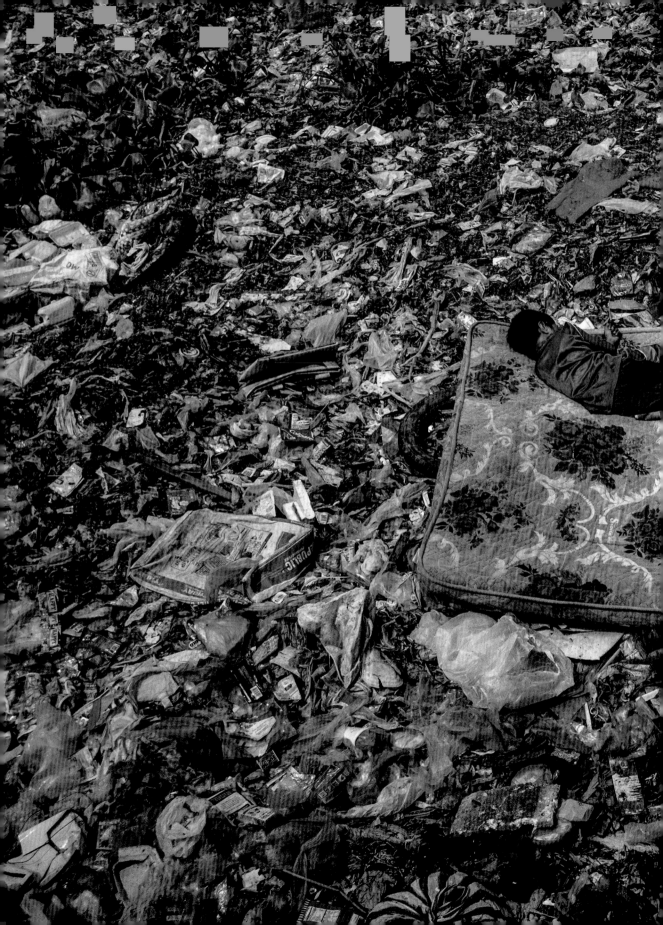

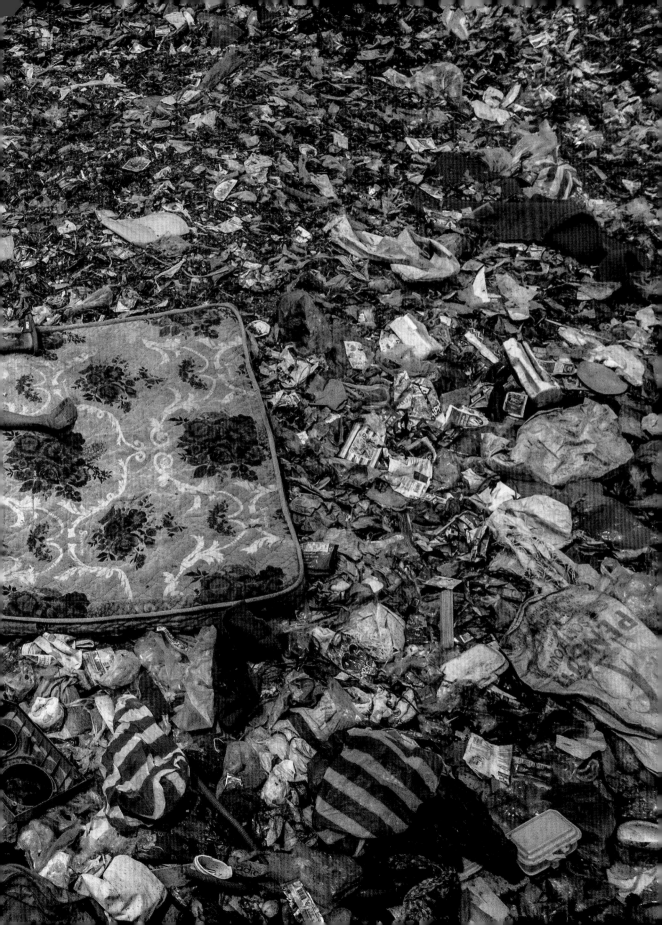

World Press Photo of the Year 2018

John Moore

United States, Getty Images /
1st Prize Spot News

Honduran toddler Yanela Sanchez cries as she and her mother, Sandra Sanchez, are taken into custody by US border officials in McAllen, Texas, USA, on 12 June.

Immigrant families had rafted across the Rio Grande from Mexico and were then detained by US authorities. Sandra Sanchez said that she and her daughter had been traveling for a month through Central America and Mexico before reaching the US to seek asylum. The Trump Administration had announced a 'zero tolerance' policy at the border under which immigrants caught entering the US could be criminally prosecuted. As a result, many apprehended parents were separated from their children, often sent to different detention facilities. After this picture was published worldwide, US Customs and Border Protection confirmed that Yanela and her mother had not been among the thousands who had been separated by US officials. Nevertheless, public outcry over the controversial practice resulted in President Donald Trump reversing the policy on 20 June.

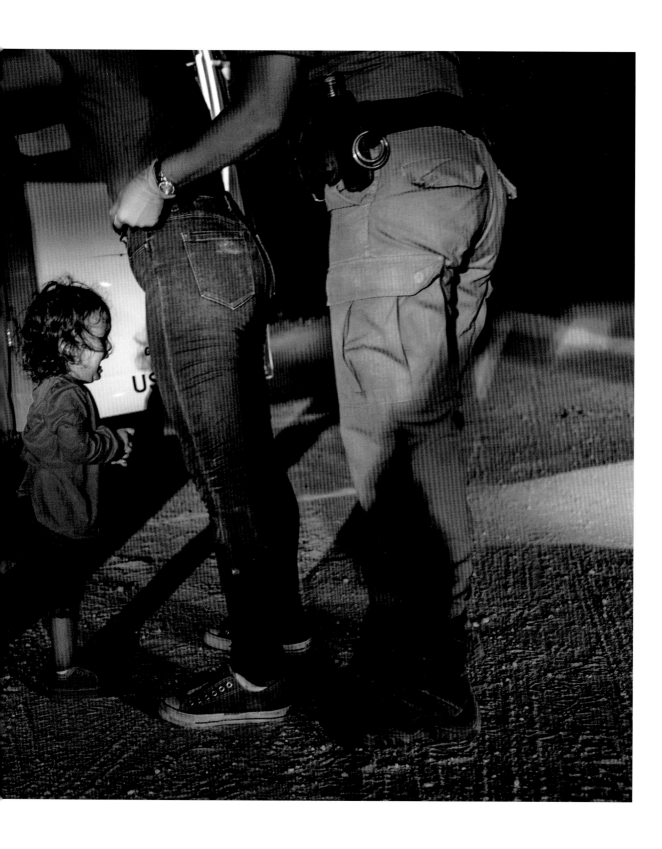

Ezra Acayan

Philippines / 2nd Prize Spot News

The body of Michael Nadayao lies in the street after he was shot dead by unidentified men in front of mourners at a wake, in Quezon City, Philippines, on 31 August.

President Rodrigo Duterte began a concerted anti-drug offensive soon after taking office in June 2016, repeatedly ordering increased attacks against suspects. Amnesty International reports that this led to human rights violations, including extrajudicial killings by both civilians and police. A spokesman for the Philippine Drug Enforcement Agency said the campaign had led to 5,050 deaths by December 2018, with Human Rights Watch citing over 12,000. In June, 38 UN member states called on President Duterte to end the killings and probe the causes of the drug war.

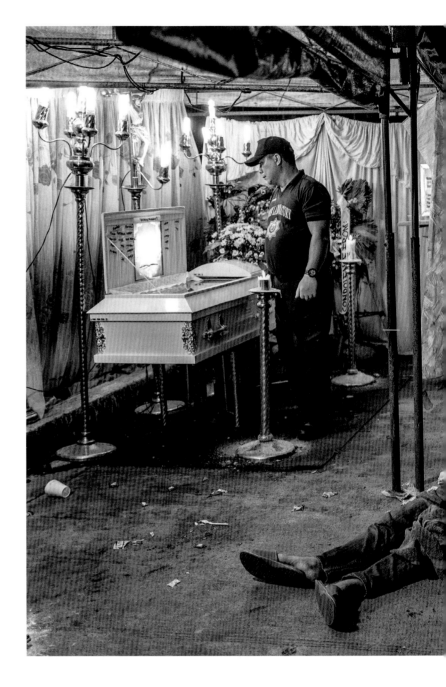

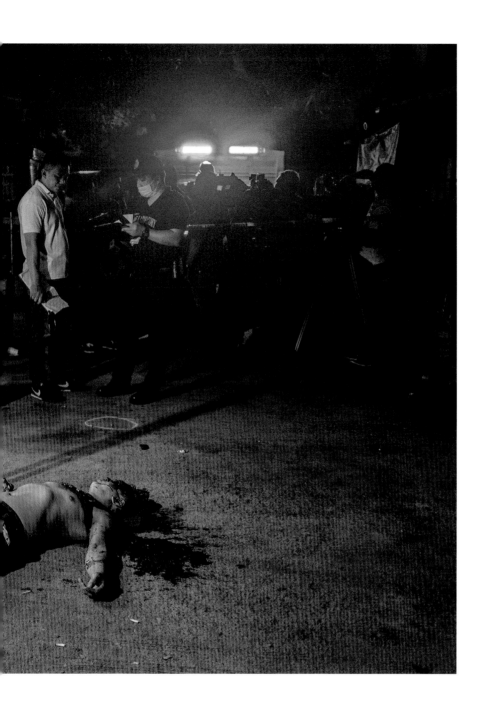

Pedro Pardo

Mexico, Agence France-Presse / 3rd Prize Spot News

Central American migrants climb the border fence between Mexico and the United States, near El Chaparral border crossing, Tijuana, Baja California, Mexico, on 25 November.

Refugees who were part of a caravan that originated in Honduras in October, began arriving at the border in November to find a backlog of some 3,000 people waiting to be processed into the United States, and a potential delay of months. This led to rising tensions, and to people breaking away from the caravan to attempt their own entry.

→

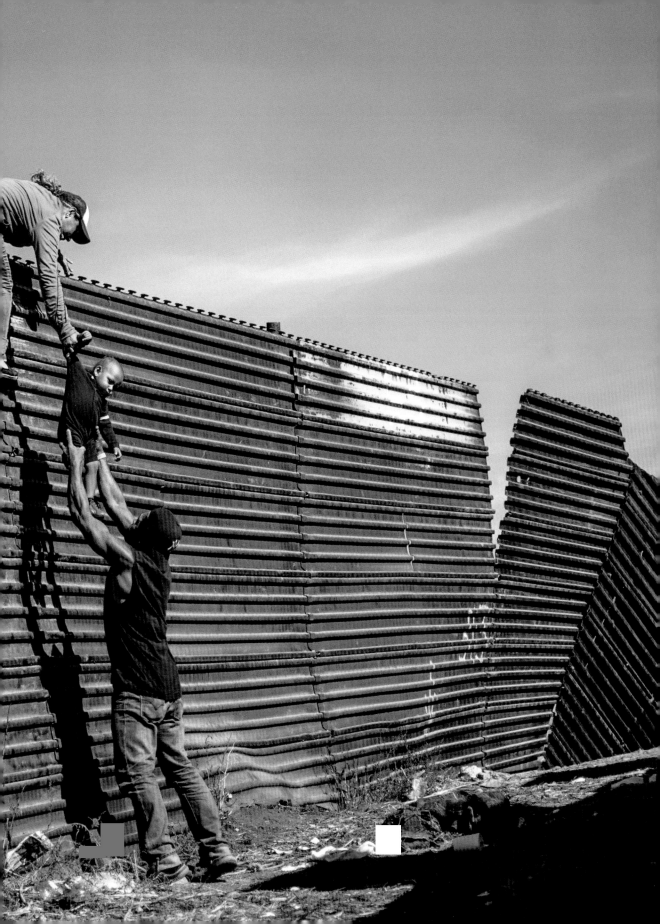

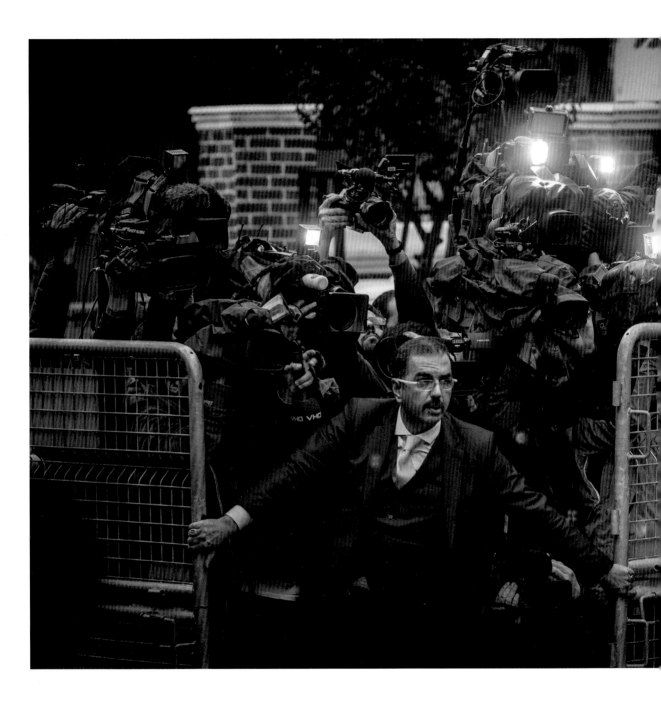

Chris McGrath

Australia, Getty Images / 1st Prize General News

An unidentified man tries to hold back the press on 15 October, as Saudi investigators arrive at the Saudi Arabian Consulate in Istanbul, Turkey, amid a growing international backlash to the disappearance of journalist Jamal Khashoggi.

A critic of the Saudi regime, Khashoggi had been missing since entering the consulate on 2 October. After weeks of false information, Riyadh announced that Khashoggi had been killed accidentally during an altercation. Turkish authorities and the CIA claimed he had been murdered by Saudi intelligence operatives, working under high Saudi authority.

Daniele Volpe
Italy / 2nd Prize General News

The living-room of an abandoned home in San Miguel Los Lotes, Guatemala, lies covered in ash after the eruption of Volcán de Fuego on 3 June.

Fuego, around 40 km southwest of the capital Guatemala City, is one of Latin America's most active volcanoes, and has been erupting periodically since 2002. It is monitored by volcanologists, but this eruption came without warning. People living around the volcano, many at Sunday lunch, were surprised by the suddenness of the event, as Fuego spewed red-hot lava, ash, poisonous gases and flaming debris onto villages below. The eruption was one of the deadliest in Guatemala for over a century. Guatemala's National Institute of Forensic Sciences reported the recovery of 318 bodies, over a third of them unidentified.

→

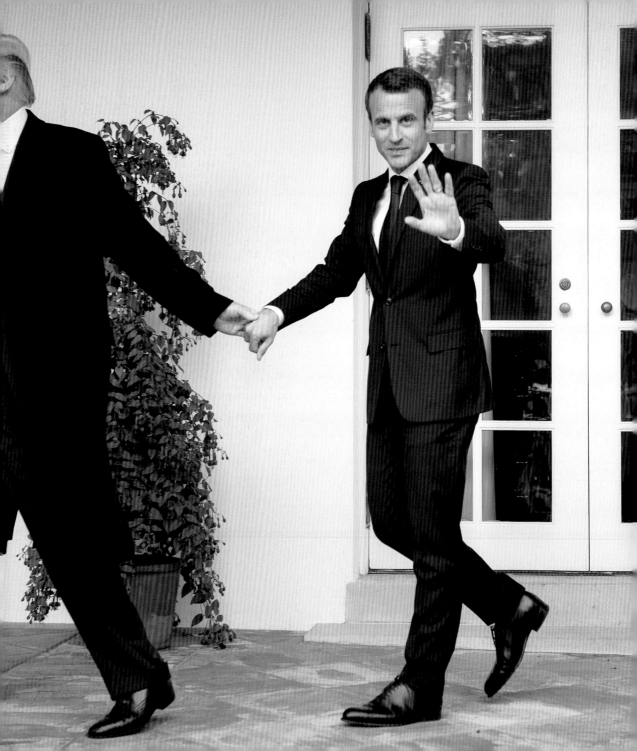

Brendan Smialowski

United States,
Agence France-Presse /
3rd Prize General News

US President Donald Trump leads France's President Emmanuel Macron by the hand while walking to the Oval Office of the White House, in Washington DC, on 24 April.

President Macron's three-day visit to the United States was the first official state visit of the Trump administration. Unexpectedly, the two presidents' body language went beyond the norm for such visits, bordering on the intimate. The leaders also praised each other effusively. The 2015 international nuclear agreement with Iran was one of the main topics under discussion. Macron aimed to persuade Trump to adhere to the deal, which limited Iran's nuclear program in return for a lifting of sanctions, but failed. On 8 May, President Trump withdrew from the agreement, breaking with European allies. The relationship between the two leaders appears to have soured, with Trump later attacking Macron on Twitter.

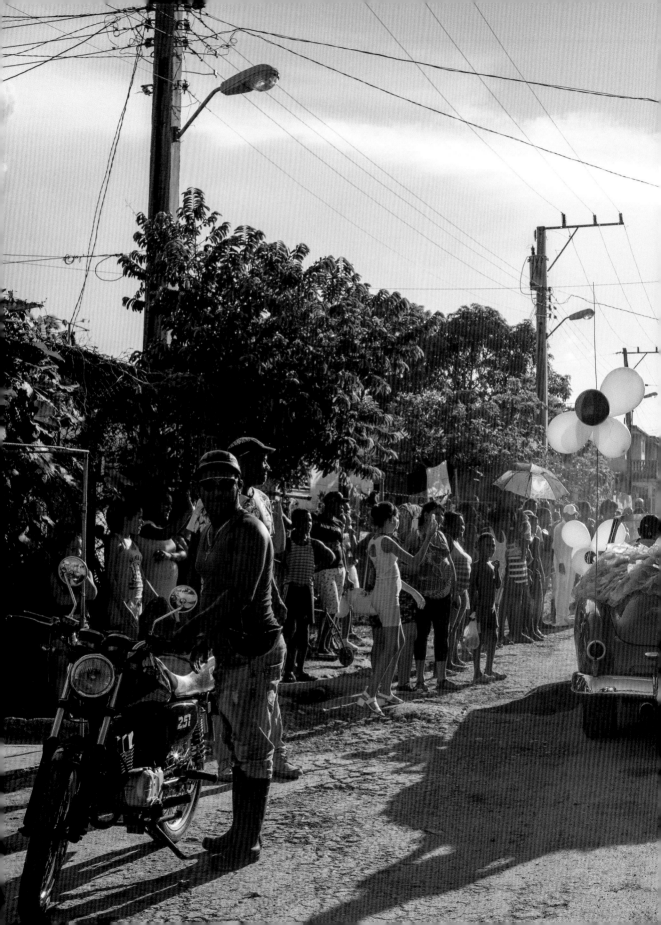

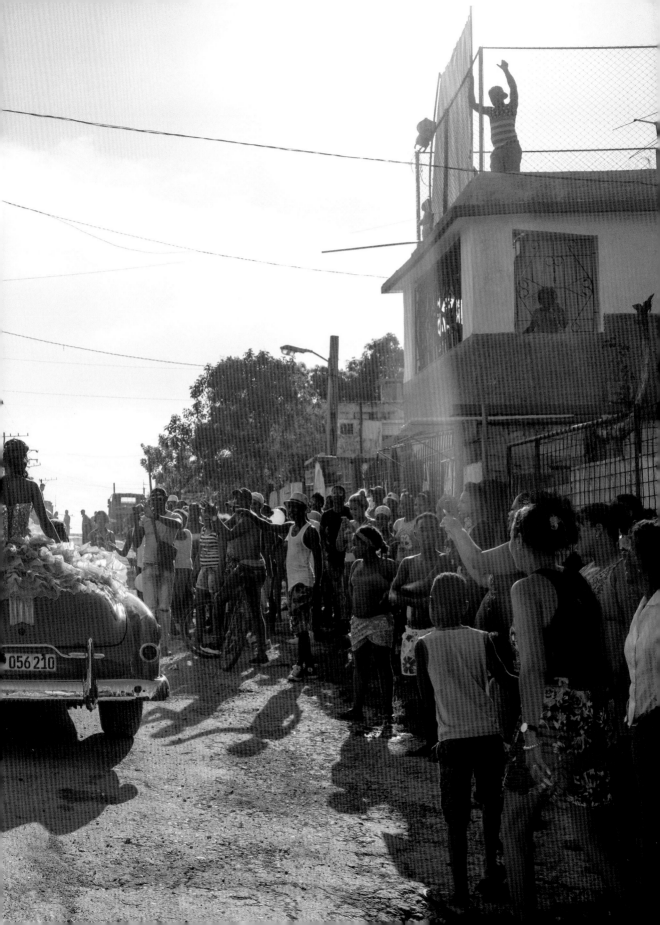

Diana Markosian

Russia/United States, Magnum Photos /
1st Prize Contemporary Issues

Pura rides around her neighborhood in a
pink 1950s convertible, as the community
gathers to celebrate her fifteenth birthday,
in Havana, Cuba.

A girl's *quinceañera* (fifteenth birthday)
is a Latino coming-of-age tradition marking
transition into womanhood. It is a gender-
specific rite of passage, traditionally
showcasing a girl's purity and readiness
for marriage. Families go to great expense,
often celebrating with a lavish party. The girl
dresses as a princess, living out a fantasy
and perceived idea of femininity. In Cuba,
the tradition has transformed into a
performance involving photo and video
shoots, often documented in a photobook.
Pura's *quinceañera* had a special poignancy,
as some years earlier, having been diag-
nosed with a brain tumor, she was told she
would not live beyond the age of 13.

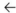

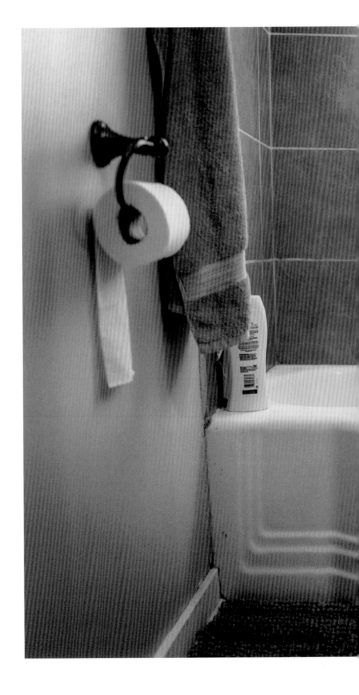

Mary F. Calvert

United States / 2nd Prize Contemporary Issues

Former US marine Ethan Hanson bathes at home in Austin, Minnesota, USA, after a sexual trauma experienced during his military service left him unable to take showers.
 During a boot camp, Ethan and fellow recruits were ordered to walk naked through a communal shower while pressed together. Ethan reported the incident, but was harassed by the other men for doing so. Nightmares and panic attacks later forced him to resign. Recent Defense Department figures show sexual assault in the military to be on the increase. Servicemen are less likely than women to report sexual trauma, fearing retaliation or stigma.

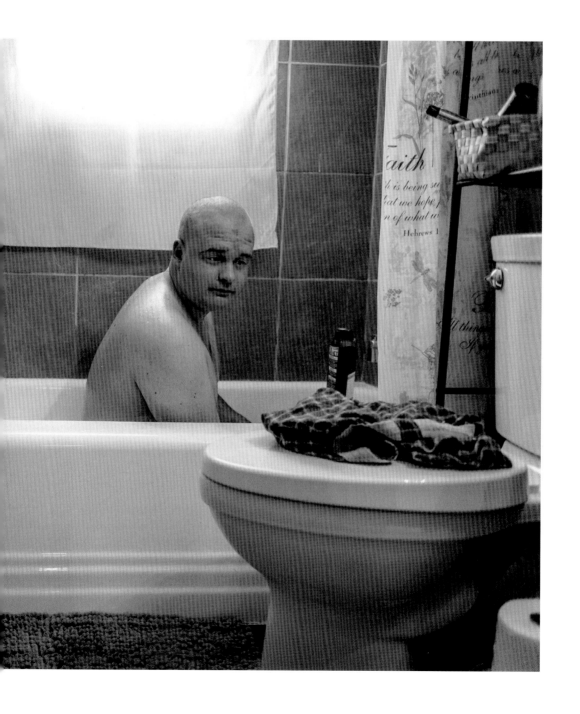

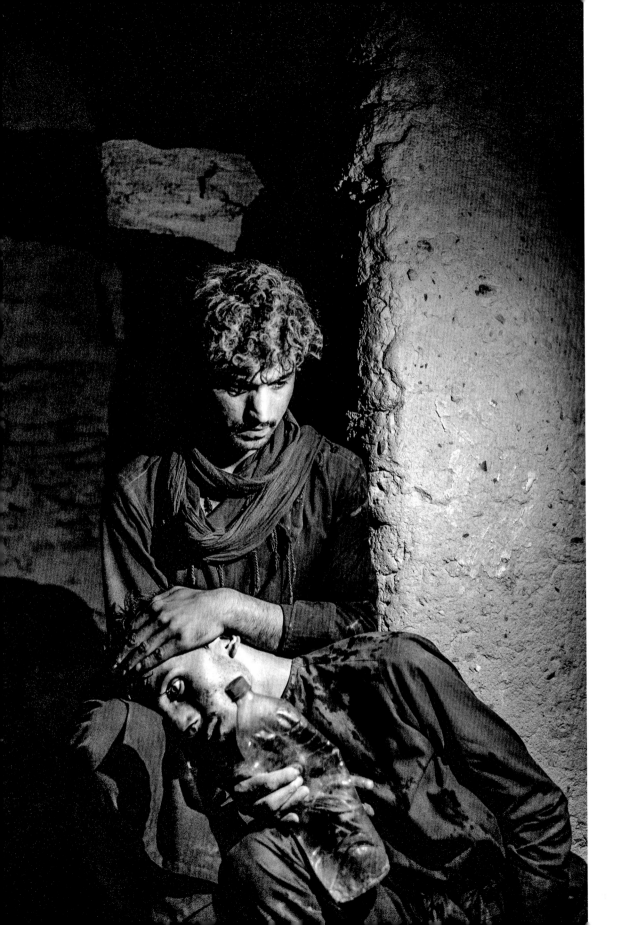

Enayat Asadi

Iran / 3rd Prize Contemporary Issues

An Afghan refugee comforts his companion while waiting for transport across the eastern border of Iran, on 27 July.

UNHCR reports that Iran has almost one million registered refugees, the vast majority from Afghanistan. In addition, more than 1.5 million undocumented Afghans are estimated to be present in the country. Many people fleeing violence, insecurity and poverty in Afghanistan find no alternative but to use illegal traffickers, along routes where they are exposed to robbery, kidnapping and death. Their aim is to pass through Iran and Turkey or Greece to seek a better life elsewhere, but trafficked refugees are highly vulnerable to forced labor, debt bondage, forced marriage, or work in the sex trade.

John T. Pedersen

Norway / 1st Prize Sports

Boxer Moreen Ajambo (30) trains at the Rhino boxing club in Katanga, a large slum settlement in Kampala, Uganda, on 24 March.

More than 20,000 people live in Katanga, crowded together and often in extreme poverty. The boxing club receives no outside funding. Ajambo, a mother of seven, boxes in the Ugandan women's team. Men's boxing has a long history in Uganda, but women boxers are often frustrated by the few opportunities to compete at an international level.

→

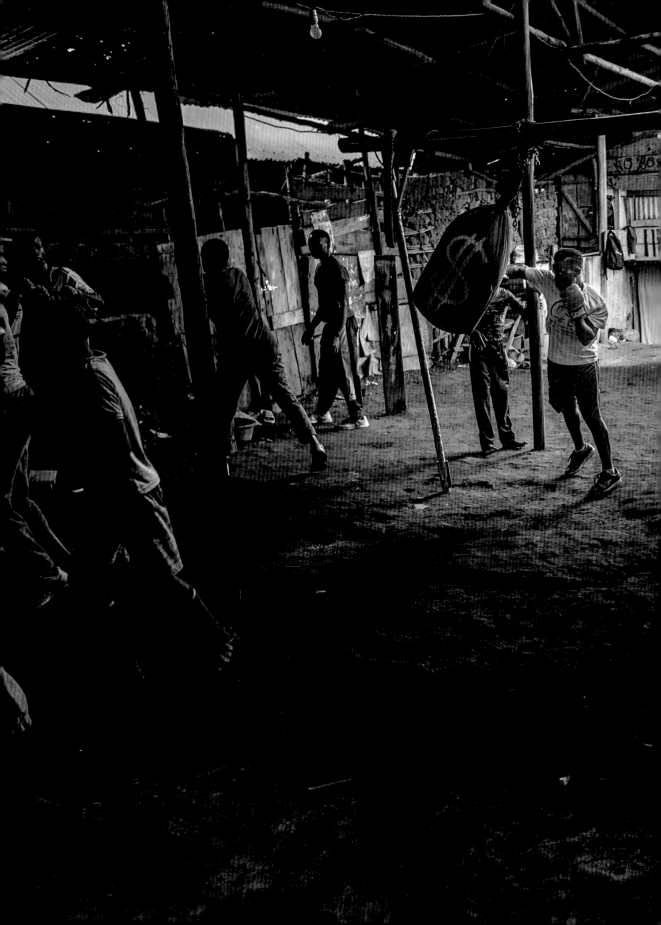

David Gray

Australia, Reuters /
2nd Prize Sports

Naomi Osaka serves during her match against Simona Halep from Romania during the Australian Open tennis tournament, at Margaret Court Arena, Melbourne, Australia, on 22 January.

Osaka, representing Japan, went on to win the tournament. In September, she won the US Open women's singles, defeating Serena Williams. Over the course of 2018, Osaka rose from number 72 in world rankings to number one.

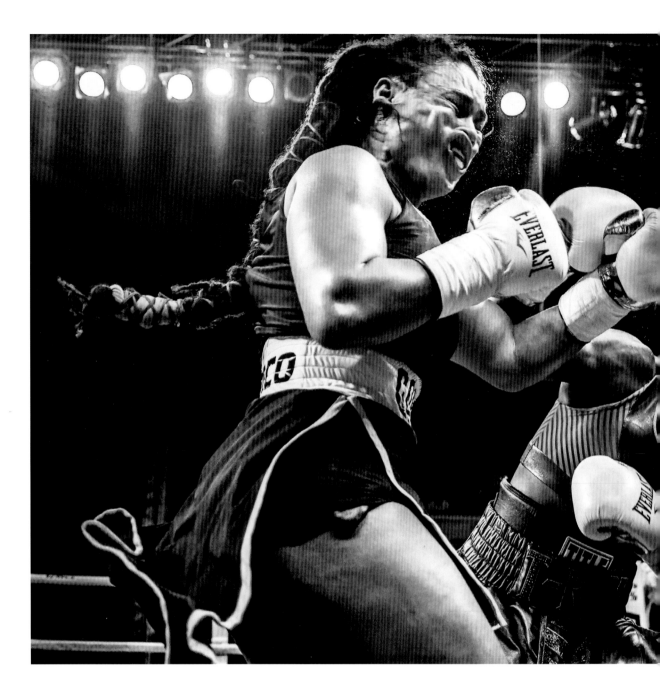

Terrell Groggins
United States / 3rd Prize Sports

Olympic champion Claressa Shields (right) meets Hanna Gabriels in a boxing match at the Masonic Temple in Detroit, Michigan, USA, on 22 June.

Shields suffered a first-round knock-down by Gabriels—the first in her career—but went on to win the match by unanimous decision. Shields is the first American woman to win an Olympic gold medal in boxing, and the first (male or female) to win a gold back-to-back in successive Olympic Games. She has had only one loss in her career, against British World Champion Savannah Marshall, in 2012.

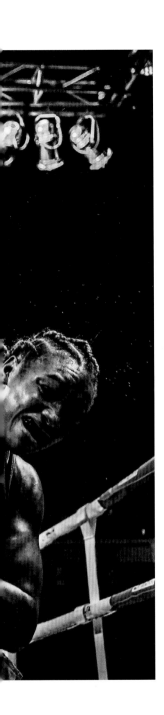

Bence Máté

Hungary / 1st Prize Nature

Frogs with their legs severed and sur-
rounded by frogspawn struggle to the
surface, after being thrown back into the
water in Covasna, Eastern Carpathians,
Romania, in April.

Frogs' legs are frequently harvested for
food in the spring, when males and females
gather to mate and spawn. Legs are some-
times severed while the animal is still
living. About US$40 million worth are sold
annually, with countries across the world
participating in the trade.

→

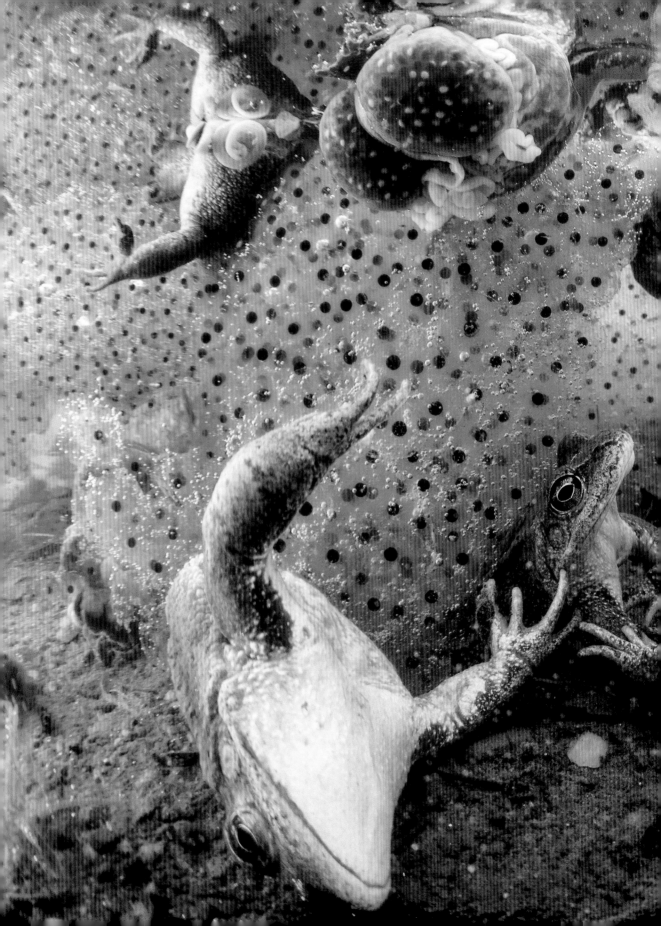

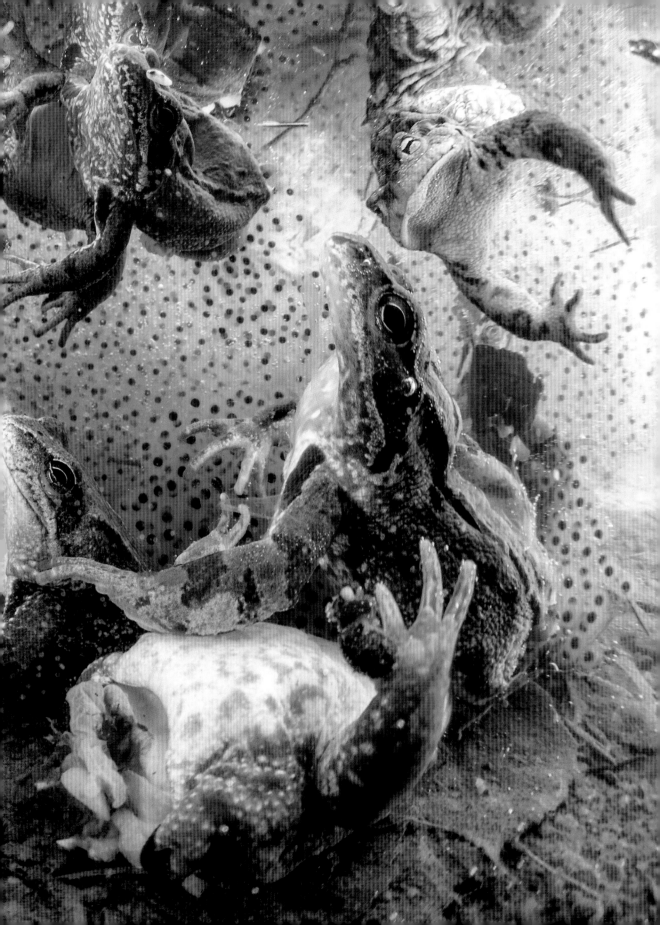

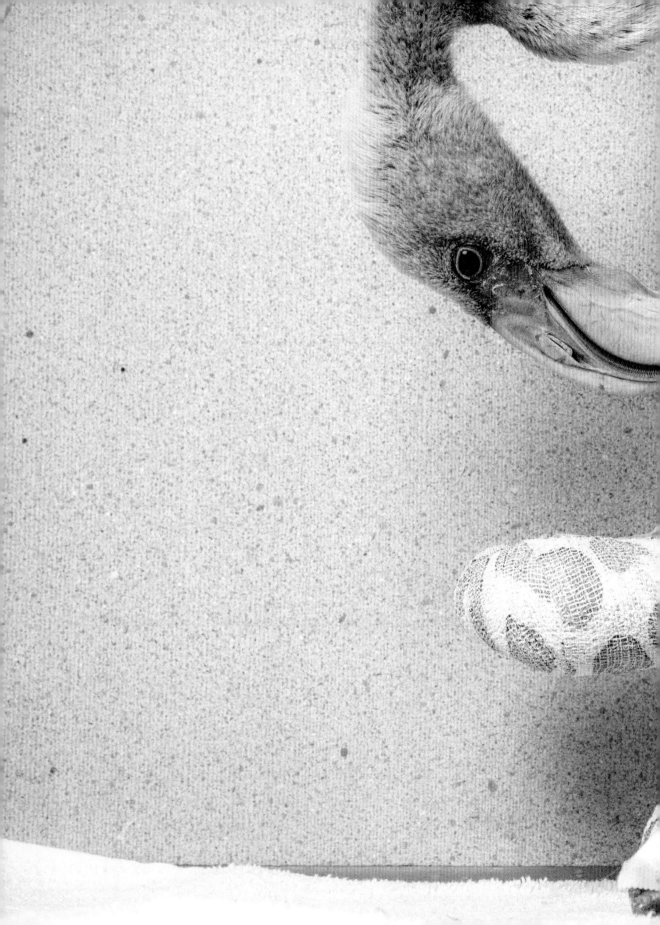

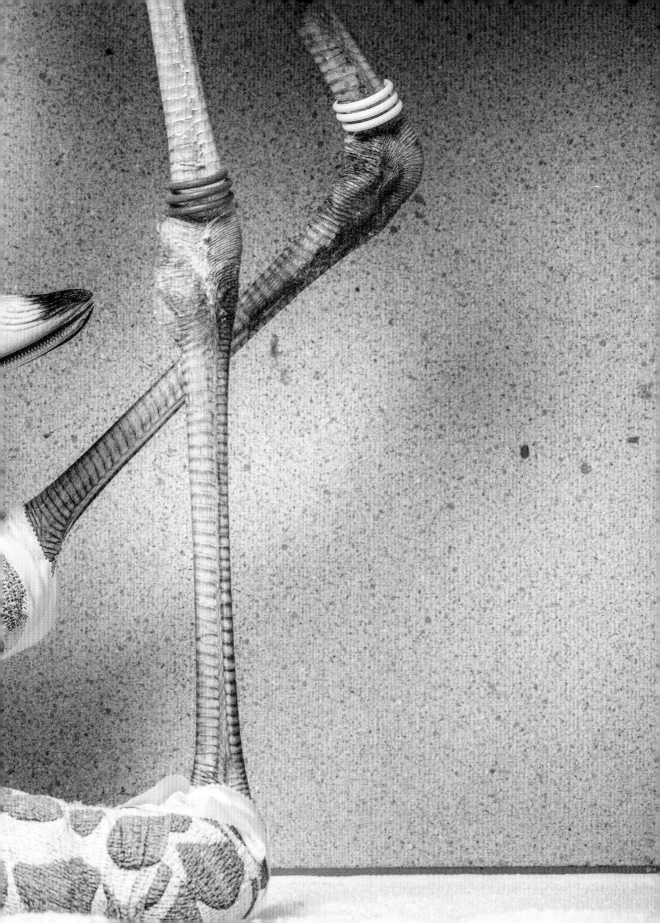

Jasper Doest

Netherlands / 2nd Prize Nature

A Caribbean flamingo inspects the impro-
vised socks created to help heal its severe
foot lesions, at the Fundashon Dier en
Onderwijs Cariben, Curaçao.
 The bird was brought by plane from
neighboring island Bonaire, after spending
a few weeks in a local rehabilitation facility.
Such lesions are common among captive
flamingos, as they have very sensitive feet
and are used to walking on soft ground.
After a few weeks of care the bird was
transported back to Bonaire. There are
around 3,000 breeding pairs of Caribbean
flamingos on Bonaire, and a further 200
to 300 birds on Curaçao.

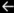

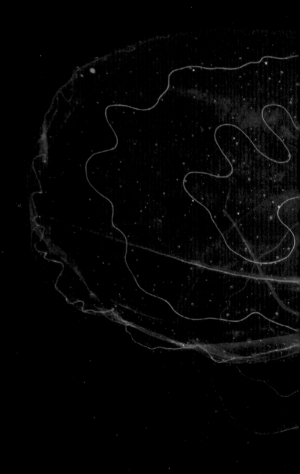

Angel Fitor

Spain / 3rd Prize Nature

A winged comb jelly, *Leucothea multicornis*, its wings widely opened, propels itself through waters off Alicante, Spain.

Leucothea multicornis, like other comb jellies, is a voracious predator, capturing its prey using sticky cells rather than by stinging. Little is currently known about the biology of comb jellies. Because the creatures are so fragile and fold their wings in reaction to the slightest vibration, they are extremely difficult to study and to photograph.

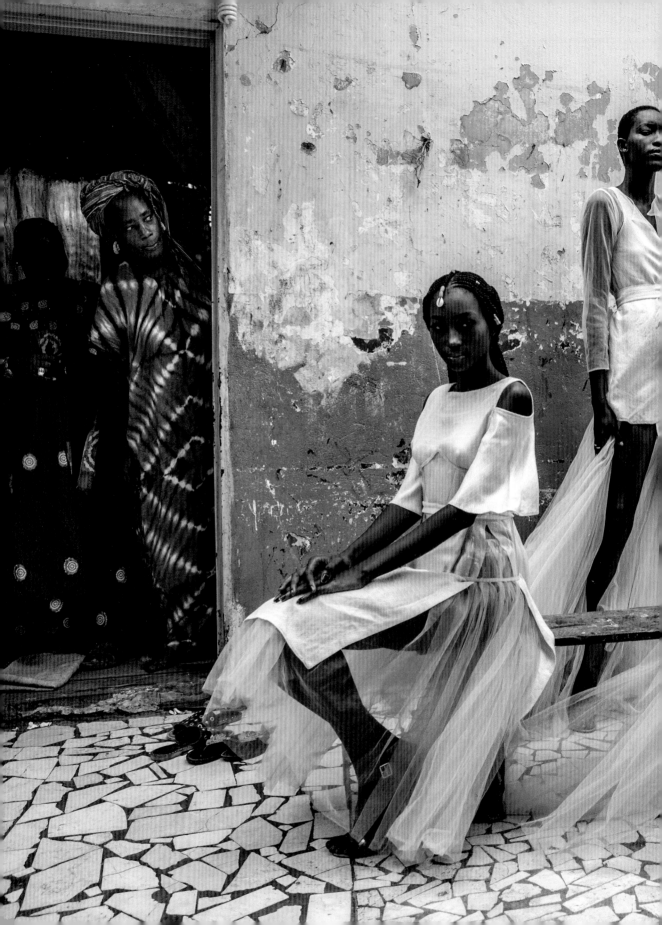

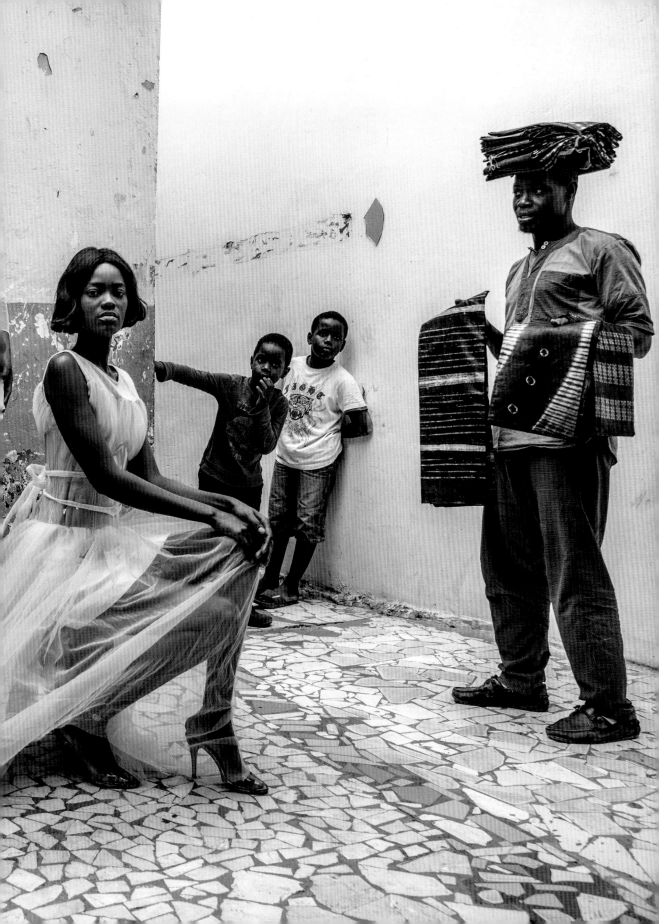

Finbarr O'Reilly

Canada/United Kingdom /
1st Prize Portraits

Diarra Ndiaye, Ndeye Fatou Mbaye and
Mariza Sakho model outfits by designer
Adama Paris, in the Medina neighborhood
of the Senegalese capital, Dakar, as
curious residents look on.

Dakar is a growing hub of Franco-African
fashion, and is home to Fashion Africa TV,
the first station entirely dedicated to fashion
on the continent. The annual Dakar Fashion
Week includes an extravagant street show
that is open to all and attended by thou-
sands from all corners of the capital.
Adama Paris (who has a namesake brand)
is a driving force behind the fashion week,
and much else on the design scene.

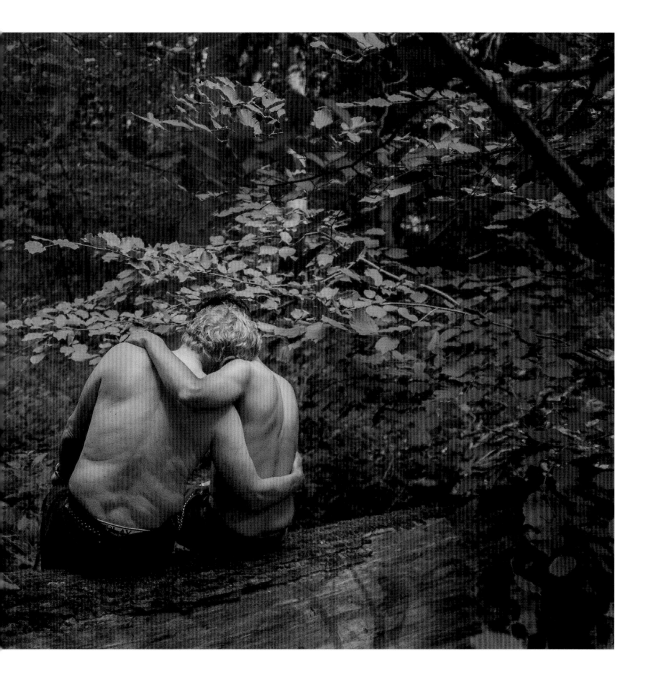

Heba Khamis

Egypt / 2nd Prize Portraits

Jochen (71) and Mohamed (21; not his real name) sit in the Tiergarten, Berlin. Jochen fell in love after meeting Mohamed, then a sex worker in the park. They have been dating for 19 months.

German aid charities have reported a marked increase in the number of young migrants turning to sex work. While they wait for their documents, refugees are not allowed to work legally or attend school. This lack of employment opportunity creates a severe lack of choice for many, with some young men becoming sex workers, sometimes to fund a heroin addiction. The Tiergarten, a large park in central Berlin, is a popular meeting spot for male sex workers and older clients. Mohamed now works in a gay bar, and is quitting heroin.

Alyona Kochetkova

Russia / 3rd Prize Portraits

Alyona Kochetkova sits at home, unable to face *borscht* (beet soup), her favorite food, during treatment for cancer.

Alyona shot this self-portrait following surgery and chemotherapy, when, although she knew the vital importance of food, she struggled to eat. Taking photos was not only a way of sharing a difficult and personal story in the hope that it might support others with a cancer diagnosis, it was also a means of accepting her ordeal by doing what she loved.

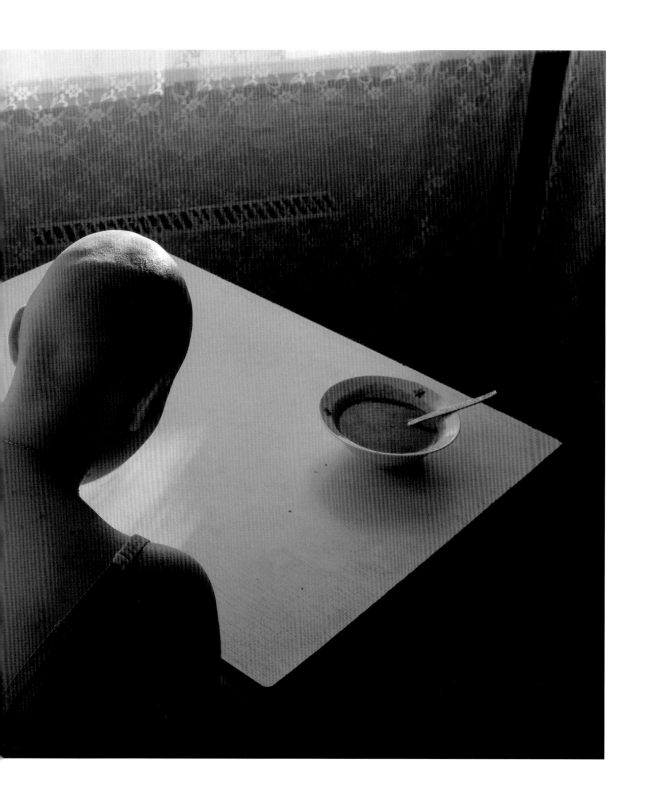

The 2019 Story of the Year Nominees

Marco
Gualazzini
Italy,
Contrasto

Pieter
Ten Hoopen
Netherlands/Sweden,
Agence VU/Civilian Act

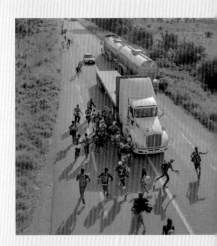

Lorenzo
Tugnoli
Italy,
Contrasto, for
The Washington Post

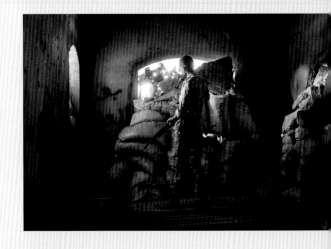

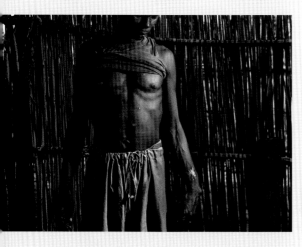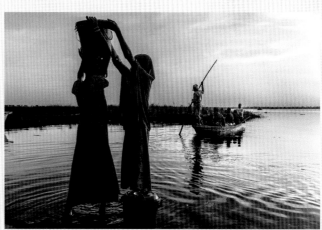
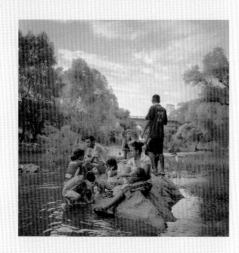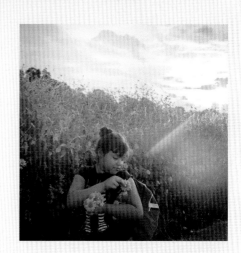
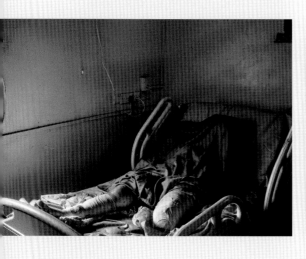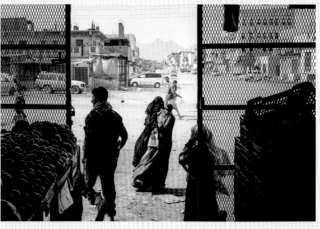

The 2019 Stories

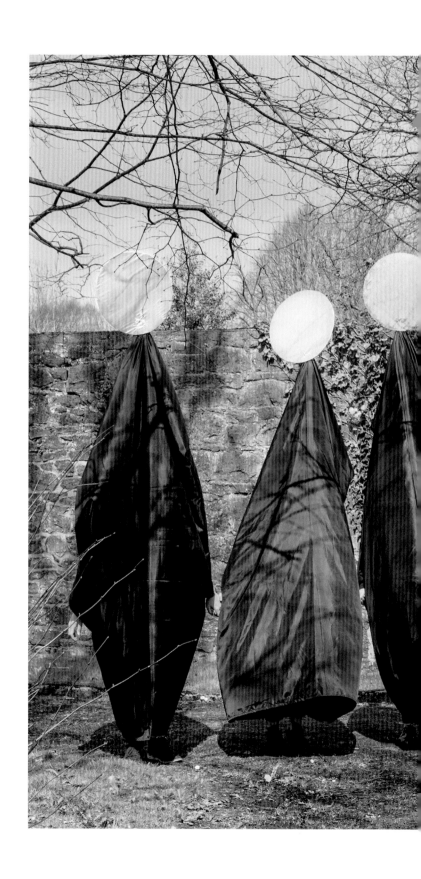

Olivia Harris

United Kingdom /
1st Prize Contemporary Issues

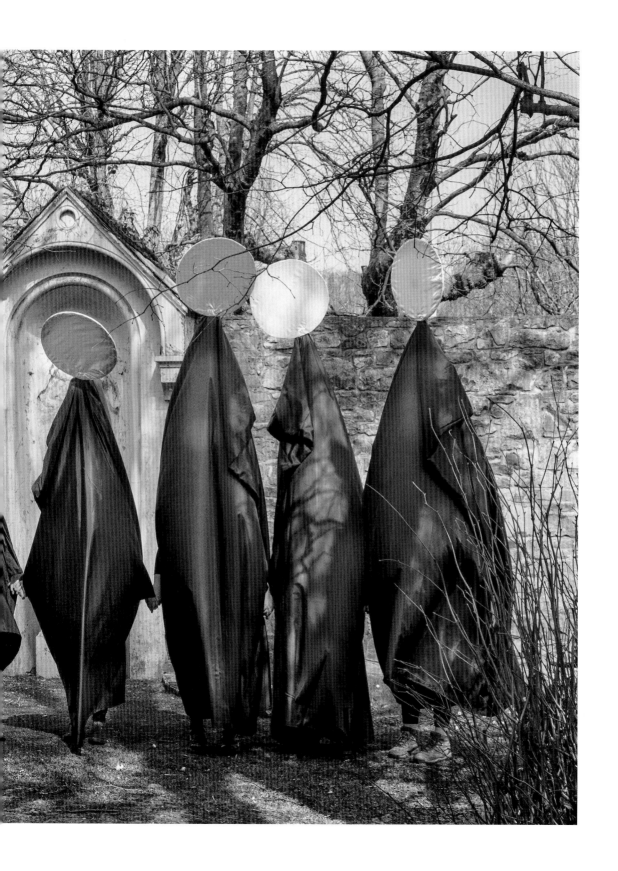

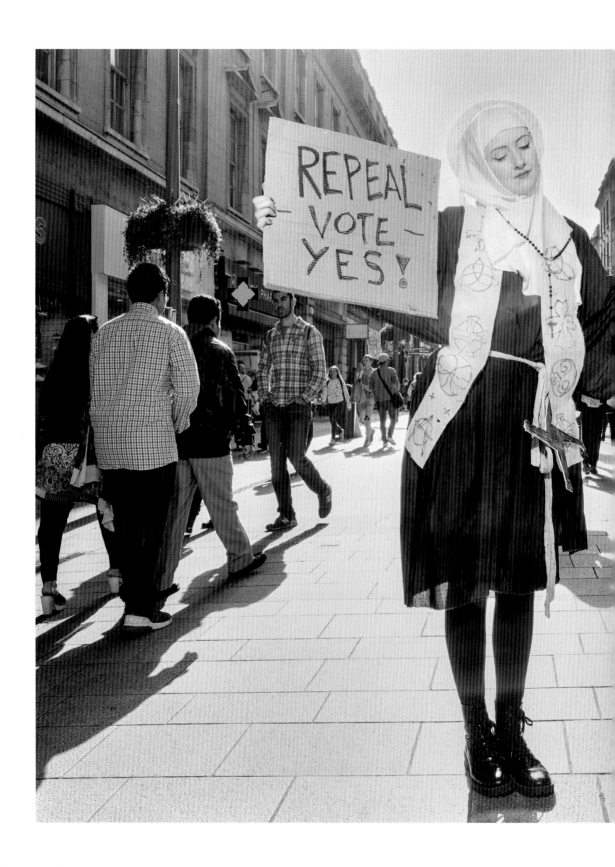

On 25 May, Ireland voted by a large majority to overturn its abortion laws, which were among the most restrictive in the world. A 1983 referendum had resulted in an Eighth Amendment to the Irish constitution, reinforcing a ban on terminations, even those resulting from rape and incest. The movement to repeal the Eighth Amendment used social media platforms to spread its message, and took the argument to the streets in the form of demonstrations and theatrical spectacle. *Previous spread*: Figures representing Ireland's dark treatment of women line up for social media cameras, before parading silently through the streets of Limerick, on 13 April. *This spread*: Repeal campaigner Megan Scott, dressed as St Brigid, Ireland's female patron, poses for a photograph on Dublin's main shopping street, on 21 April. (*continues*)

(*continued*) Prior to the referendum, an estimated 3,000 women traveled to the UK annually for abortions. The repeal campaign argued that restrictions on women impact everyone in society, and that the support of men, too, was necessary to effect change. *Right*: Women fold a cloth in front of a banner reading 'Our Toil Doth Sweeten Others', created by artist Alice Maher, at the Eva International Art Festival in Limerick. Campaigners used art to open conversations on topics previously considered off-limits in a conservative society. (*continues*)

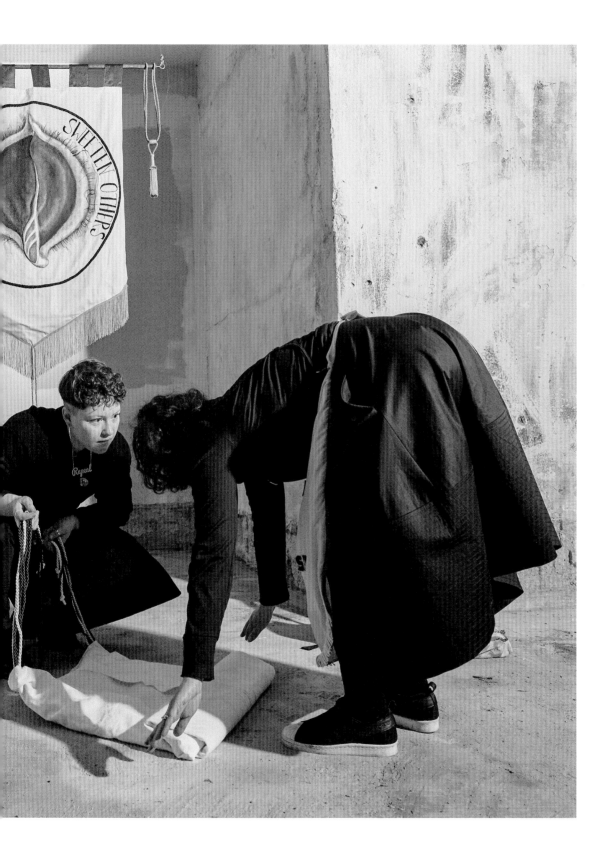

63

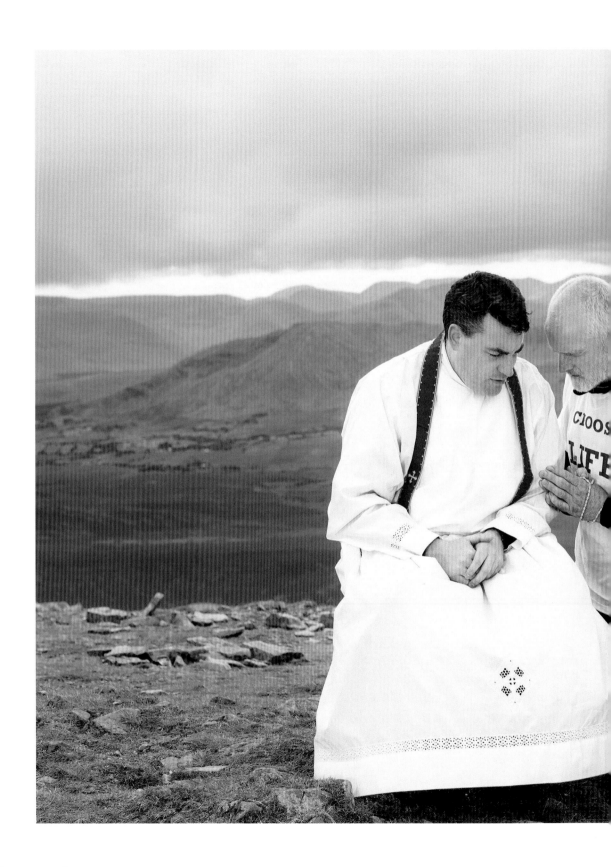

(*continued*) Nearly two thirds of the Irish population turned out to partici- pate in the referendum, with 66.4 percent voting to overturn the abortion prohibition. By the end of the year, the Irish president had signed a new bill into law, making abortion for any pregnancy less than 12 weeks available without cost. *Left*: Aidan prays with a priest after confession, at the summit of the holy mountain Croagh Patrick, in County Mayo. The mountain is the scene of many pilgrimages, including that of a men's pro-life group.

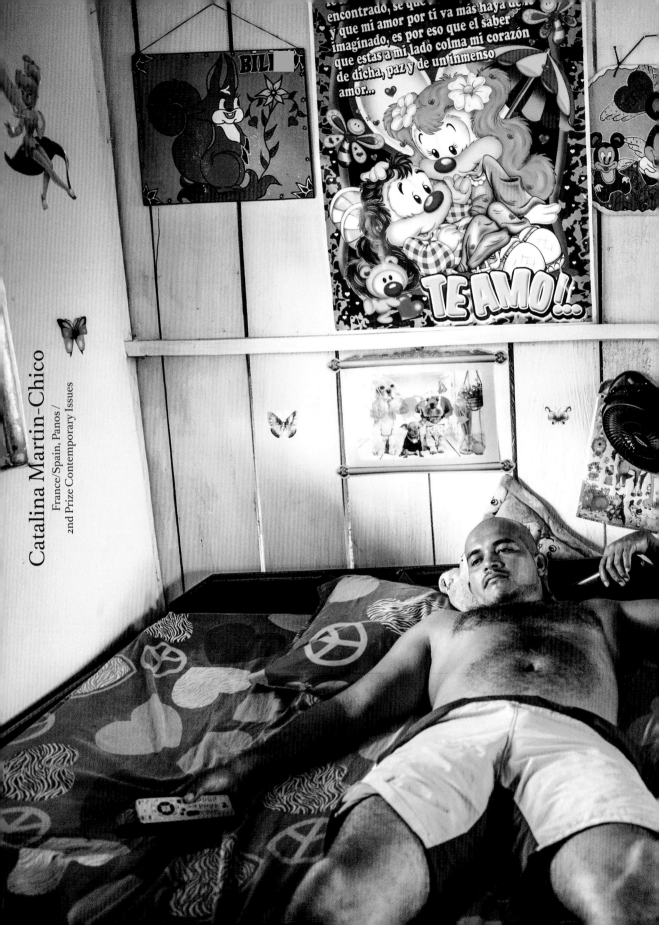

Catalina Martin-Chico
France/Spain, Panos /
2nd Prize Contemporary Issues

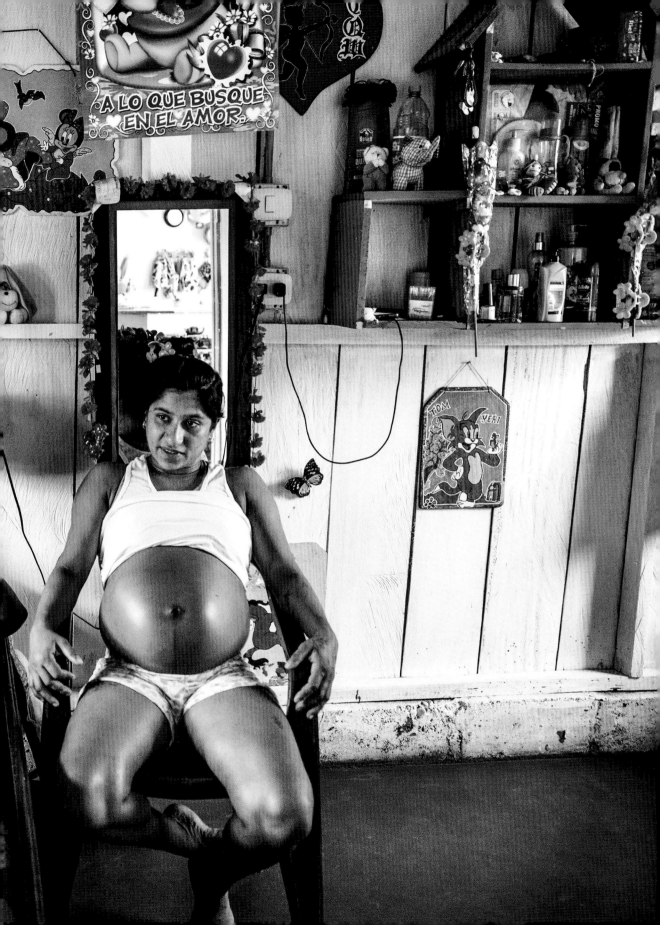

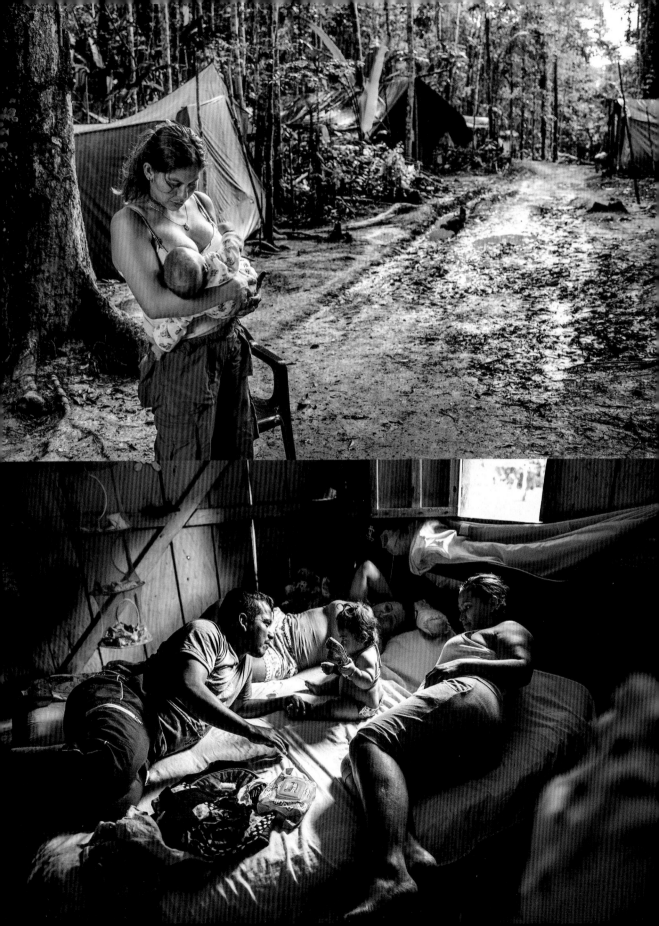

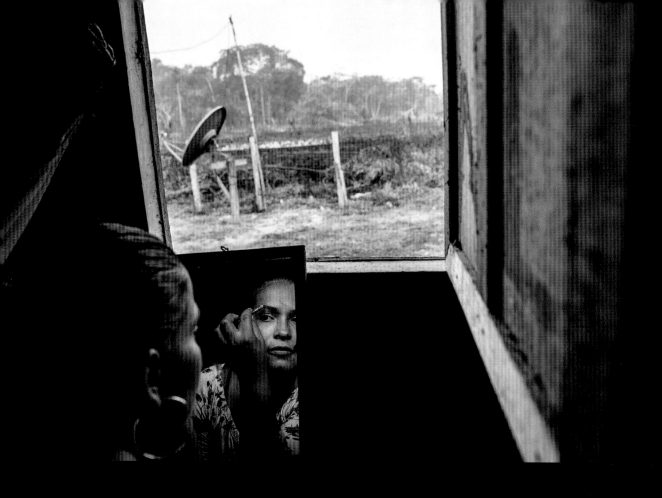

Since the signing of a peace agreement between the Colombian government and the FARC rebel movement in 2016, there has been a baby boom among former female guerrillas. Pregnancy was thought incompatible with guerrilla life. Women were obliged to put war before children, leaving babies with relatives or, some say, undergoing forced abortions—a charge FARC denies. *Previous spread*: Yorladis is pregnant for the sixth time, after five other pregnancies were terminated during her FARC years. She says she managed to hide the fifth pregnancy from her commander until the sixth month by wearing loose clothes. *Facing page, top*: Angelina was one of the first female guerrillas to become pregnant in one of the rehabilitation camps set up to help FARC members in the transition back to everyday life. *Below*: Dayana (33) and Jairo, both previously with FARC, have had a baby daughter since the peace process. *Above*: Dayana gets ready to return to collect belongings left at her former guerrilla camp. *Following spread*: Icononzo transition camp, south of Bogotá.

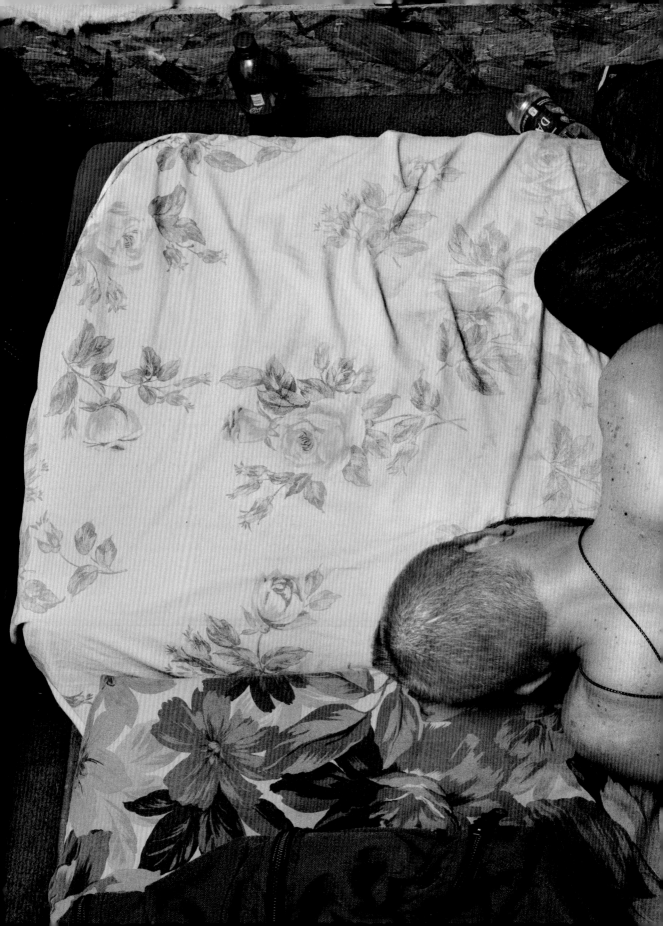

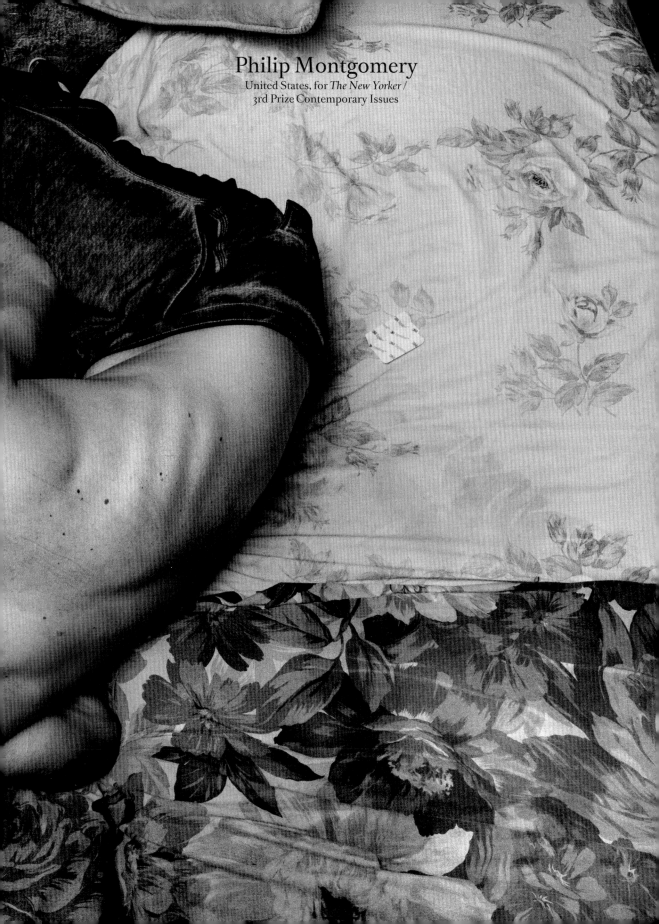

Philip Montgomery
United States, for *The New Yorker* /
3rd Prize Contemporary Issues

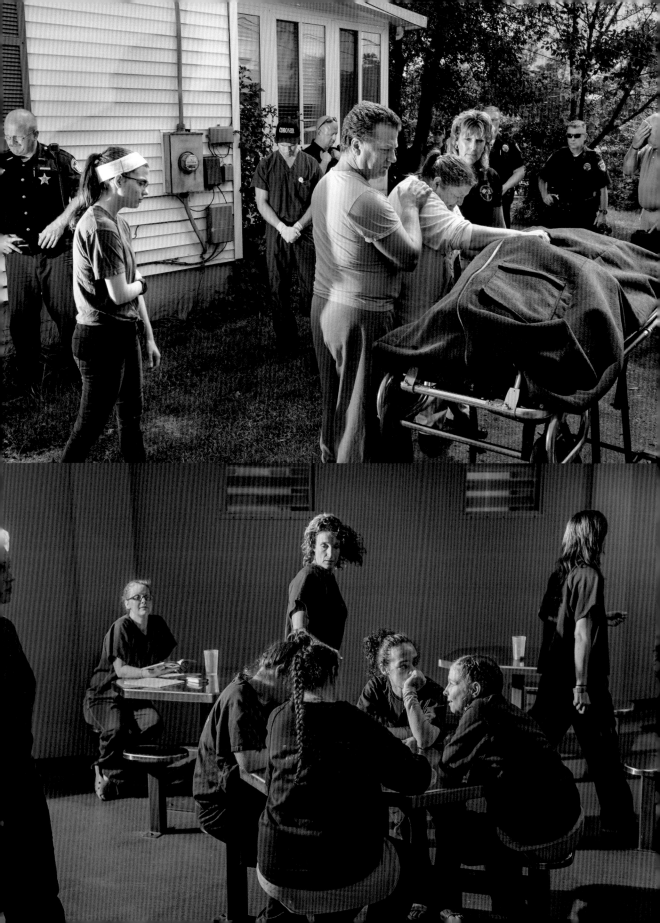

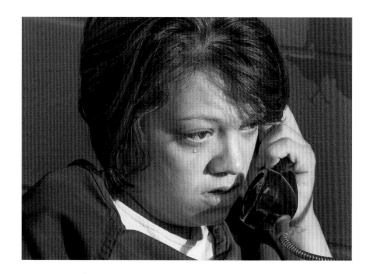

According to the National Institute on Drug Abuse, more than 130 people a day in the US die after overdosing on opioids. President Donald Trump has declared the opioid epidemic a national public health emergency. The crisis has its roots in the 1990s, when pharmaceutical companies assured doctors that opioid pain relievers were not addictive. The firm Purdue Pharma, in particular, has been accused of aggressive marketing even when the effects of opioids were known. Increased prescription of opioids such as Oxycontin led to widespread misuse. Some people switched to heroin, which was cheaper, and later to synthetic opioids, which are more potent and more likely to lead to a fatal overdose. *Previous spread*: A man overdosing on heroin collapses after first-responders administer Narcan, which blocks effects of opioids, Dayton, Ohio. *Facing page, top*: The body of Brian Malmsbury is taken away after he overdosed on heroin in the basement of his family's home, Miamisburg, Ohio. *Below*: Inmates of the drug detoxification ward of the Montgomery County Jail in Dayton, Ohio. *This page*: A woman phones from the drug detoxification unit at Montgomery County Jail. *Following spread*: Veronica 'Ronnie' Elam (24) cries while discussing her family's history with addiction, outside her home in Drexel, Ohio.

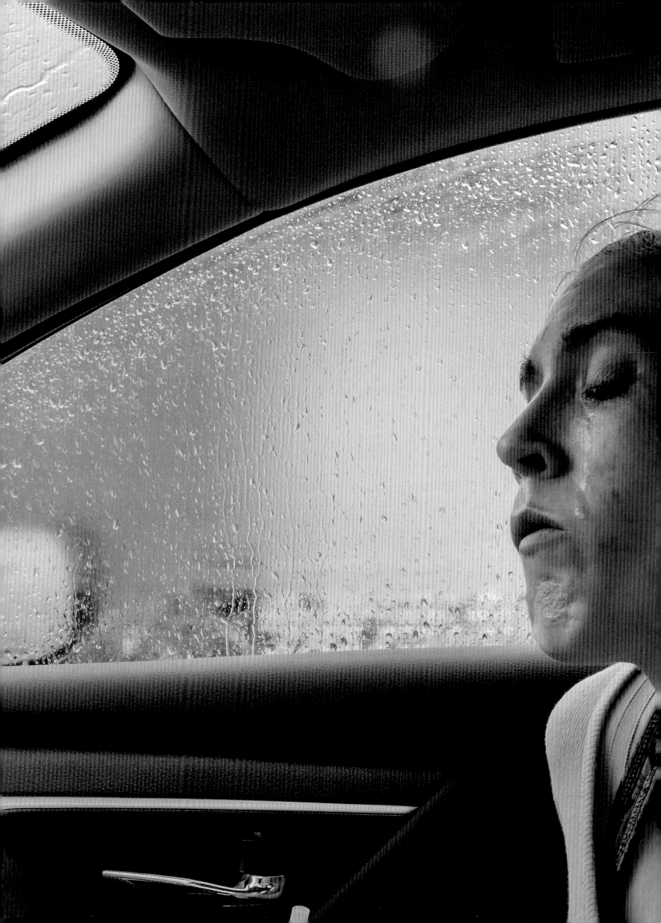

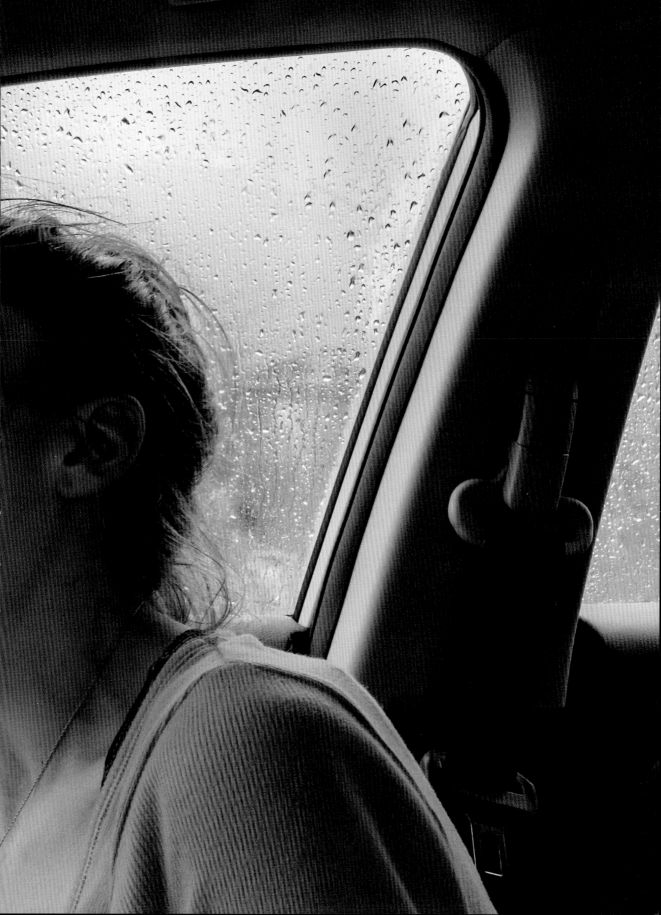

Pieter Ten Hoopen

Netherlands/Sweden, Agence VU/Civilian Act /
1st Prize Spot News

World Press Photo Story of the Year 2018

During October and November, thousands of Central American migrants joined a caravan heading to the United States border. The caravan, assembled through a grassroots social media campaign, left San Pedro Sula, Honduras, on 12 October, and as word spread drew people from Nicaragua, El Salvador and Guatemala. They were a mix of those facing political repression and violence, and those fleeing harsh economic conditions in the hope of a better life. Traveling in a caravan offered a degree of safety on a route where migrants have previously disappeared or been kidnapped, and was an alternative to paying high rates to people smugglers. *Facing page*: People run to a truck that has stopped to give them a ride, outside Tapanatepec, Mexico, on 30 October. Some drivers charged to give travelers a lift for part of the way, but most offered services free as a sign of support. (*continues*)

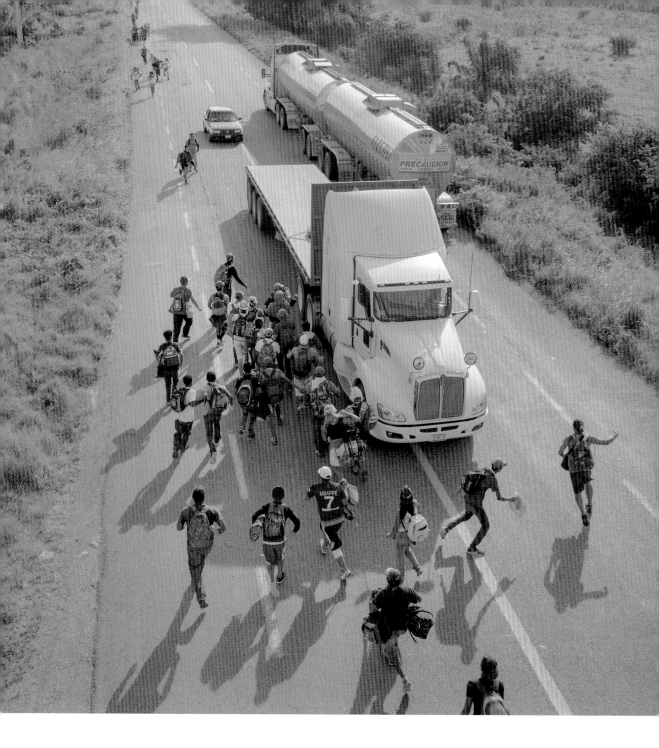

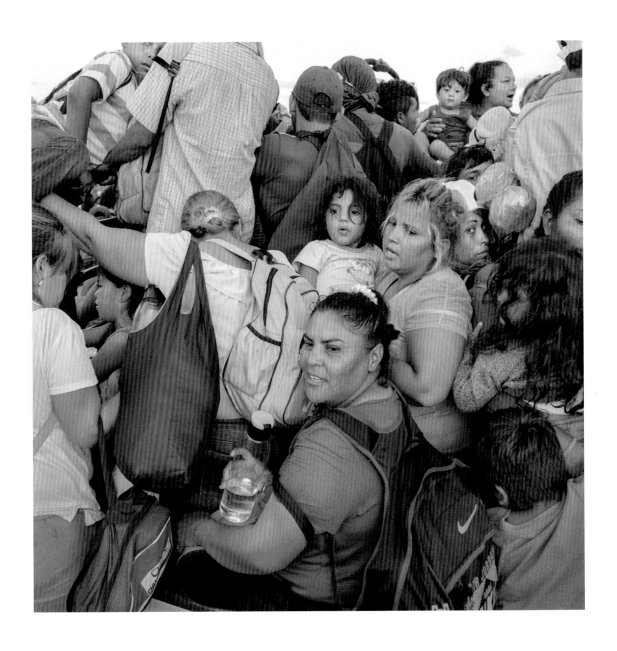

(*continued*) Migrant caravans travel to the US border at different times each year, but this was the largest in recent memory with as many as 7,000 travelers, including at least 2,300 children, according to UN agencies. *Above*: Refugees board a truck offering a lift, on the outskirts of Tapanatepec, on 29 October. *Facing page*: People cook over an open fire after setting up camp outside the town of Juchitán, on 1 November. (*continues*)

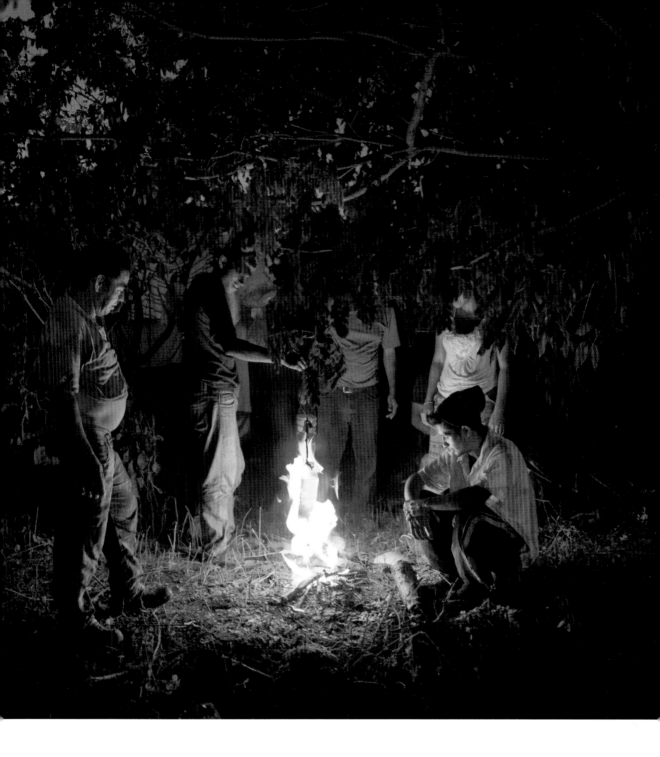

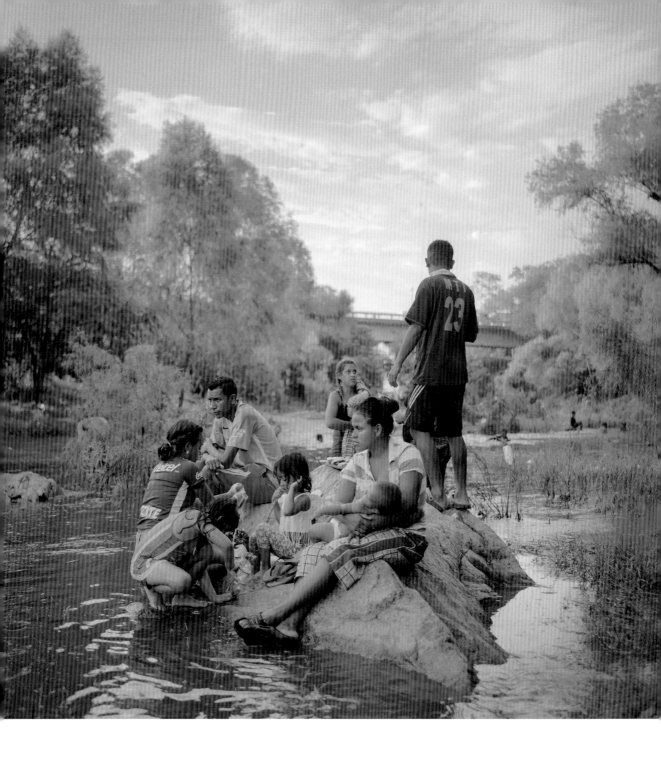

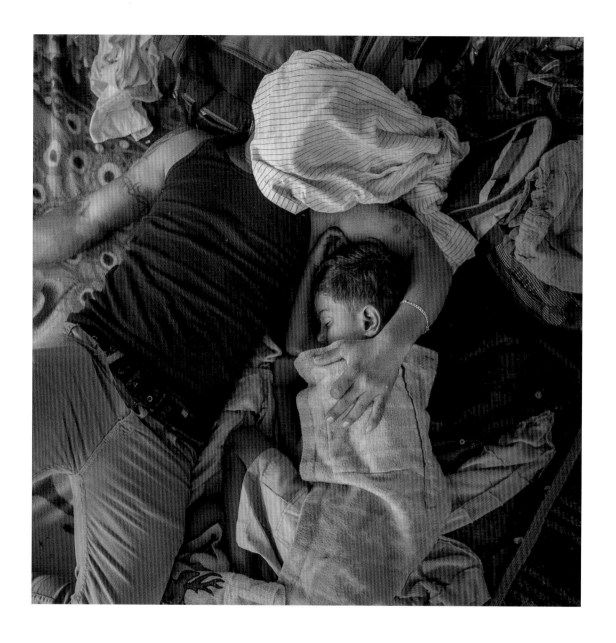

(*continued*) Conditions along the way were grueling, with people walking around 30 km a day, often in temperatures above 30°C. The caravan usually set off at around 4am each day to avoid the heat. *Facing page*: Families bathe, wash clothes and relax beside the Rio Novillero, when the caravan takes a rest day near Tapanatepec. *Above*: A father and son sleep after a long day's walking, Juchitán, 30 October. (*continues*)

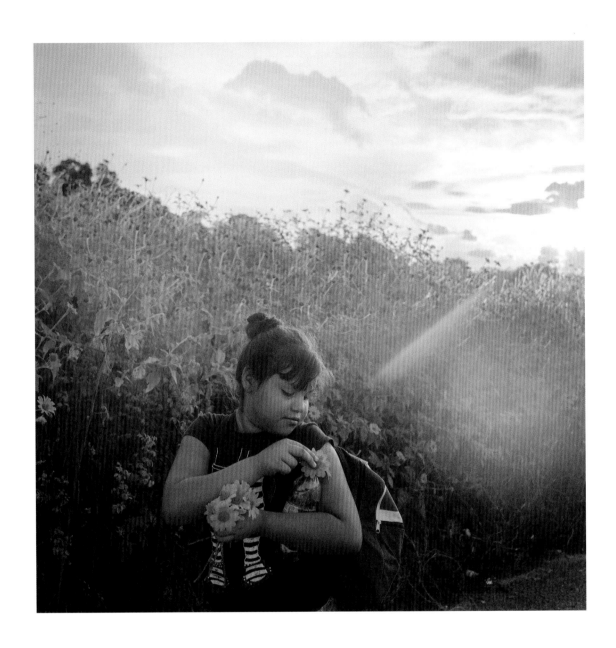

(continued) Like others, this caravan drew condemnation from US president Donald Trump, who made it a focal point of rallies and used it to reiterate his call for tough immigration policies and the building of a border wall. *Above*: A girl picks flowers during the day's walk from Tapanatepec to Niltepec, a distance of 50 km. *Facing page*: The caravan camps outside a bus station in Juchitán.

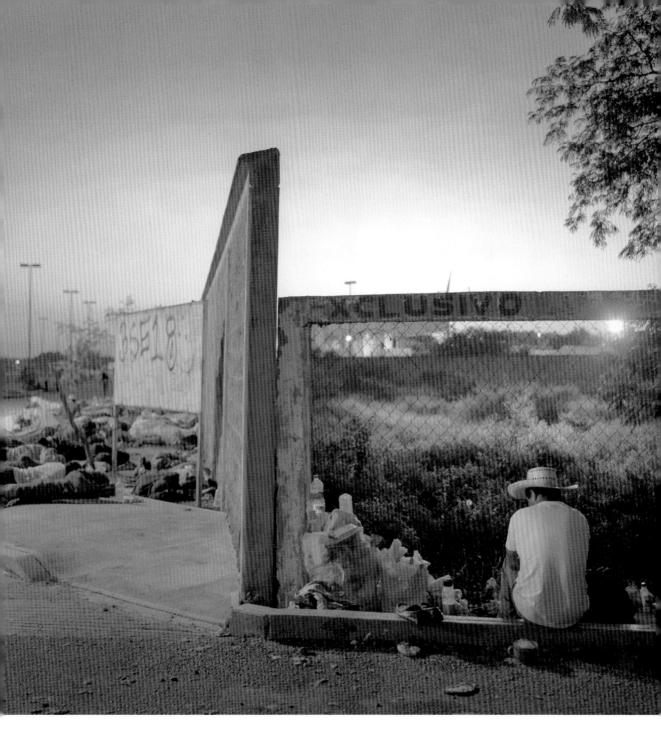

Mohammed Badra
Syria, European Pressphoto Agency /
2nd Prize Spot News

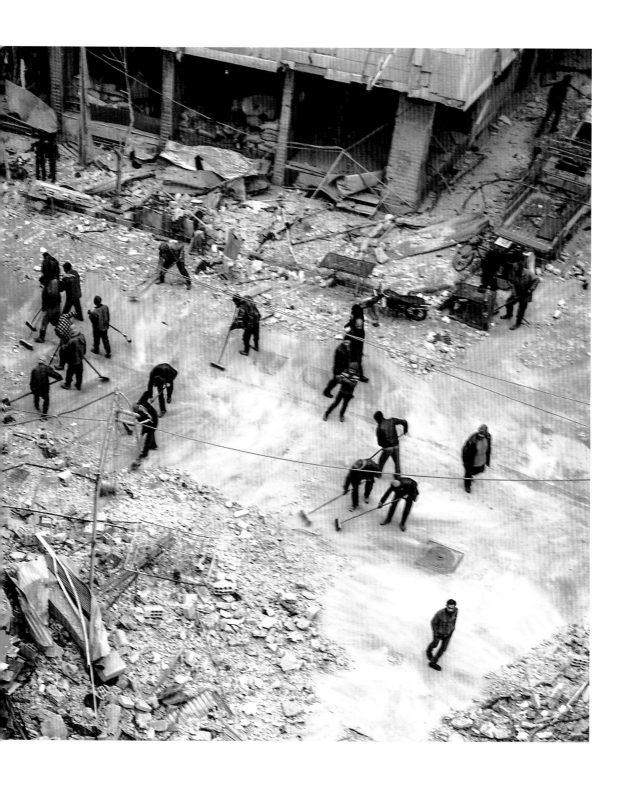

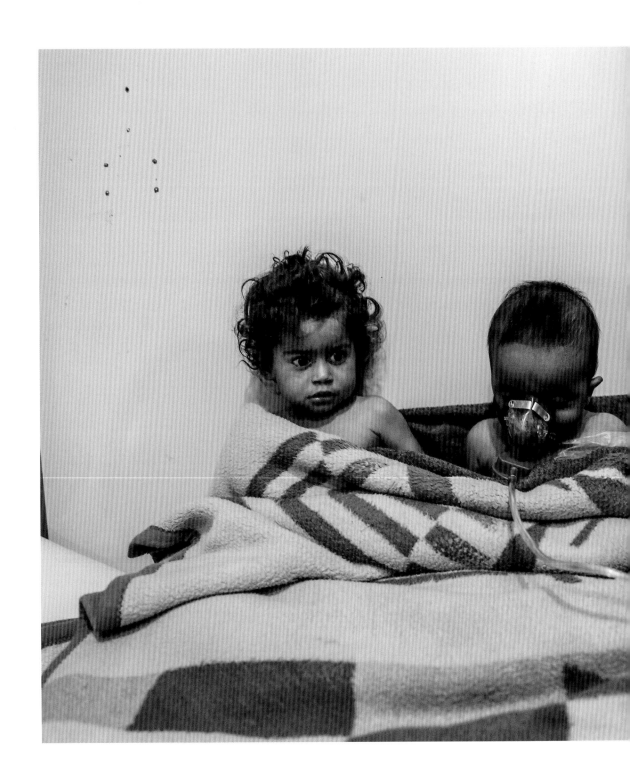

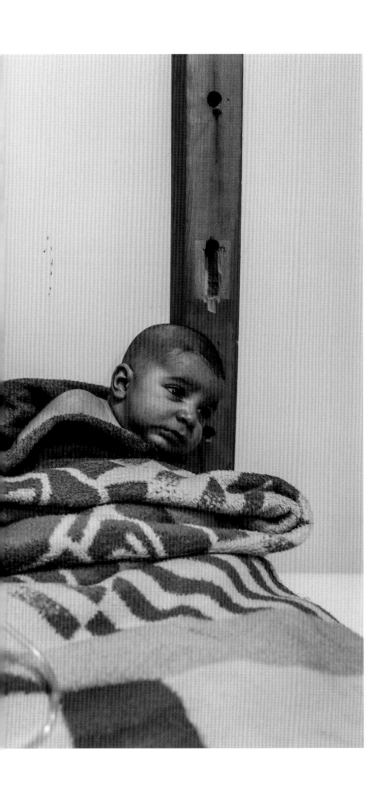

By February 2018, the people of Eastern Ghouta, a suburban district outside Damascus and one of the last rebel enclaves in the ongoing Syrian conflict, had been under siege by government forces for five years. During the final offensive, Eastern Ghouta came under rocket fire and air bombardment, including at least one alleged gas attack—on the village of al-Shifunieh, on 25 February. *Previous spread*: People clear rubble around buildings damaged in several airstrikes the previous day, Douma, Eastern Ghouta, 22 February. *This spread*: Children receive treatment after the suspected chlorine attack on the village of al-Shifunieh, 25 February. (*continues*)

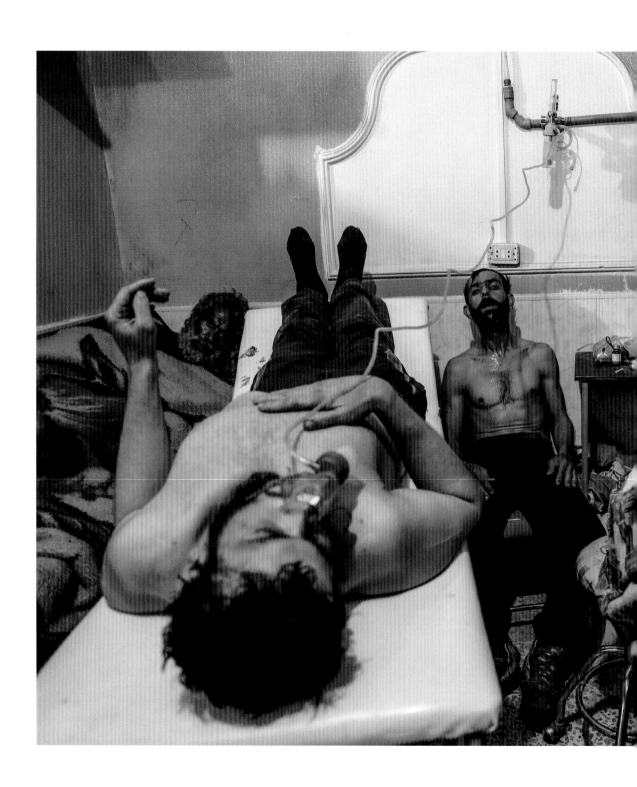

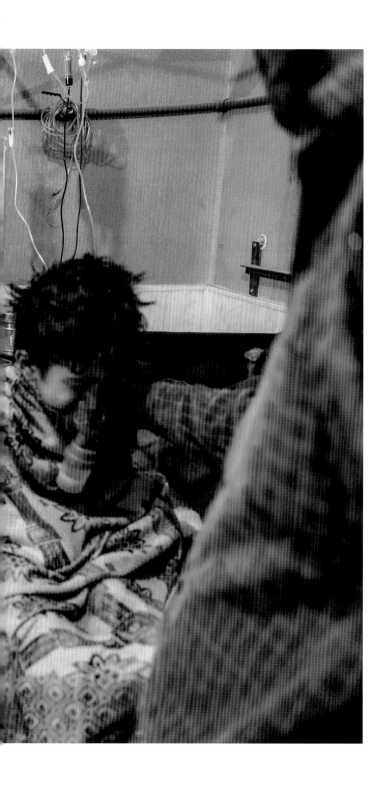

(*continued*) Figures are difficult to verify, but Médecins Sans Frontières (MSF) reported 4,829 wounded and 1,005 killed between 18 February and 3 March, according to data from medical facilities they supported alone. MSF also reported 13 hospitals and clinics damaged or destroyed in just three days. *Facing page*: A man and a child receive treatment after the suspected gas attack on al-Shifunieh, 25 February. (*continues*)

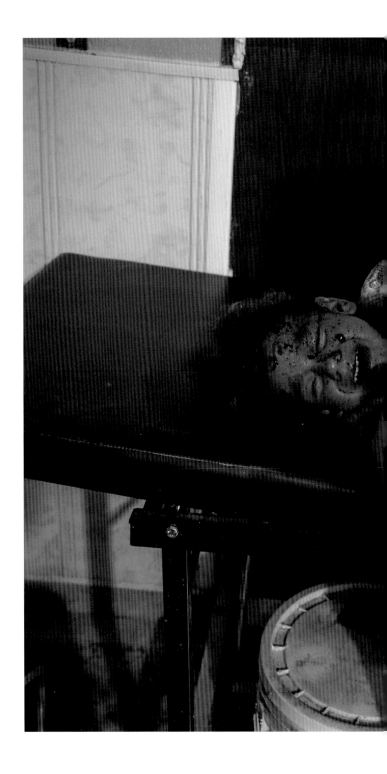

(*continued*) Reports on the end of the siege in Eastern Ghouta are conflicting, though the Syrian army appear to have recaptured most of the south of the country by July. UNICEF reported the siege of Eastern Ghouta to have ended by late March, with limited humanitarian access becoming available. *Facing page*: A wounded child is comforted by his brother in a makeshift hospital after bombing in Douma, on 8 February.

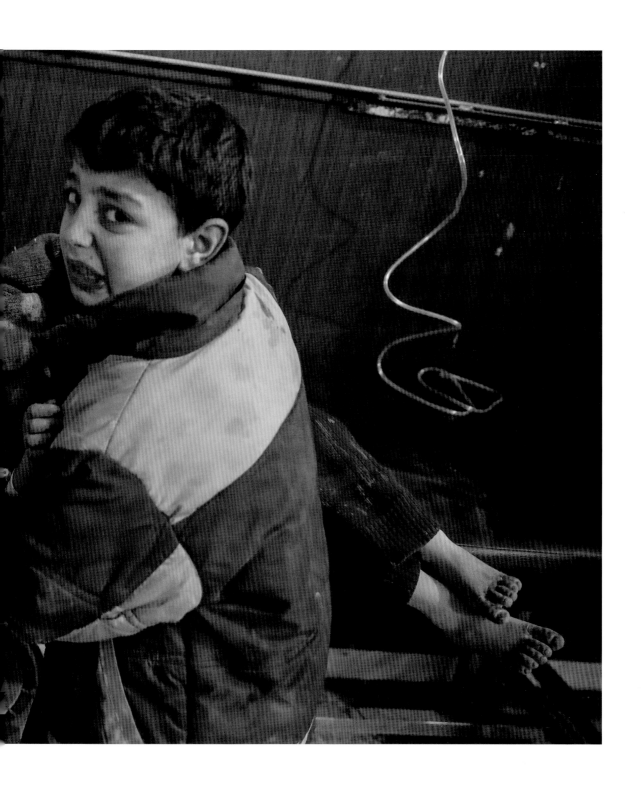

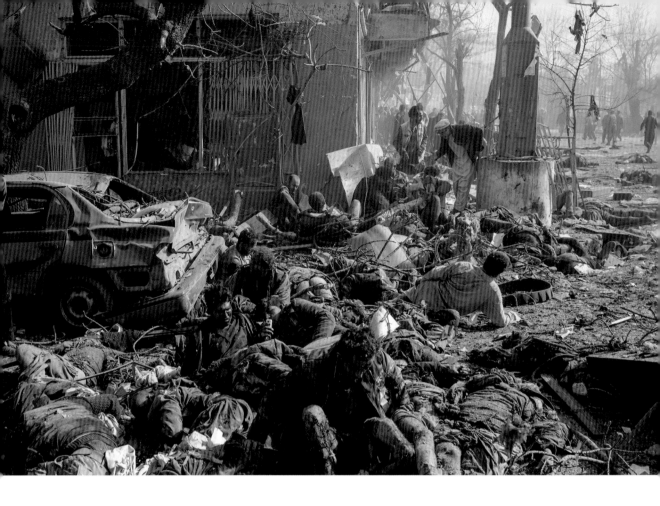

Andrew Quilty
Australia, Agence VU /
3rd Prize Spot News

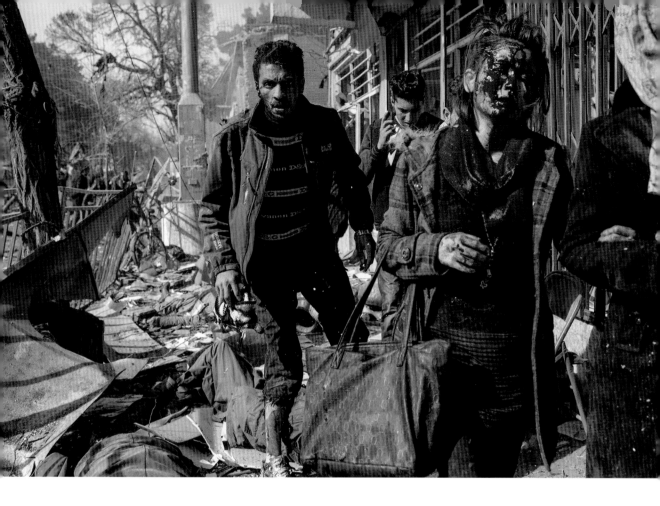

An ambulance packed with explosives killed 103 people and injured 235 in Kabul, Afghanistan, on 27 January. The ambulance had passed through one security point unnoticed, but although the attacker was identified at a second checkpoint, he couldn't be stopped from detonating his explosives. The bombing took place at lunchtime near Chicken Street, a shopping area once popular among foreign nationals, and close to government and diplomatic buildings. The Taliban claimed responsibility for the ambulance bombing, considered to be the worst in a string of civilian attacks in the Afghan capital in some months. Taliban commanders said they were intensifying urban attacks in retaliation for increased airstrikes on areas under their control. *Facing page*: Victims lie dead and severely wounded only meters from the scene of the blast. *Above*: Rahela, her face bloodied by shattered glass from the shop where she had been with her sister (right), is helped from the scene before being taken to hospital. *Following spread*: Victims lie along Chicken Street after the blast.

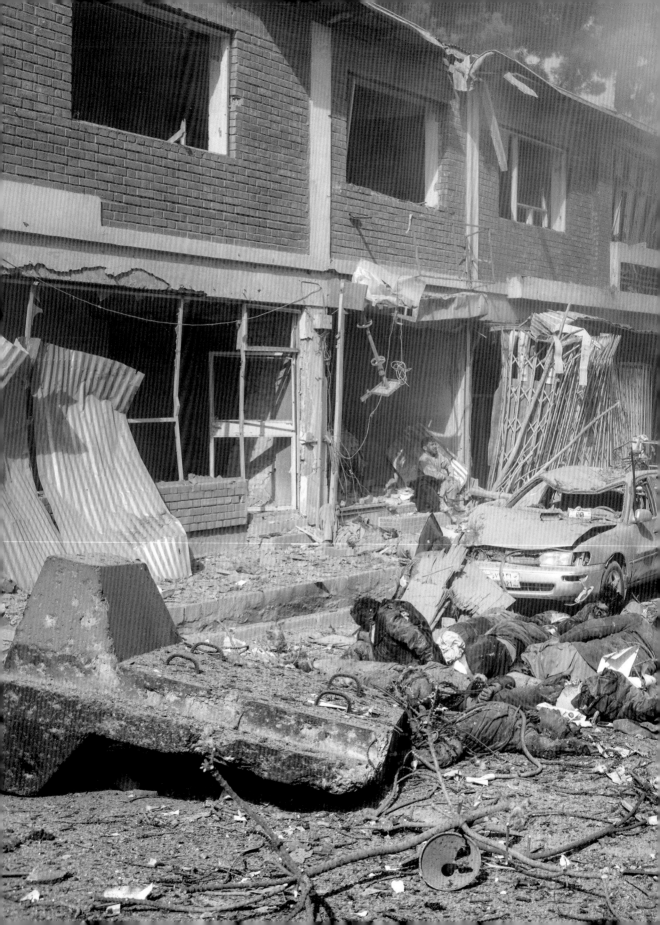

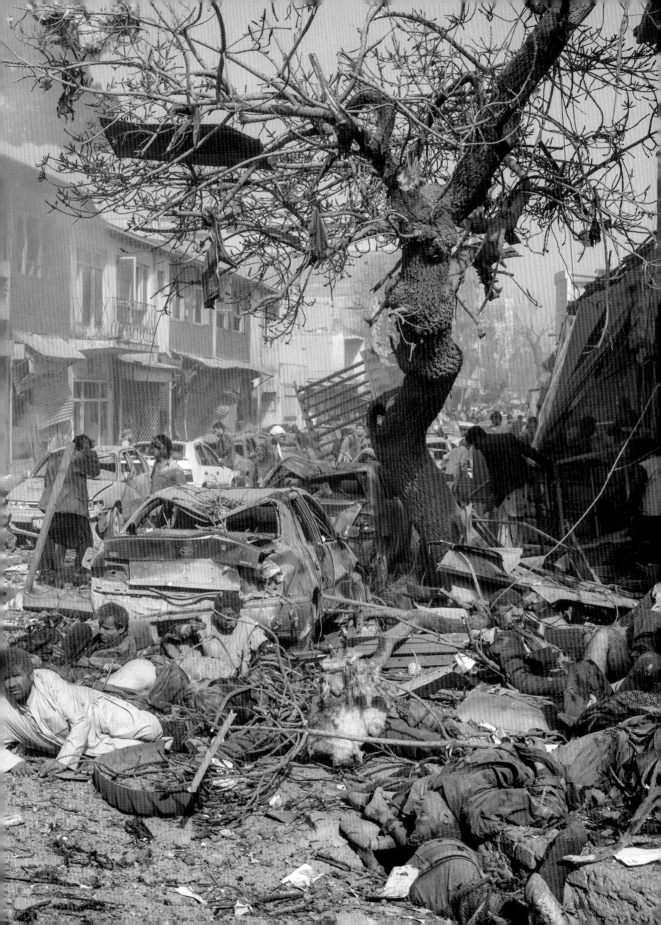

Lorenzo Tugnoli

Italy, Contrasto, for *The Washington Post* /
1st Prize General News

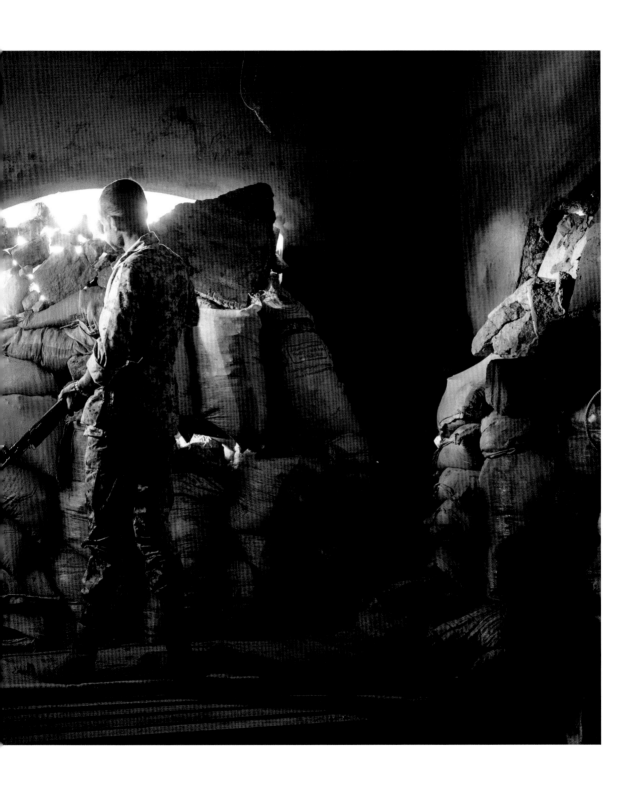

After nearly four years of conflict in Yemen, at least 8.4 million people are at risk of starvation and 22 million people—75 percent of the population—are in need of humanitarian assistance, according to the UN. In 2014, Houthi Shia Muslim rebels seized northern areas of the country, forcing the president, Abdrabbuh Mansour Hadi, into exile. The conflict spread, and escalated when Saudi Arabia, in coalition with eight other mostly Sunni Arab states, began air strikes against the Houthis. By 2018, the war had led to what the UN termed the world's worst man-made humanitarian disaster. *Previous spread*: A militiaman stands in a frontline position outside the besieged city of Taiz, on 26 November. Aid and supplies could be delivered to the city only along a road under control of the Saudi coalition. *Right*: Wafa Ahmed Hathim (25) lost her left leg when a mortar landed on her house in the strategically important Red Sea port of Hudaydah on 8 December—at a time when long-negotiated peace talks were taking place in Sweden. (*continues*)

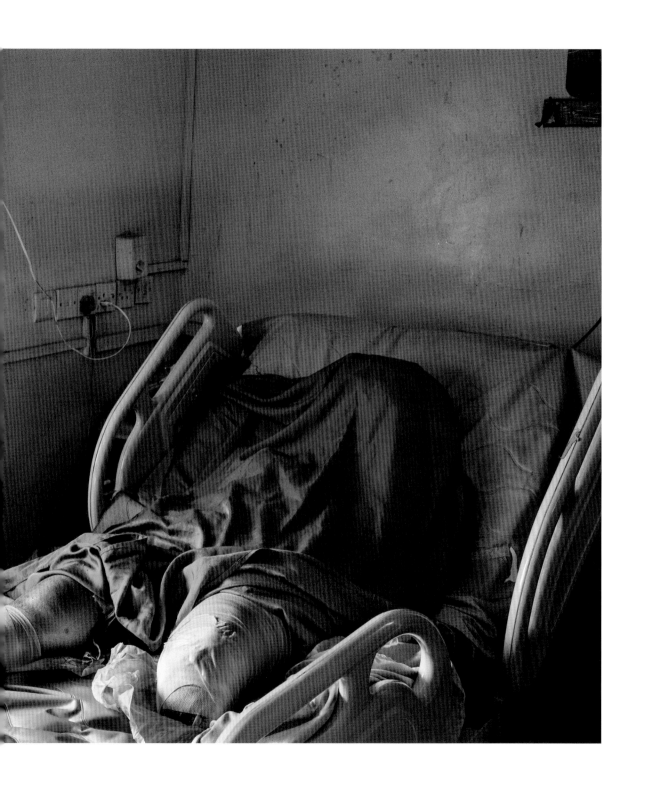

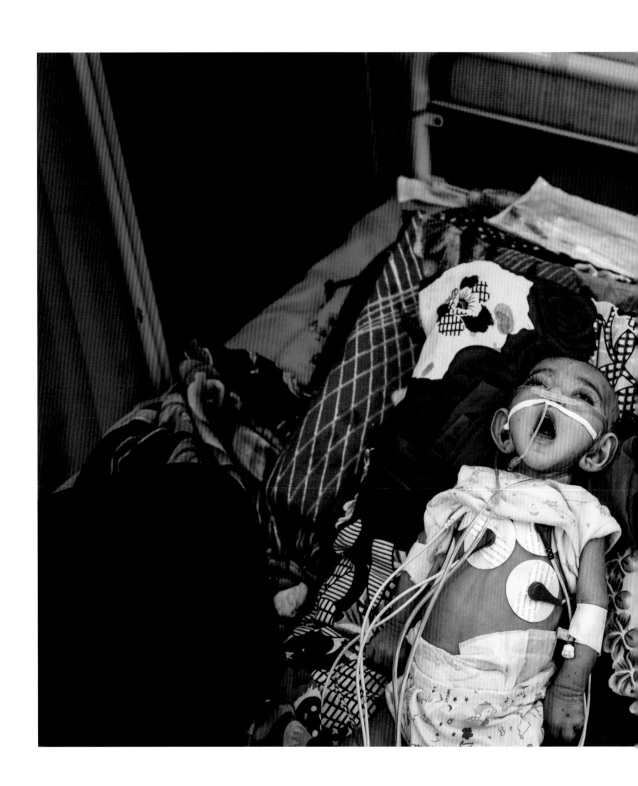

(*continued*) Saudi Arabia said that Iran—a Shia-majority state and their rival regional power—was backing the Houthis with weapons and supplies, a charge Iran denied. The Saudi-led coalition implemented a blockade on Yemen, imposing import restrictions on food, medicines and fuel. Resulting shortages exacerbated the humanitarian crisis. *Left*: Taif Fares gasps for air in the intensive-care unit at al-Sadaqa hospital, Aden, on 21 May. She had a heart disorder and required constant care. Supplies of oxygen and medicine to the hospital had been discontinued, and, on 14 May, a violent confrontation between a member of the militia controlling the hospital and a doctor had led to doctors going on strike. Taif died a few days after the photograph was taken. (*continues*)

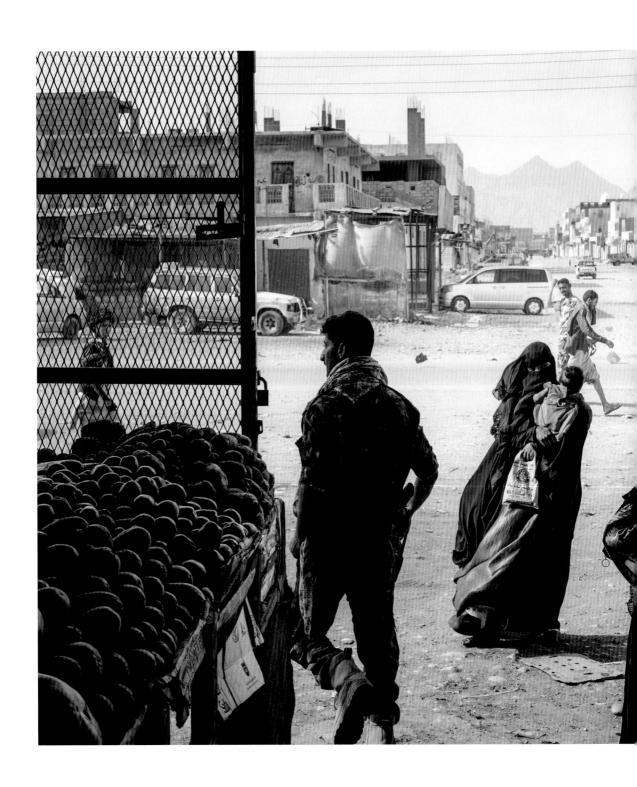

(*continued*) In many cases, conditions of near-famine were caused not so much by the unavailability of food, but because it became unaffordable, priced out of reach to most Yemenis by import restrictions, soaring transport costs due to fuel scarcity, a collapsing currency and other man-made supply disruptions. *Left*: A woman begs outside a grocery store in Azzan, a pivotal southern crossroads town that had seesawed back and forth between government and insurgent forces, on 22 May.

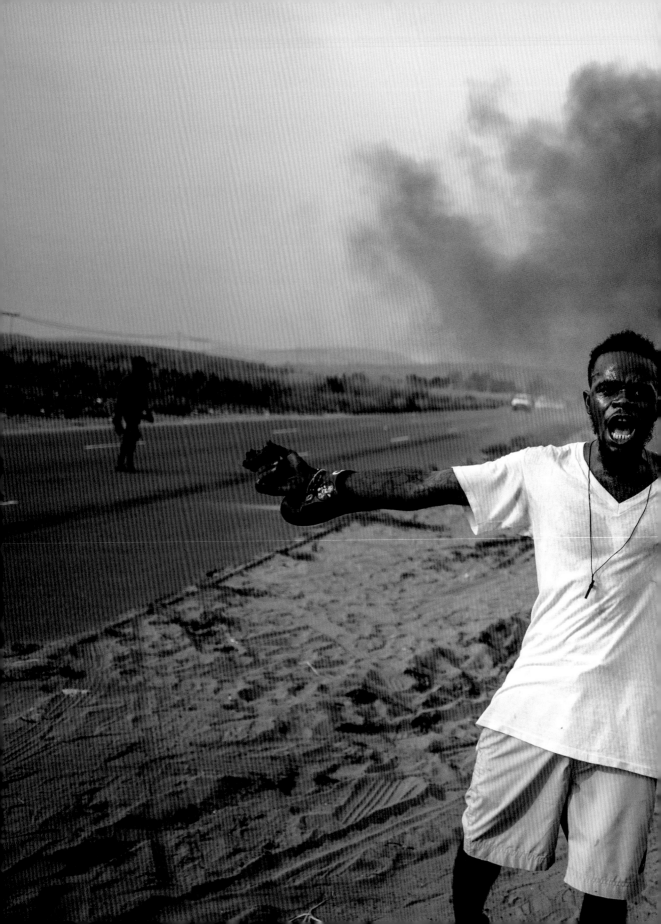

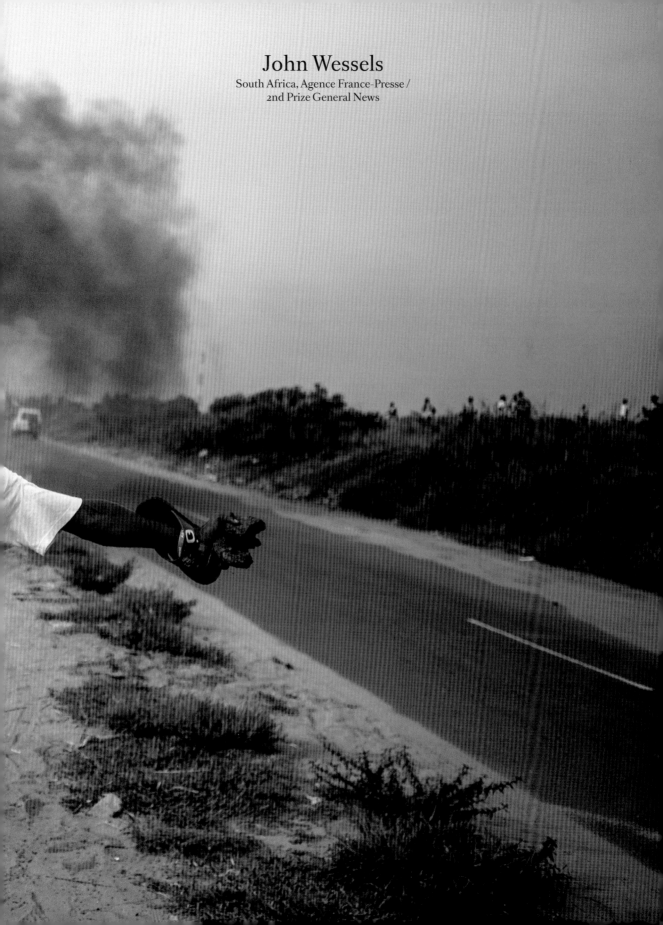

John Wessels
South Africa, Agence France-Presse /
2nd Prize General News

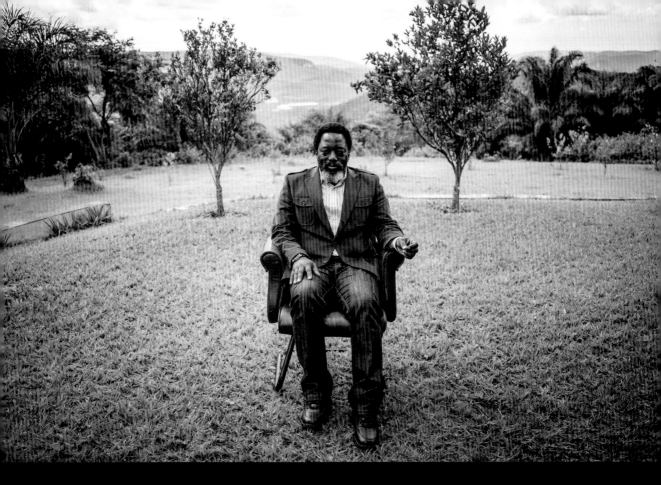

Long-delayed general elections to find a successor to President Joseph Kabila in the Democratic Republic of Congo (DRC), were finally held on 30 December. The run-up was marked by protests, street rallies and clashes between opposition supporters and police. Elections had been repeatedly postponed since President Kabila's mandate expired in 2016. The election was won by Felix Tshisekedi, leader of DRC's largest opposition party, the Union for Democracy and Social Progress (UDPS). The result was disputed by rival parties, but welcomed internationally as the first peaceful transfer of power since Congo's independence

in 1960. *Previous spread*: A supporter of Martin Fayulu, leader of an opposition party, runs from police tear gas in Kinshasa, on 19 December. *Above*: President Kabila sits in the garden of his ranch in Kinshasa, on 10 December. *Facing page, top*: Tear gas is used on Tshisekedi supporters welcoming the UDPS leader to Kinshasa at the start of his campaign, on 27 November. *Below*: A man casts his vote in Kinshasa. *Following spread*: UDPS supporters gather outside party headquarters, on 21 December. A fire that destroyed polling equipment had led to another postponement of the election, initially scheduled for 23 December.

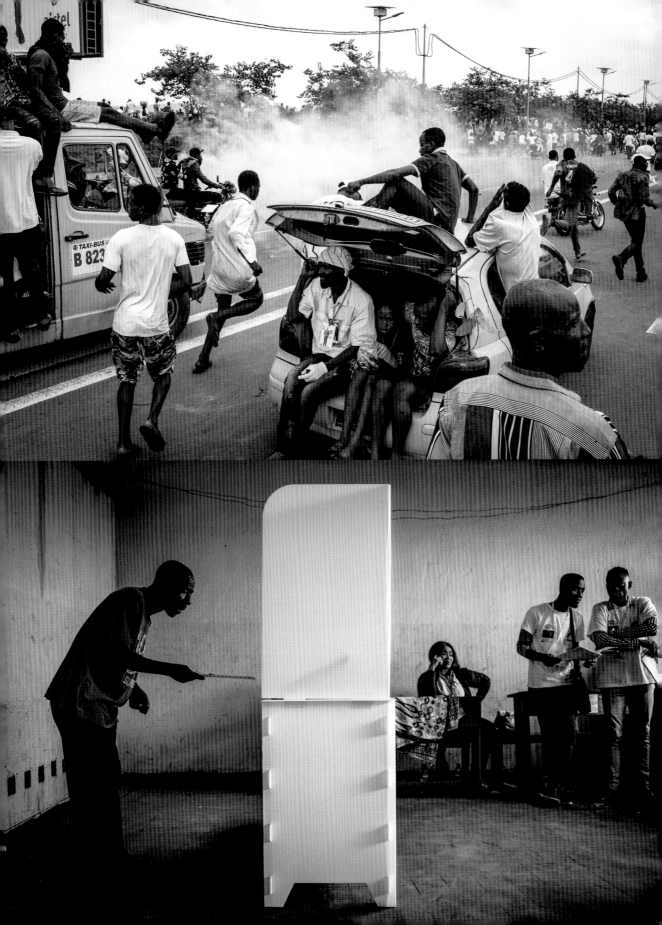

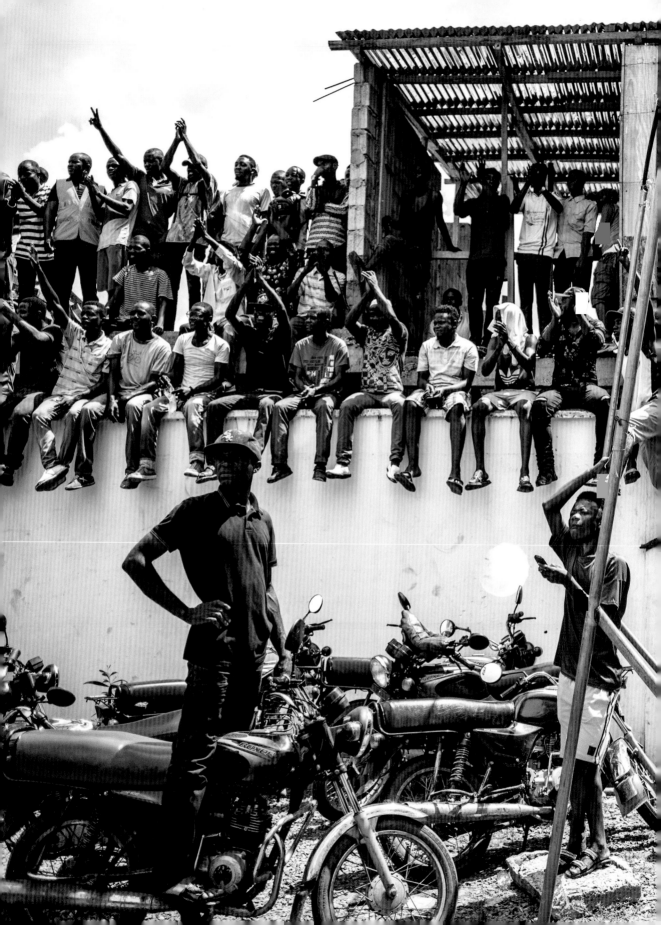

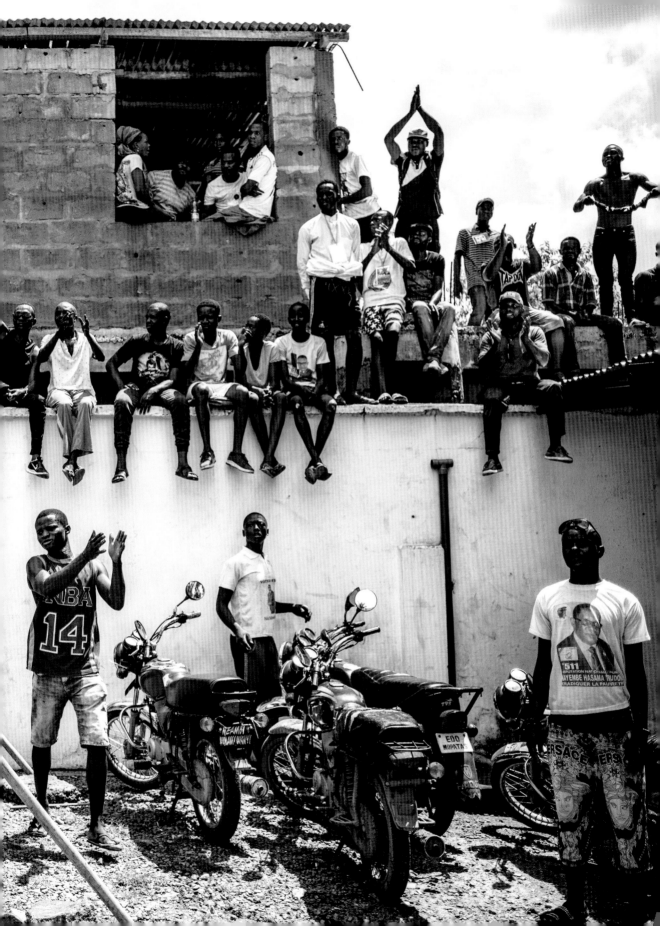

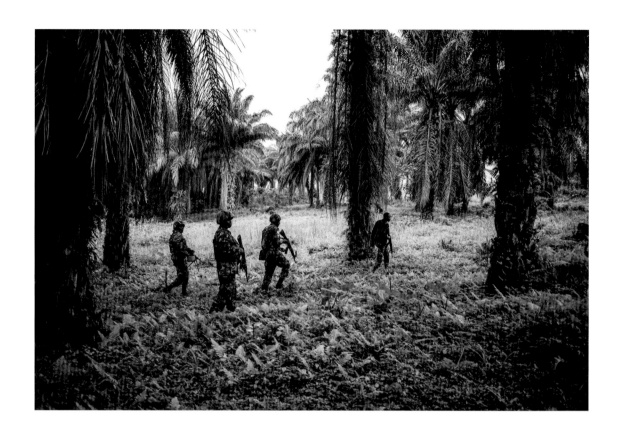

John Wessels
South Africa, Agence France-Presse /
3rd Prize General News

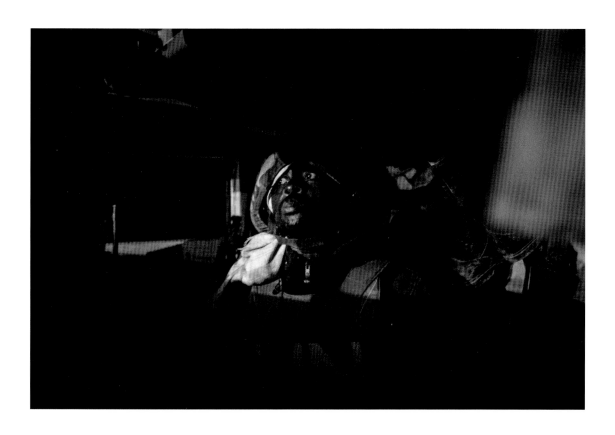

Beni, in northeastern Democratic Republic of Congo (DRC), has been affected by conflict for over 25 years, and in 2018 had also to deal with a major outbreak of the deadly Ebola virus. Over 100 armed groups are estimated to be active in the region, with government troops backed by MONUSCO, a UN stabilization mission, battling with the Allied Democratic Forces (ADF) and other rebel groups. Attacks in and around the town spiked during the Ebola outbreak, which Médecins Sans Frontières (MSF) called the second-largest recorded anywhere. *Facing page*: MONUSCO soldiers patrol against the ADF, a partly Islamist group of Ugandan origin, on 13 November. *Above*: A MONUSCO soldier sits after an ADF attack in Oicha, 30 km north of Beni, on 5 October. (*continues*)

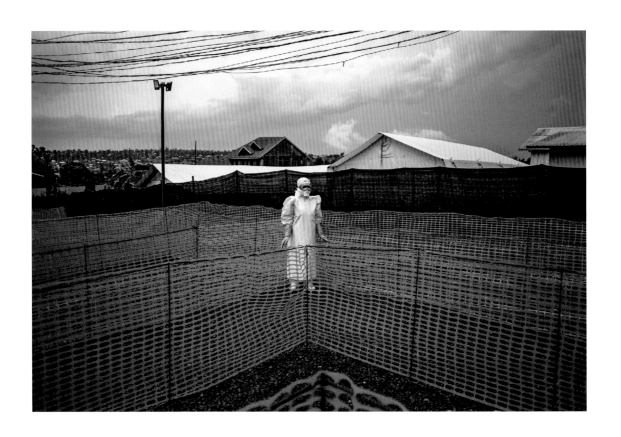

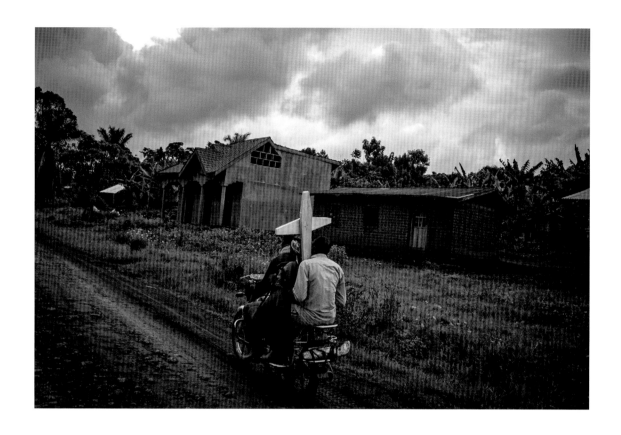

(*continued*) The Ebola outbreak was first declared on 1 August, in the small town of Mangina, 30 km from Beni, and soon spread. By the end of the year, some 700 cases and over 460 deaths had been reported. Containing the highly contagious disease was almost impossible in a conflict situation. Widespread displacement made containing and tracking cases complicated and meant some stricken areas were difficult to access. Medical teams' operations were disrupted, and misinformation about the disease was rife. *Facing page*: A health worker waits to handle an unconfirmed case of Ebola at a newly built treatment centre in Bunia, 200 km north of Beni, on 7 November. *Above*: People carry a cross to mark a grave on the road between Mangina and Beni, on 23 August.

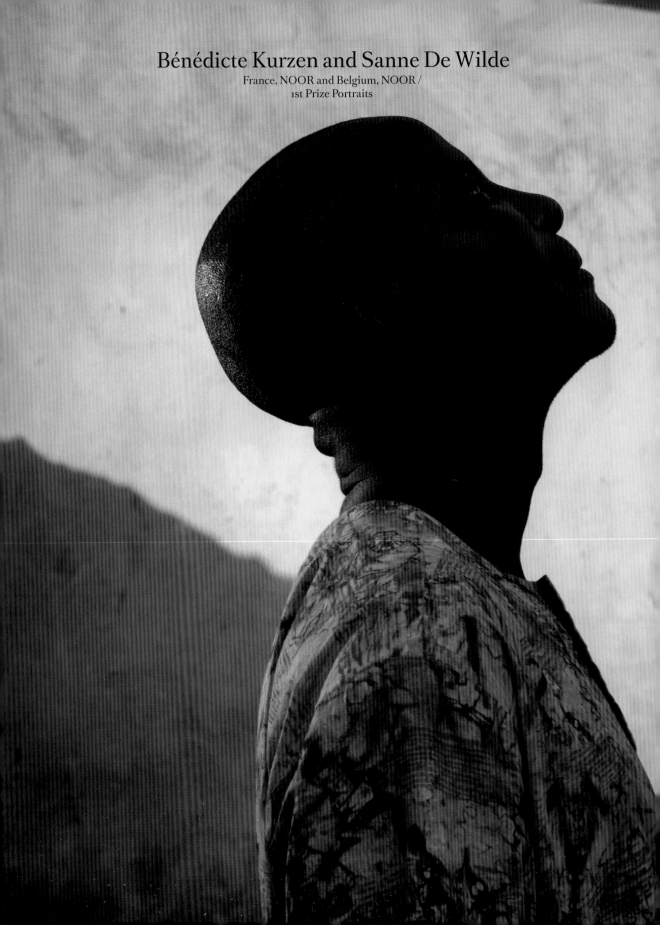

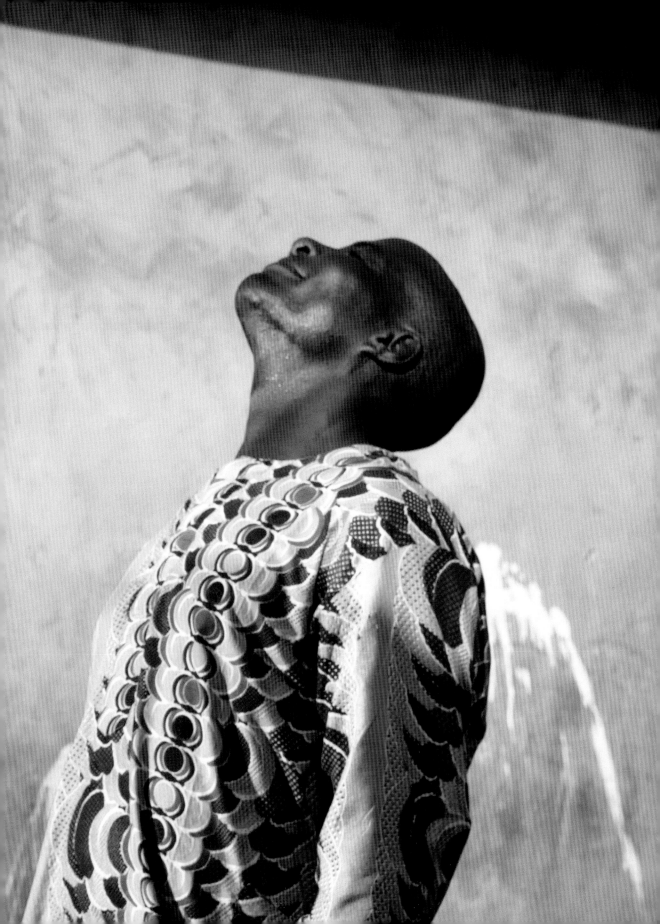

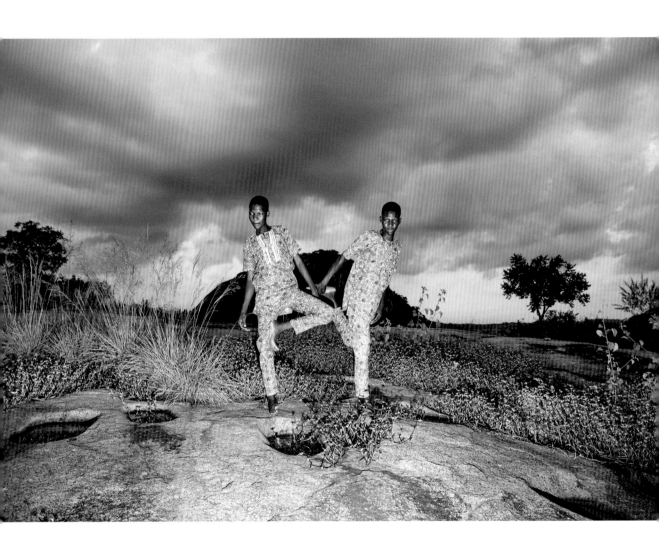

Nigeria has one of the highest occurrences of twins in the world, particularly among the Yoruba people in the southwest. Communities have developed different cultural practices in response to this high birth rate, from veneration to demonization. In earlier times, twins in some regions were considered evil, and vilified or killed at birth. Nowadays, the arrival of twins is generally met with celebration, and many think they bring good luck and wealth. In the southwestern town of Igbo-Ora, dubbed 'The Nation's Home of Twins', reportedly almost every family has at least one set. In 2018, the town hosted a Twins Festival, attended by over 2,000 pairs. Two color filters were used, to express duality: of identity, of photographers, and of attitude to twins. *Previous spread*: Twin brothers near their home in Igbo-Ora. *Above*: Twin brothers stand on a hill outside Tapa. *Facing page*: Dressed for church, twin sisters stand on a hill near Igbo-Ora. *Following spread*: Twin sisters stand side-by-side.

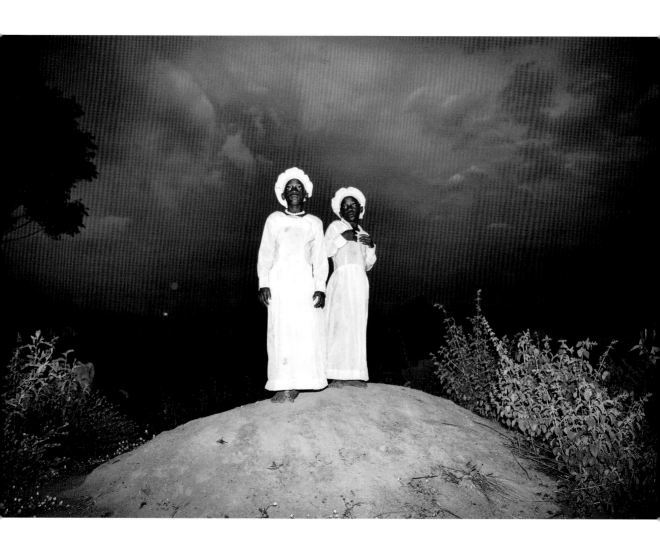

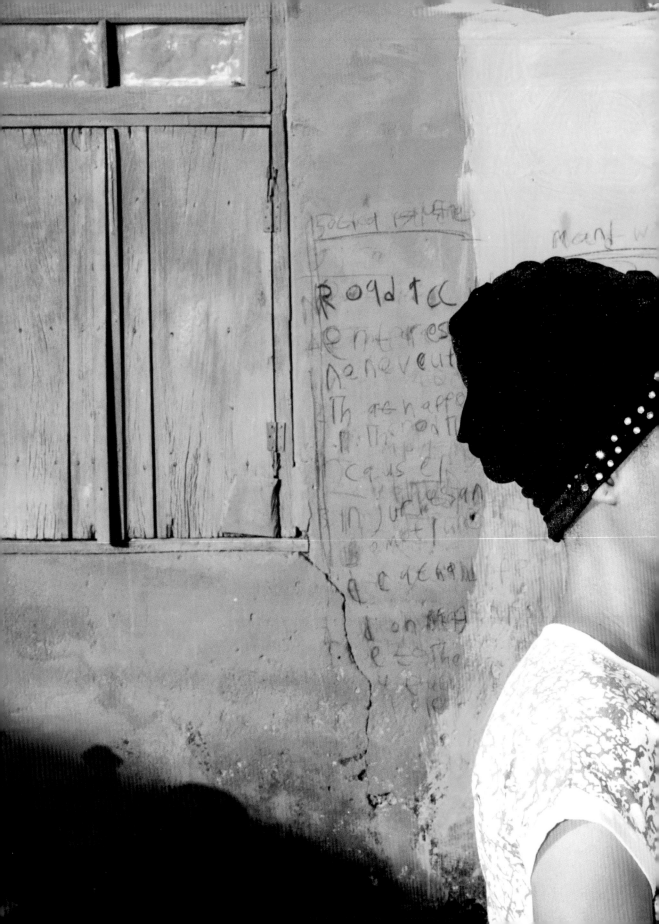

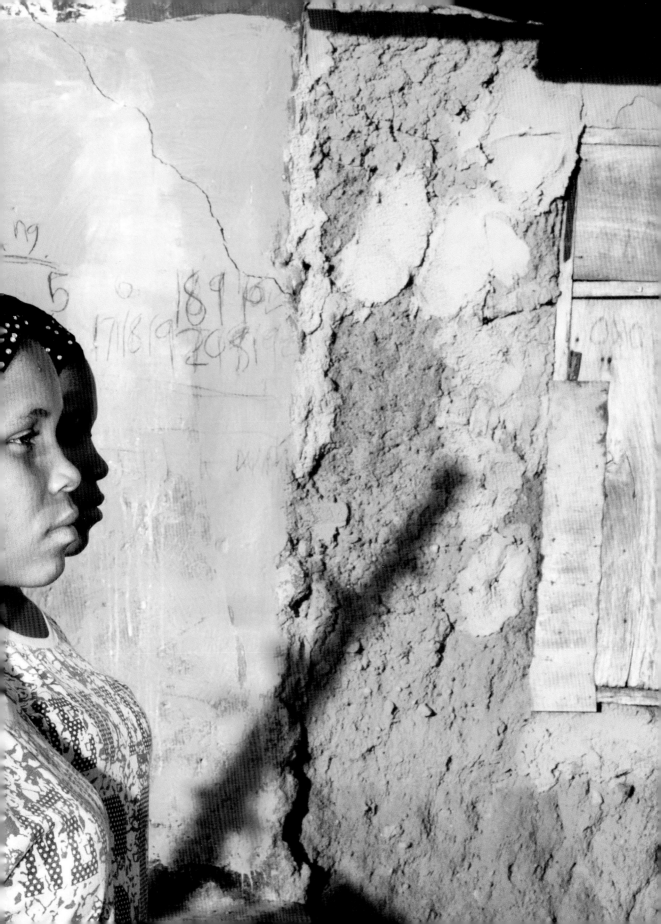

Jessica Dimmock

United States, for *Topic* /
2nd Prize Portraits

Transgender individuals around the world are still exposed to widespread social stigma and abuse. Senior transgender women in northwestern USA are pictured in the places where they hid their female identities for decades. *Above*: Barbara Anne (74) applies lipstick in her car in Kent, Washington. She first came out in 2002, and until 2010 would change into her dress and wig in her car when that was difficult to do elsewhere. *Facing page*: Margo (64), from Oakland, California, started dressing at around the age of five, but remained closeted until she was 59. She would rent cheap hotel rooms to change into women's clothes. (*continues*)

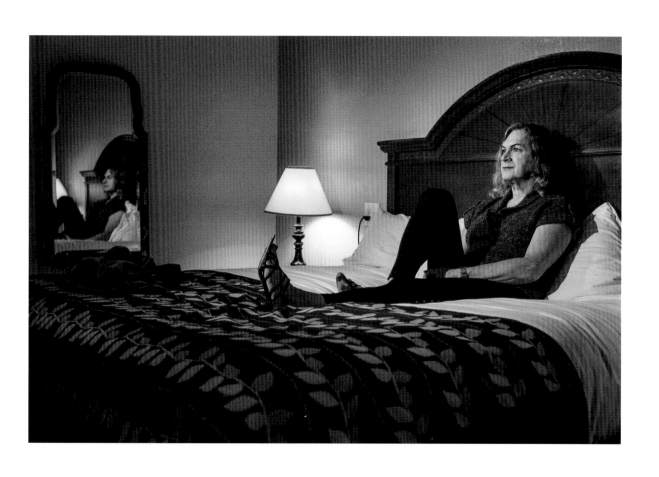

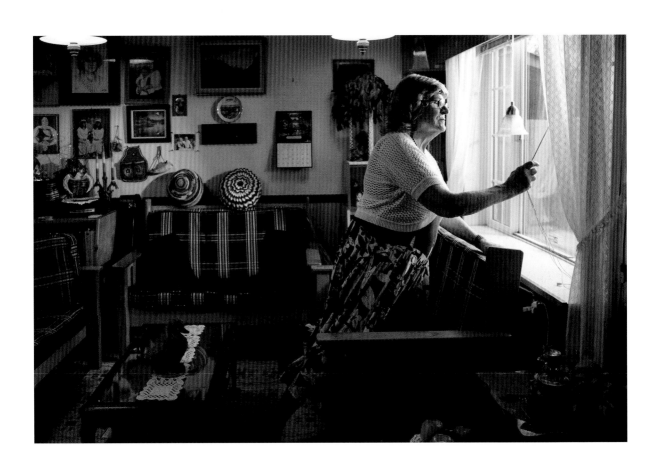

(*continued*) For many transgender women, coming to terms with their female selves is an ongoing process. Some find resourceful ways in which to express their identities in private. *Facing page*: Mharie (83), in Eugene, Oregon, used to draw her curtains so that neighbours wouldn't see her dressed in women's clothes while her wife was out. *Above*: Amy (42) from Tacoma, Washington, used to wear her female clothing under baggy sweatpants when going out, and change in an alley near the club she was heading to.

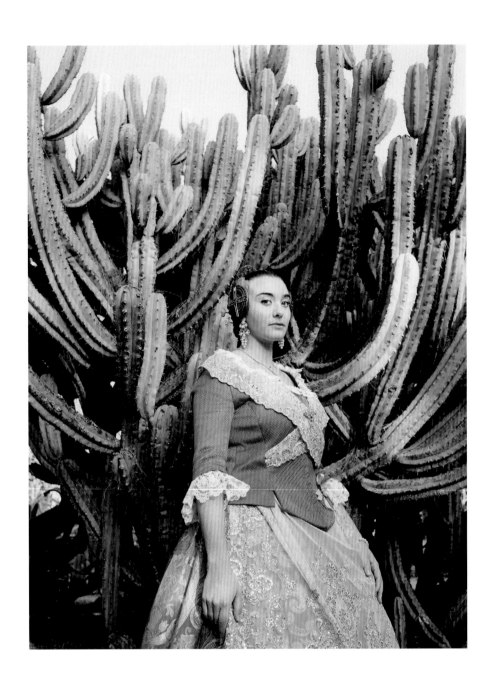

Luisa Dörr

Brazil /
3rd Prize Portraits

Women and girls wear *fallera* dresses for the Fallas de Valencia festival in Valencia, Spain. Inspired by clothes worn centuries ago by women working in rice fields around the city, the dresses have changed over time and are now elaborate creations that can cost in excess of €1,000. *Facing page*: As *fallera* gowns are so expensive, Maria Fernandez bought a second-hand one and customized it. *Above*: Lola (10) was born in Ethiopia and adopted by a Valencian family. She has been dressing as a *fallera* since she was two. (*continues*)

(*continued*) Made mainly of lace and silk, *fallera* dresses are worn by anyone who wants to take part in what is one of Spain's biggest street festivals. To complement the gown, *falleras* set their hair in a traditional style adorned with elaborate combs and jewelry. *Facing page*: Emma Xifeng Abril (left) was born in China and her sister Eva Lanhan Abril in Vietnam. When their adoptive mother went to meet Emma, she decided to buy fabrics from her daughter's homeland to make a *fallera* dress for her. *Above*: Twins Claudia and Victoria stand ready for the festivities.

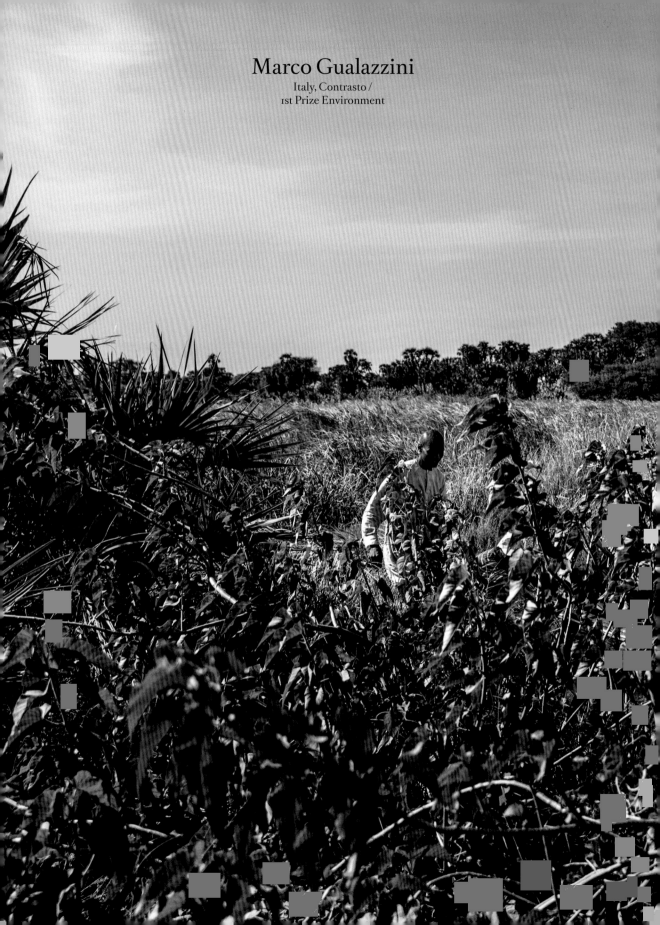

Marco Gualazzini

Italy, Contrasto /
1st Prize Environment

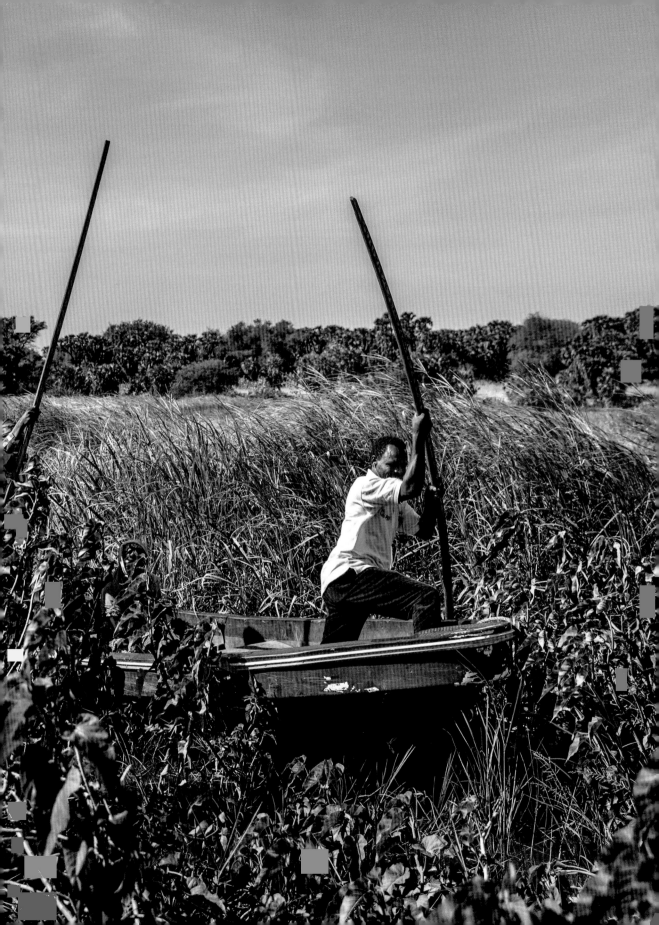

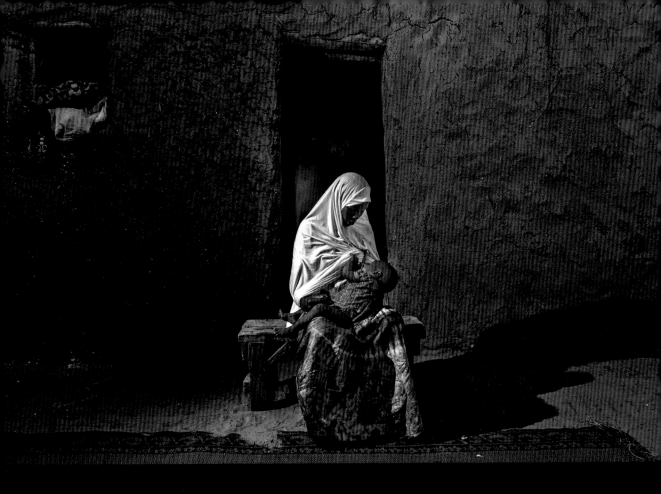

A humanitarian crisis is underway in the Chad Basin, caused by a complex combination of political conflict and environmental factors. Lake Chad—once one of Africa's largest lakes and a lifeline to 40 million people—is experiencing massive desertification. As a result of unplanned irrigation, extended drought, deforestation and resource mismanagement, the size of the lake has decreased by 90 percent over the past 60 years. Traditional livelihoods such as fishing have withered, and water shortages are causing conflict between farmers and cattle herders. Jihadist group Boko Haram, which is active in the area, both benefits from the hardship and widespread hunger and contributes to it.

The group uses local villages as a recruiting ground, and the protracted conflict has uprooted 2.5 million people, exacerbating food insecurity. *Previous spread*: Men punt a pirogue through marshy cane thicket at the lake's edge. *Above*: Maria Hassan (20), in Melea, Chad, was kidnapped by Boko Haram, forced to marry an extremist and had their child, but managed to escape. *Facing page, top*: Women gather water from the lake. *Below*: Ababakar Mbomi, an anti-Jihad activist in Melea, Chad, was shot 11 times when Boko Haram kidnapped his wife in 2014. *Following spread*: An orphaned boy walks past a wall with drawings depicting rocket-propelled grenade launchers, in Bol, Chad.

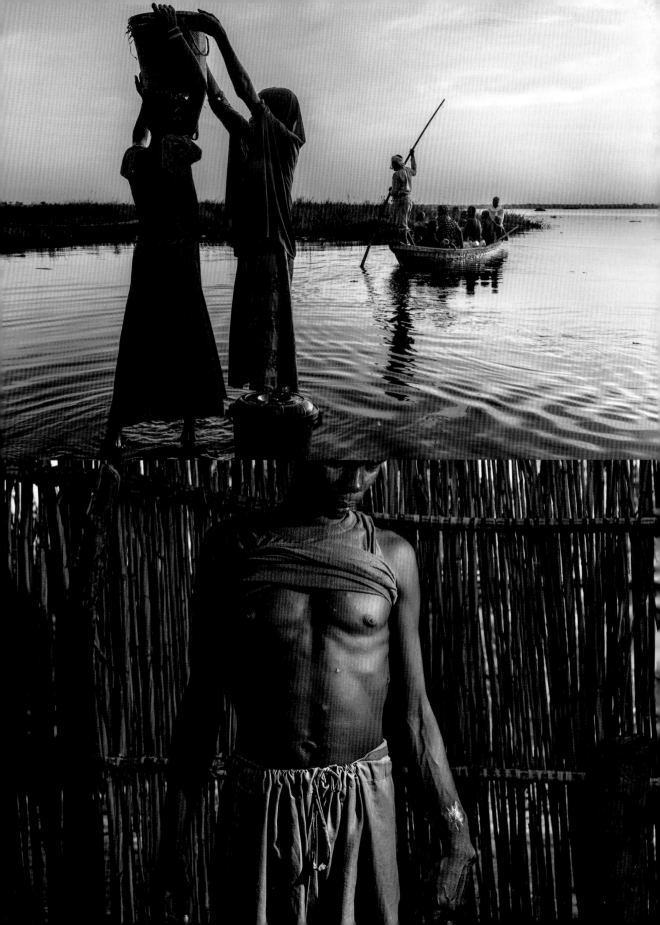

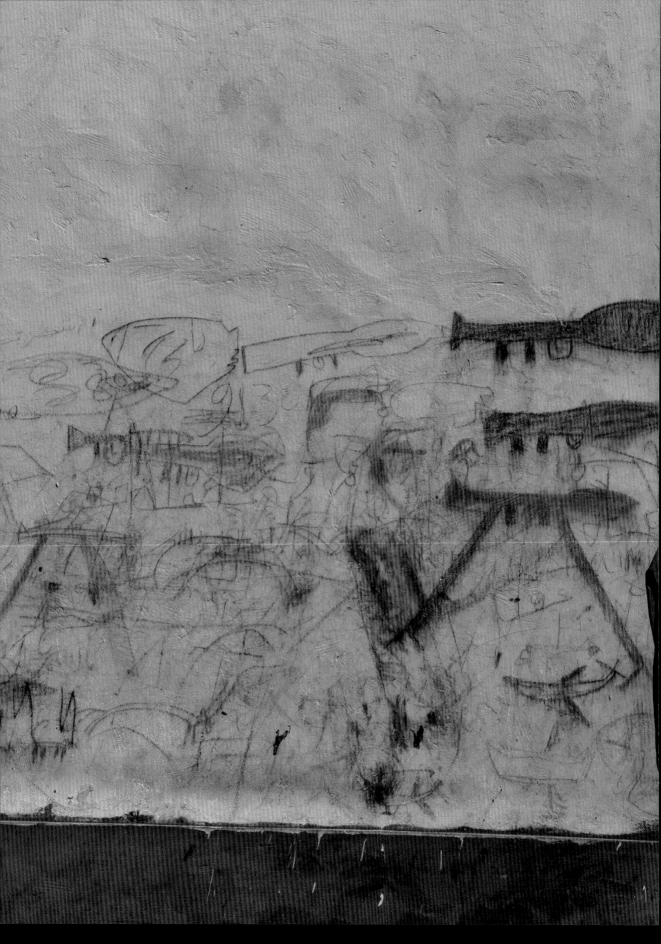

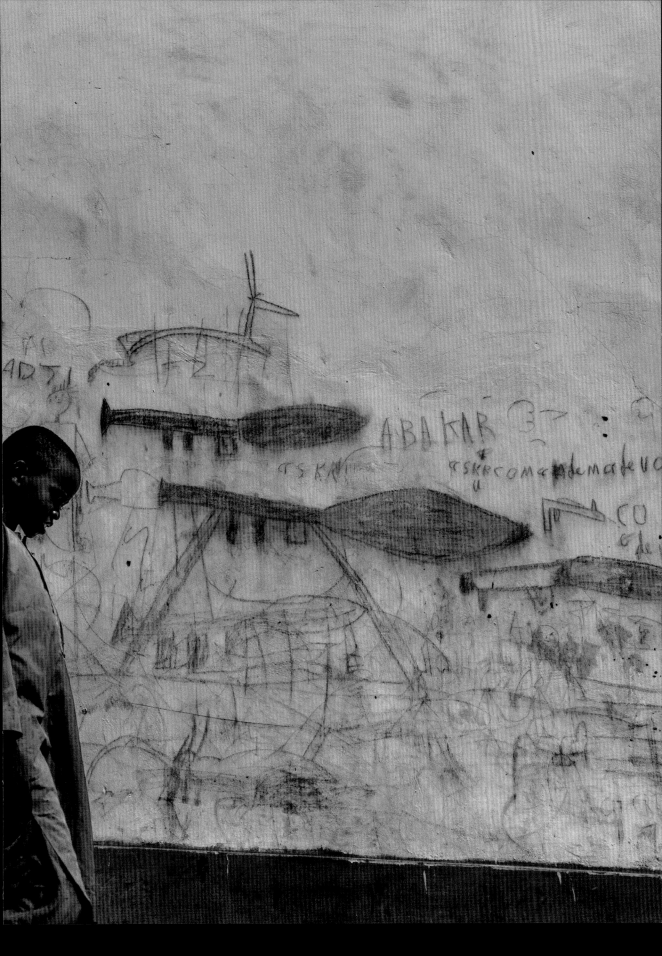

Nadia Shira Cohen

United States /
2nd Prize Environment

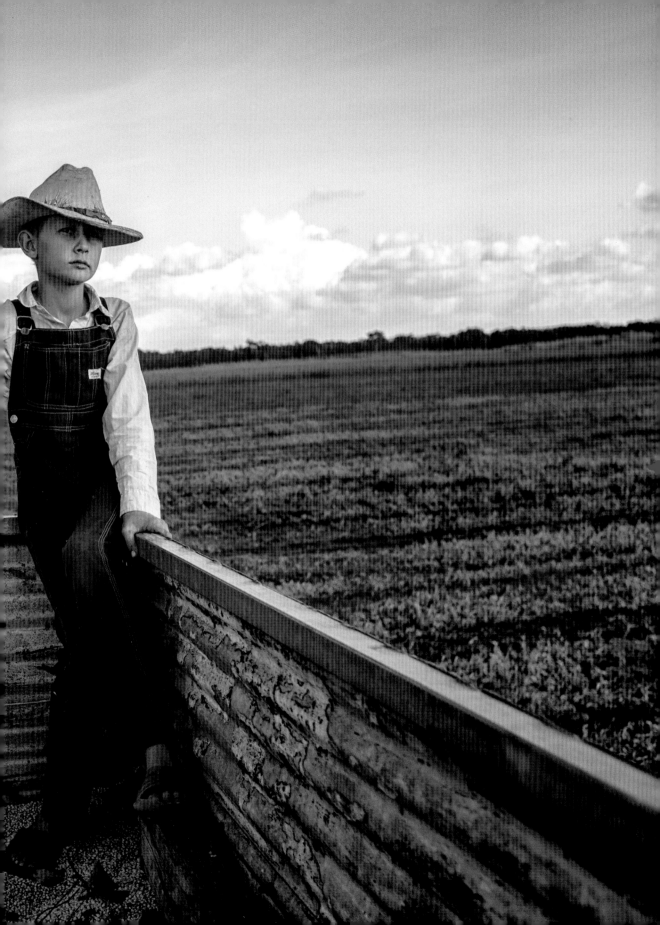

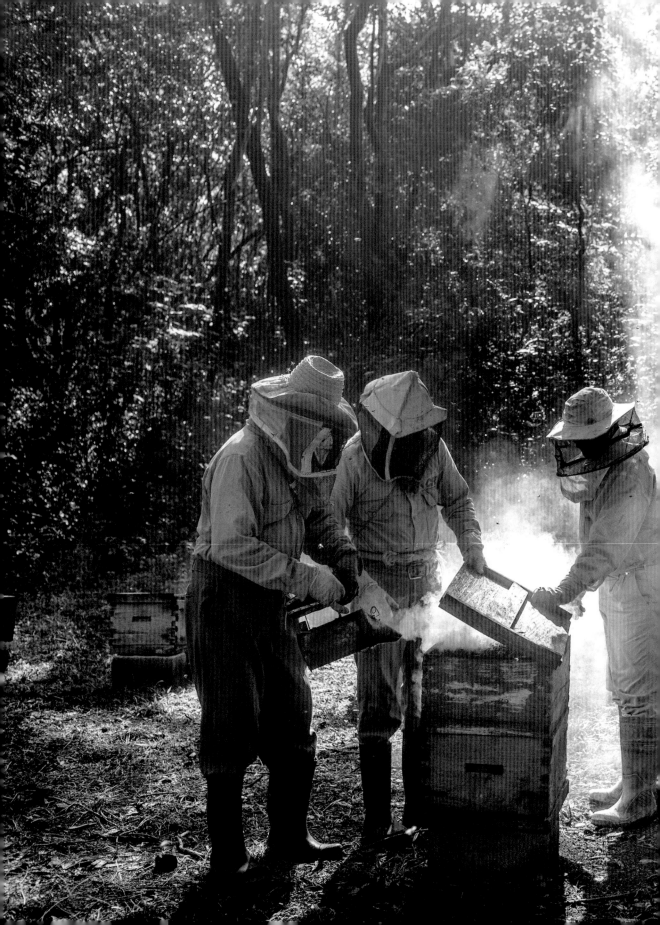

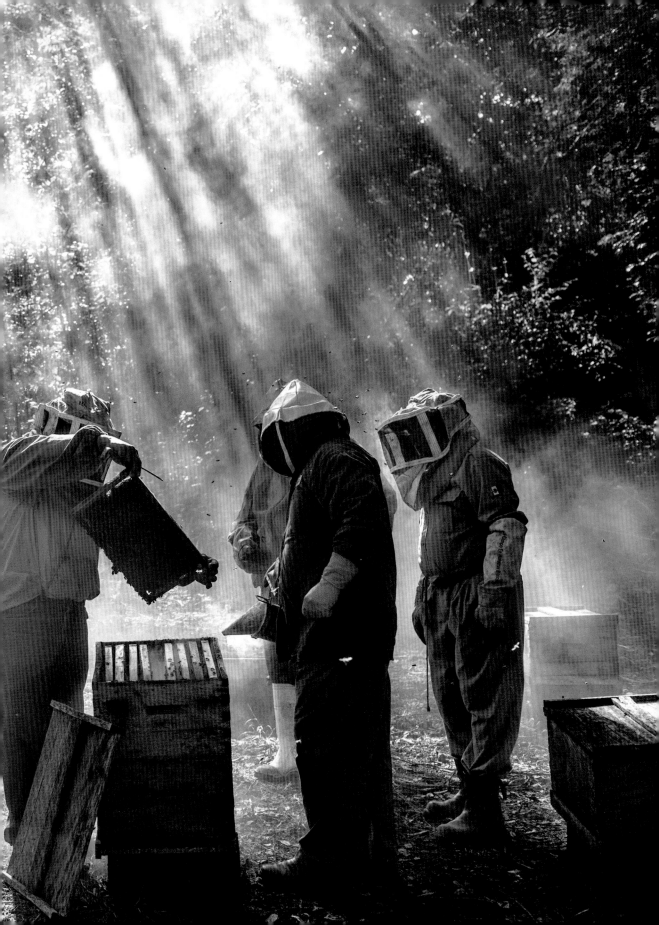

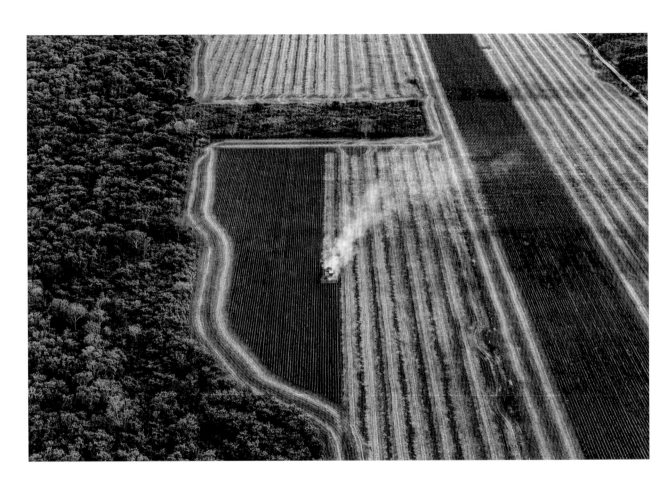

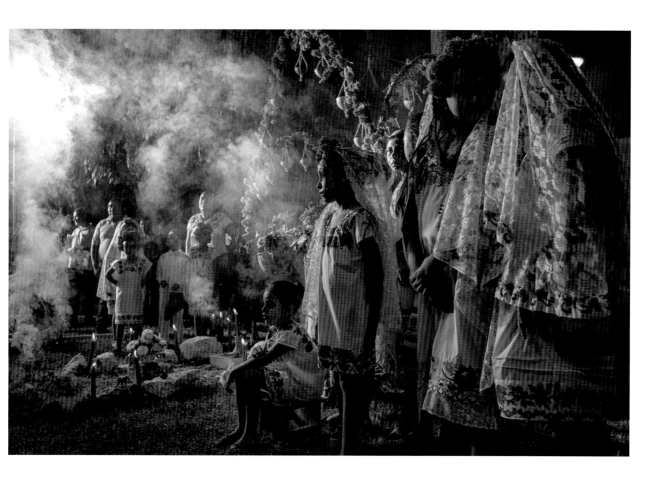

Mennonite farmers growing soy in Campeche, on the Yucatán Peninsula in Mexico, are allegedly adversely impacting the livelihood of local Mayan beekeepers. The Mennonites farm large tracts of land in the area. Environmental groups and honey producers say that the introduction of genetically modified soy and use of the agrochemical glyphosate endangers health, contaminates crops, and reduces the market value of honey by threatening its 'organic' label. Soy production also leads to deforestation, as land is increasingly bought for farming, further affecting bee populations. *Two spreads back*: Peter Peters (10) rides in his father's truck during soy harvest, in Nuevo Durango. *Previous spread*: Beekeepers tend their hives in Tinúm. *Facing page*: Soy is harvested in Hopelchén. *Above*: Mayan people celebrate *Hanal Pixán*, the Day of the Dead, Hopelchén. *Following spread*: Ana Ham cleans a pig's head, while men of the family attend to the carcass.

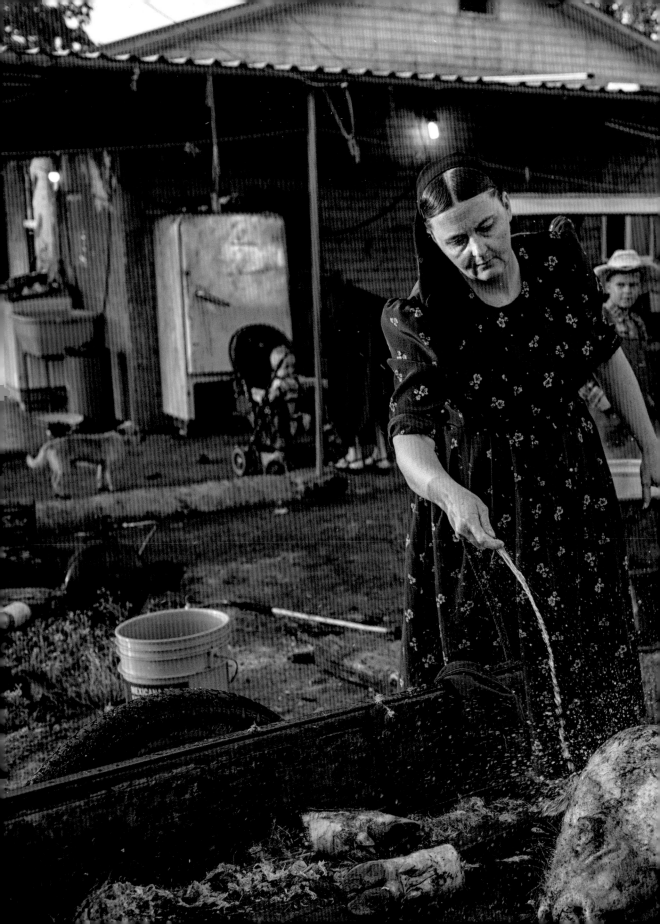

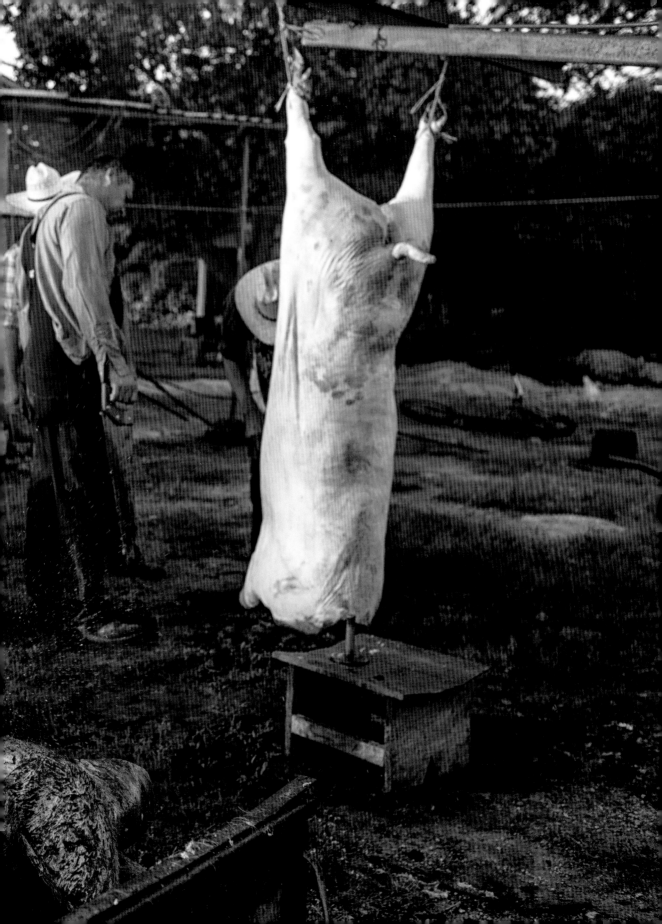

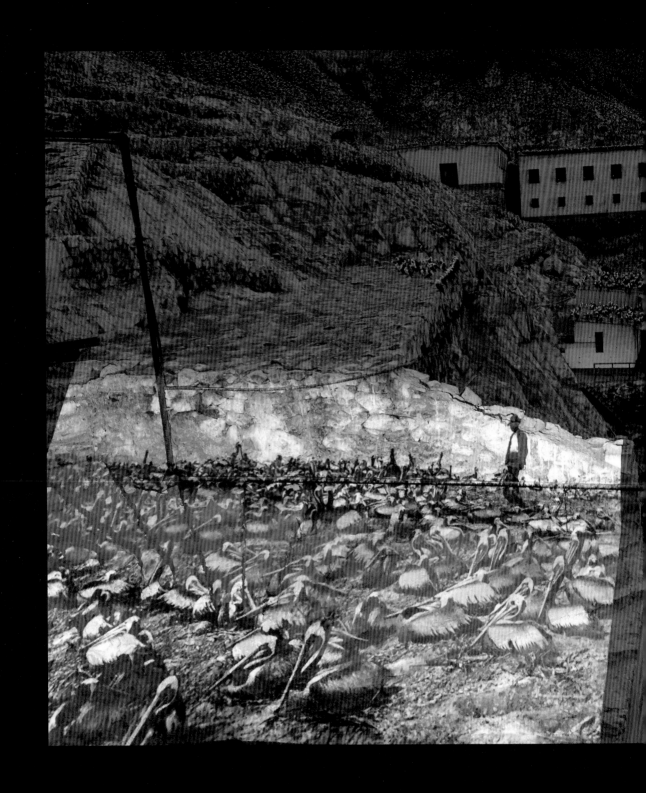

Thomas P. Peschak
Germany/South Africa, National Geographic /
3rd Prize Environment

Archive images were projected into contemporary scenes on the Guano Islands, Peru, where the seabird population that declined dramatically as a result of 19th-century guano harvesting is now beginning to recover. Guano, the nitrate-rich droppings of birds such as pelicans, boobies and cormorants, became popular as a fertilizer in the 19th century, and Peru's Guano Islands were a prime source. The boom ended with the introduction of ammonia-based chemical fertilizers in the early 20th century, but the bird populations had nosedived. Today, mining of guano in Peru takes place roughly once a decade, rotates location, and is supervised by conservationists. *Previous spread*: Pelicans nest above an image projected onto an old mining building, Isla Guañape Norte. *Right*: An image is projected onto a decaying fisherman's chapel, Isla Lobos de Afuera. The archive photographs were taken by the marine biologist Robert E. Coker, who began working in Peru in 1906.

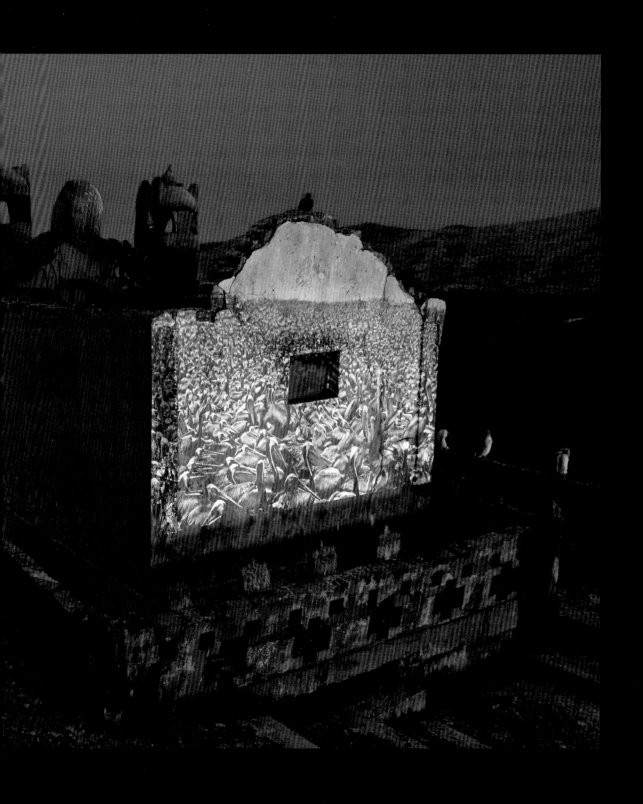

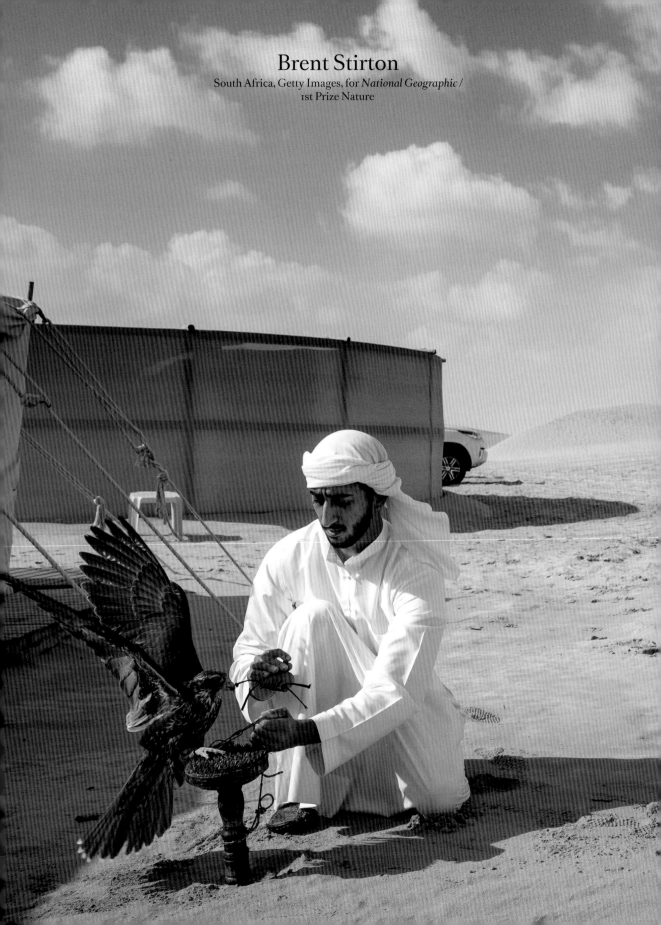

Brent Stirton
South Africa, Getty Images, for *National Geographic* /
1st Prize Nature

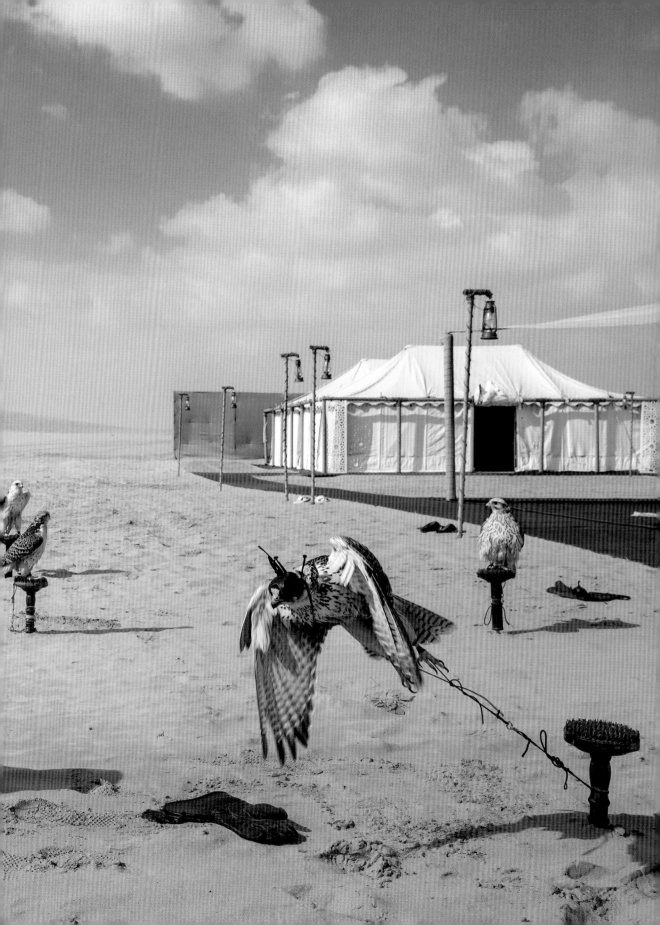

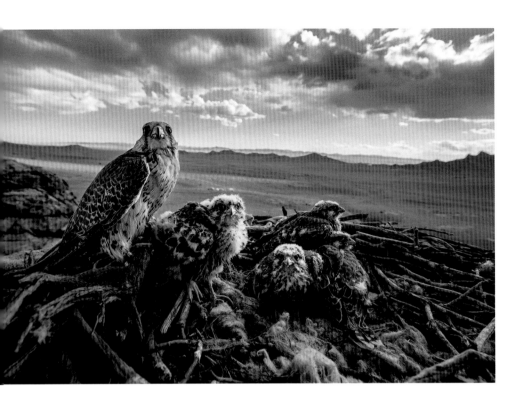

The millennia-old practice of falconry is experiencing an international resurgence, especially as a result of efforts in the Arab world. Falcons bred in captivity have helped diminish the trade in captured wild birds, including some species that are listed as endangered. *Previous spread*: Falcons are tied to a perch at a camp near Abu Dhabi, UAE. *This page, top*: A female saker falcon with her chicks in Erdene Sant, Mongolia. Sakers are endangered, due to habitat loss and the illegal wildlife trade.

Below: Falcon breeder Howard Waller wears a breeding hat on which he hopes to lure a gyr falcon to ejaculate, in order to collect sperm, Elgin, Scotland. *Facing page, top*: Saker falcons electrocuted on badly designed power lines are laid out in Ulaanbaatar, Mongolia. Electrocution kills some 4,000 sakers a year in Central Asia. *Below*: Sheikh Butti bin Maktoum bin Juma is seen with his prize captive-bred falcons, Dubai, UAE. *Following spread*: The sheikh trains falcons in the desert outside Dubai.

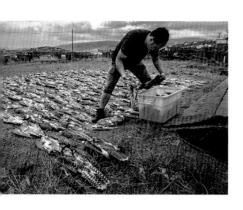

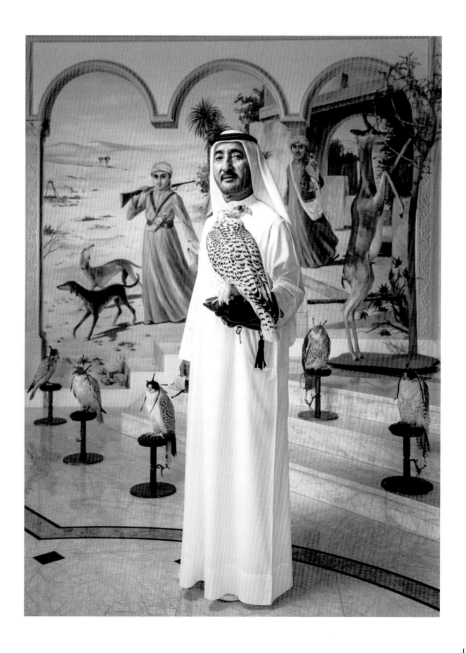

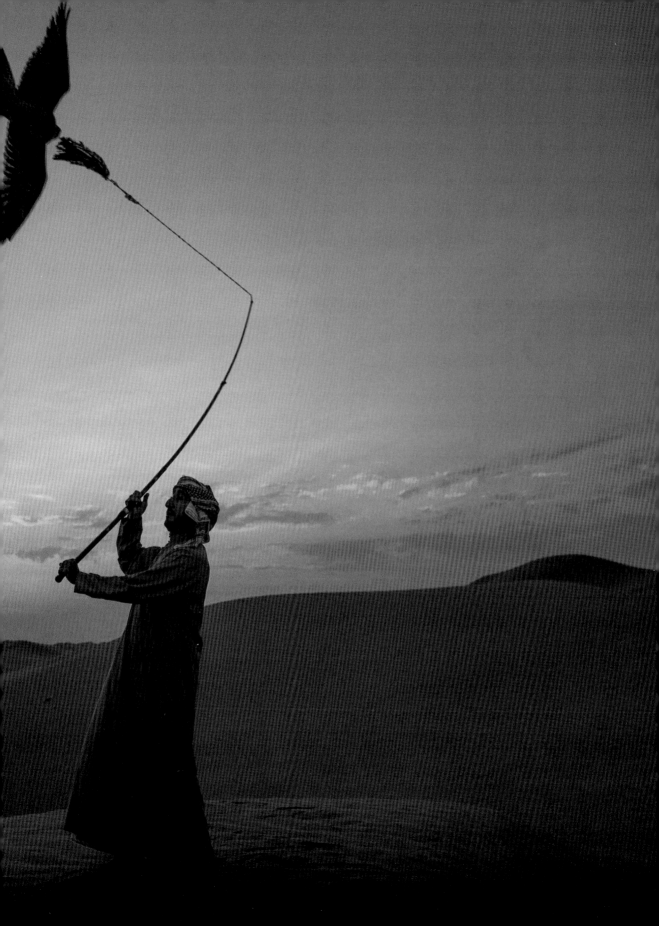

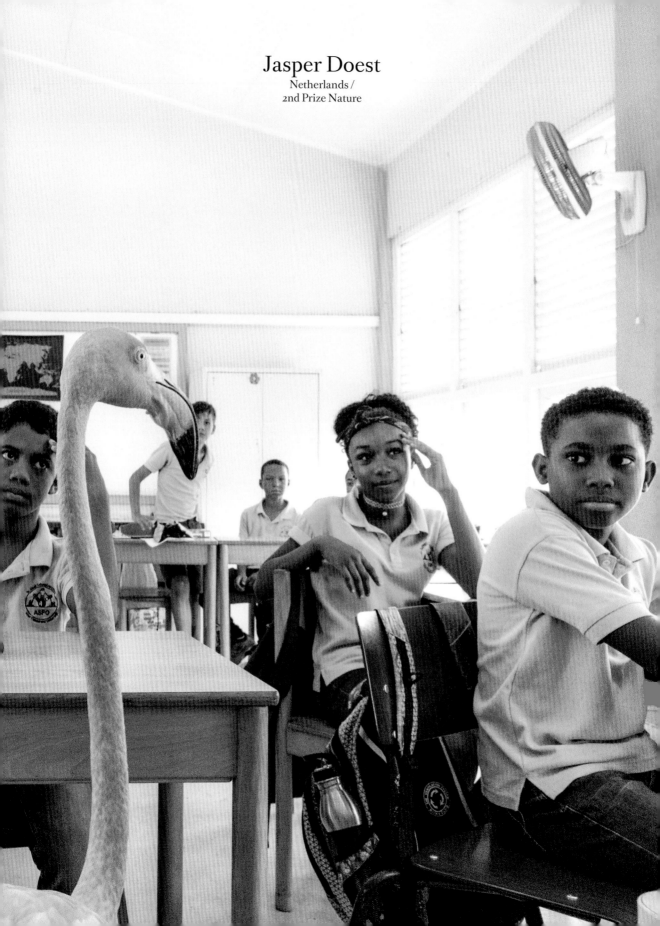

Jasper Doest

Netherlands /
2nd Prize Nature

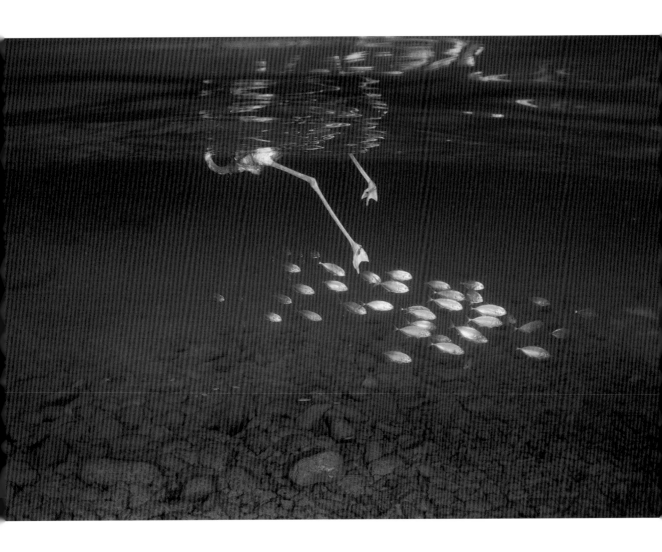

Bob, a rescued Caribbean flamingo, lives among humans on the Dutch island of Curaçao. Bob was badly injured when he flew into a hotel window, and was cared for by Odette Doest who runs Fundashon Dier en Onderwijs Cariben (FDOC), a wildlife rehabilitation center. During Bob's rehabilitation, Odette discovered that he had been habituated to humans, and so would not survive if returned to the wild. Instead, he became an 'ambassador' for FDOC, which educates local people about the importance of protecting the island's wildlife. *Previous spread*: Bob accompanies Odette on a visit to the Dr Albert Schweitzer School in Willemstad to educate children about flamingos and their habitat. *Above*: Bob swims in the sea, under Odette's supervision. *Facing page*: Bob walks through the hallway, back to his room. *Following spread*: Odette has built a saltwater pool for birds at the house.

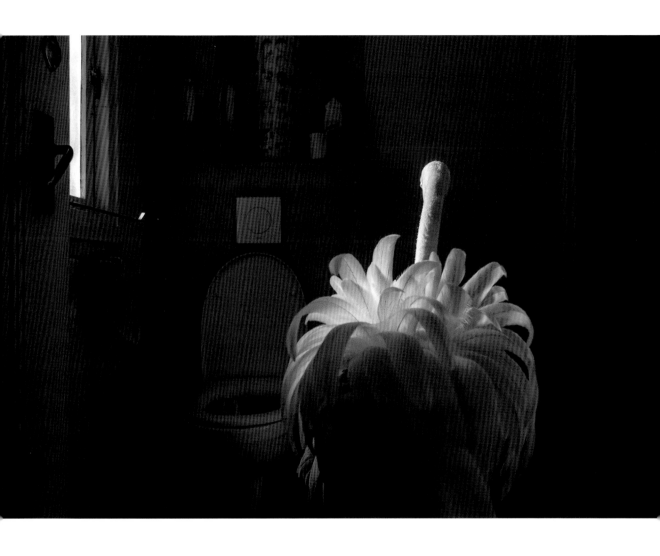

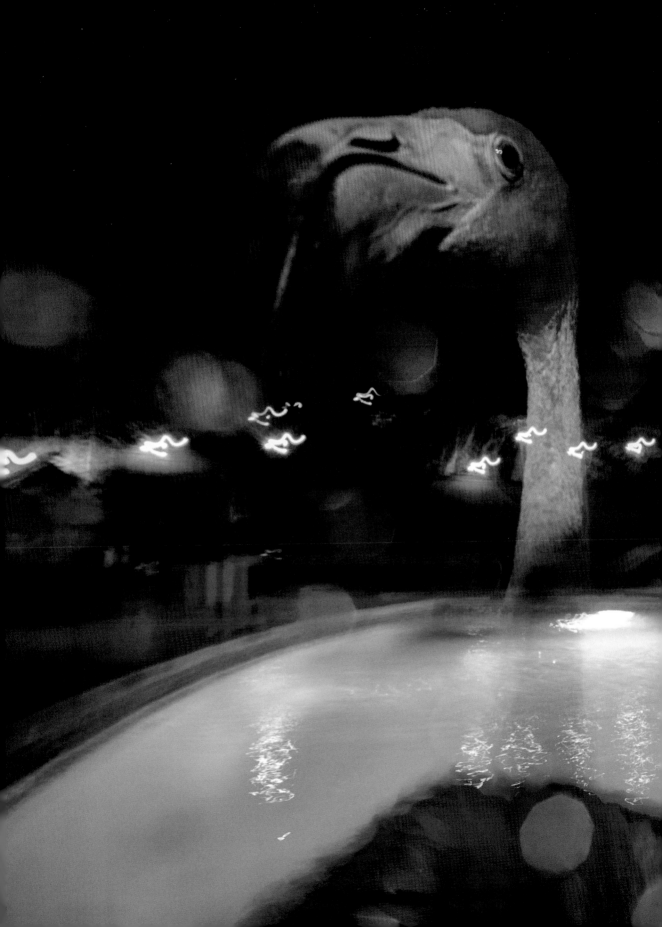

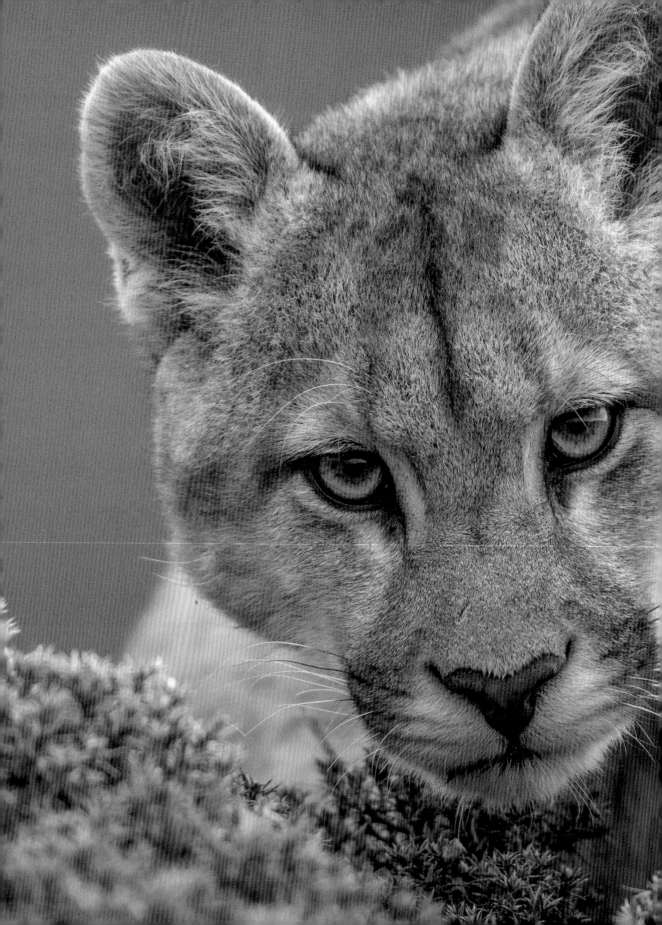

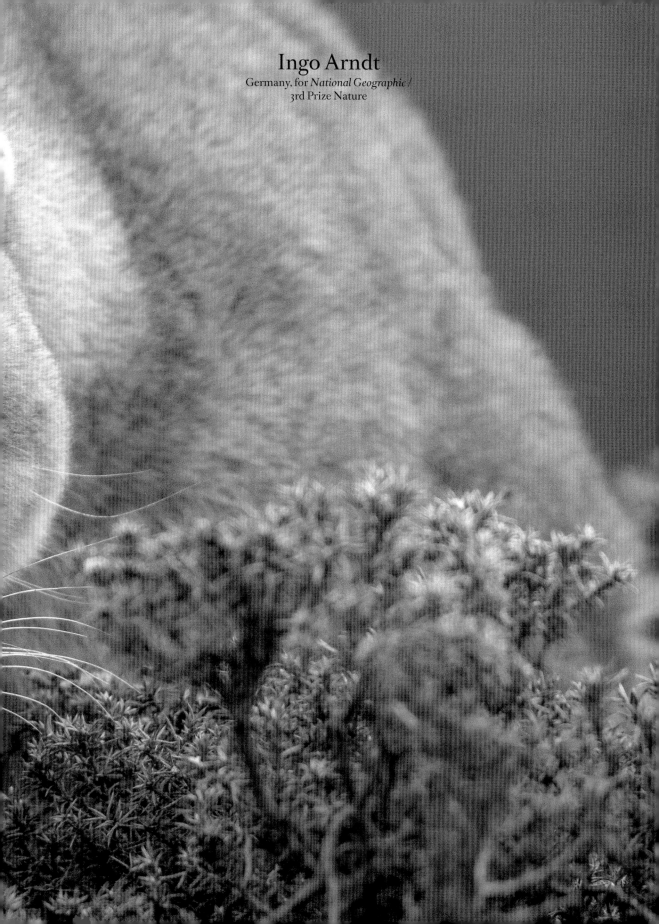

Ingo Arndt
Germany, for *National Geographic* /
3rd Prize Nature

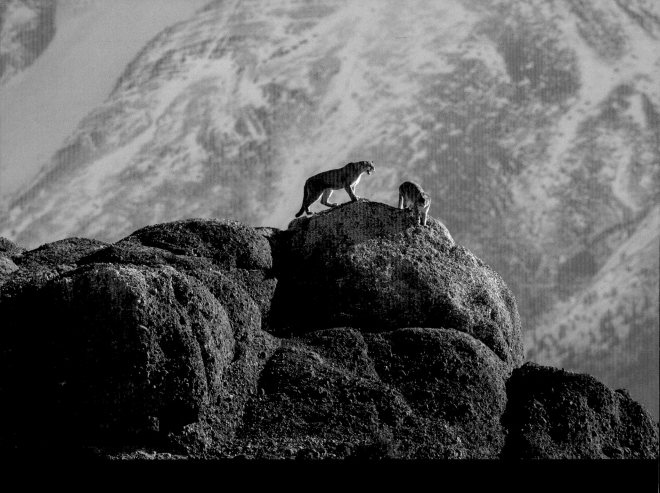

Pumas, also known as mountain lions or cougars, are found from the Canadian Yukon to the southern Andes, the widest range of any large wild mammal in the Western Hemisphere. They can survive in a variety of habitats, from deserts and prairies to forests and snowy mountains, but are generally shy and elusive to humans. The Torres del Paine region in Chilean Patagonia is thought to contain higher concentrations of pumas than anywhere in the world. Pumas are ambush predators, stalking their prey from a distance for an hour or more before attacking. In Torres del Paine, pumas feed mainly on guanacos, which are closely related to llamas. *Previous spread*: Young female puma in Torres del Paine. *Above*: A male puma follows a female on heat. *Facing page, top*: A female puma hunts a full-grown male guanaco. *Below*: Year-old puma cubs feed from the carcass of an adult guanaco, killed the night before.

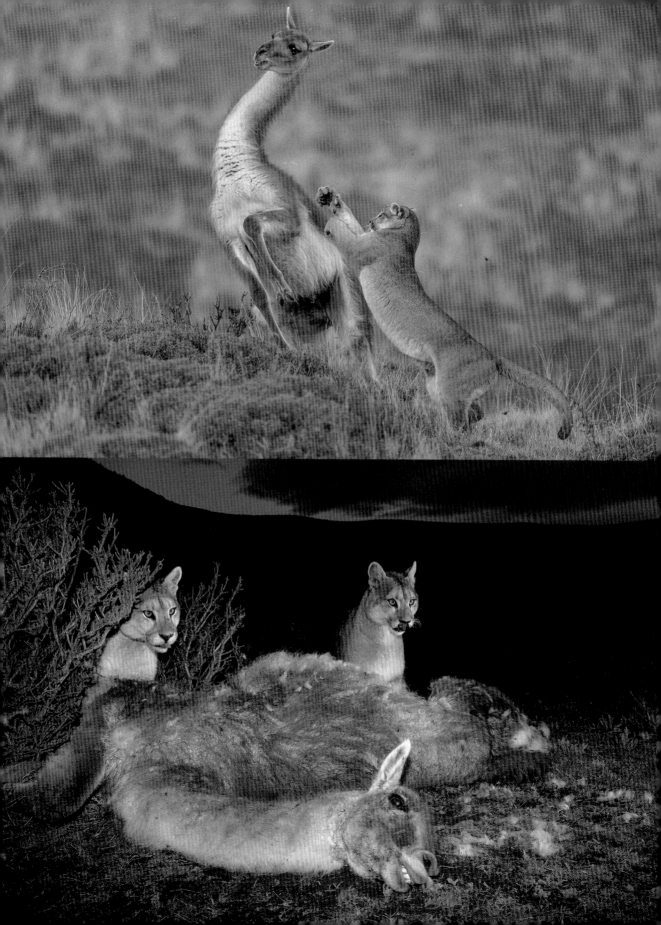

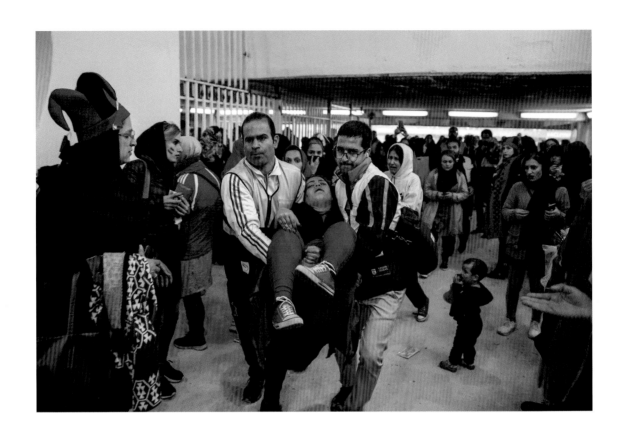

Forough Alaei
Iran /
1st Prize Sports

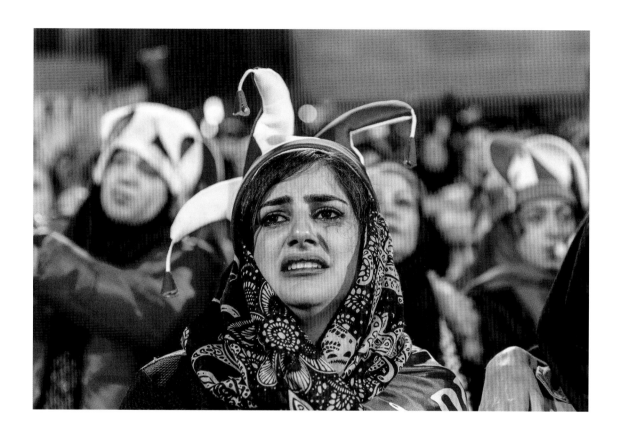

In Iran, there are restrictions on female fans entering football stadiums. As football is the nation's most popular sport, the ban has been a controversial public issue. On 1 March, FIFA president Gianni Infantino met with the president of Iran, Hassan Rouhani, to address the issue. Social-media groups also put the president under pressure, and on 20 June a ruling allowed Tehran's Azadi stadium to admit selected groups of women for international matches. *Facing page*: A female fan passes out after Iran's Persepolis loses the AFC Championship League Cup to Japan's Kashima Antlers, Azadi Stadium, Tehran, 10 November. *Above*: A fan cries after Persepolis loses the match. (*continues*)

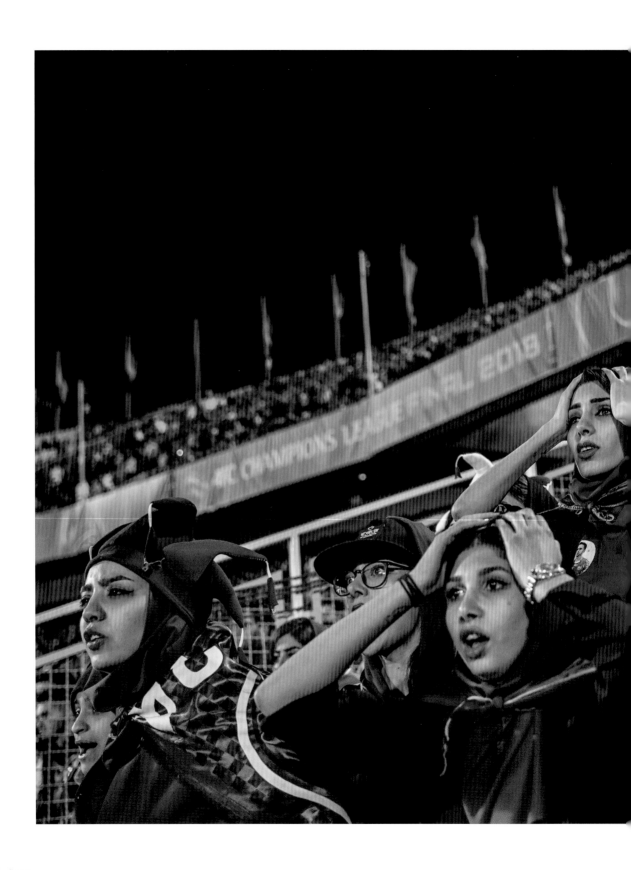

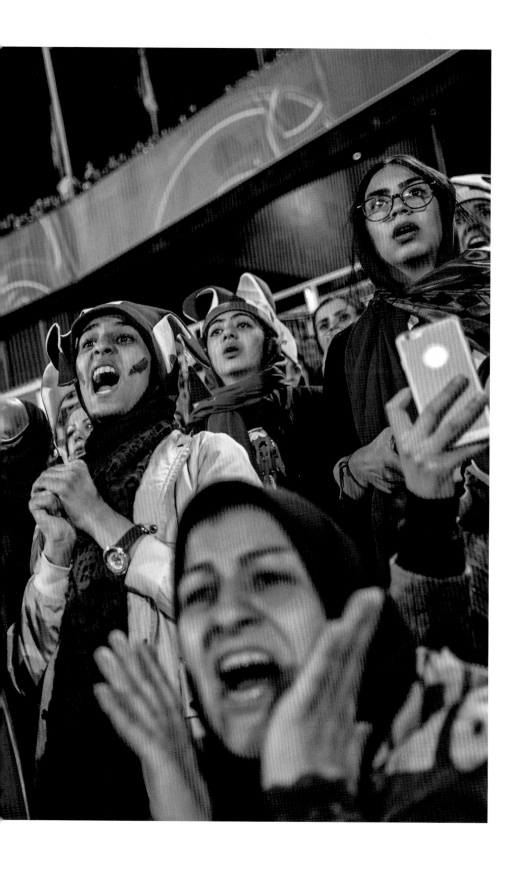

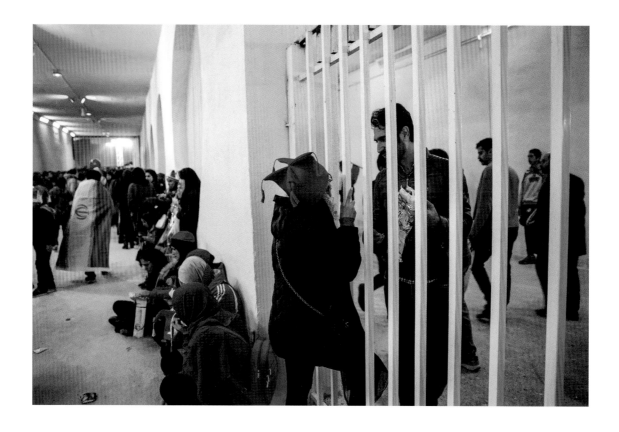

(*continued*) The concession to women fans applied only to international matches, and after a senior judicial officer objected in October, it was withdrawn. On 10 November, the FIFA president, who was attending the AFC Cup match in Tehran, asked to be shown that women were being allowed to attend. A selection of women was permitted to enter, though many others were barred. *Previous spread*: Women follow the match from a separate stand, Azadi Stadium, Tehran, 10 November. *Facing page*: A woman watches a national match, disguised as a young man. *Above*: Male and female fans have to use separate parts of the stand, at the Azadi Stadium, 10 November.

Michael Hanke
Czech Republic /
2nd Prize Sports

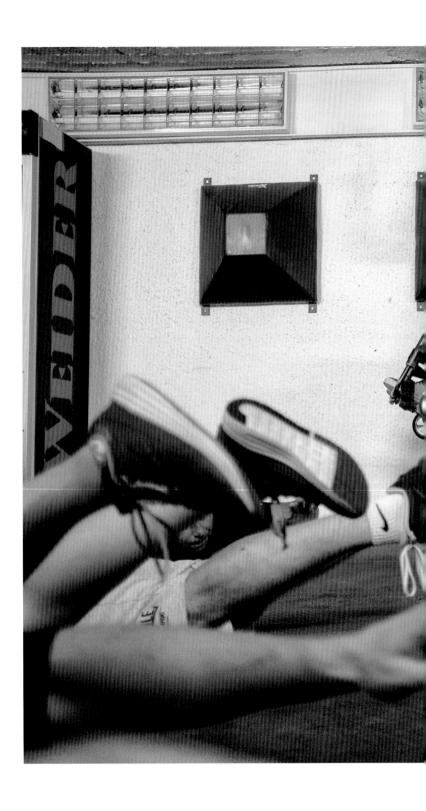

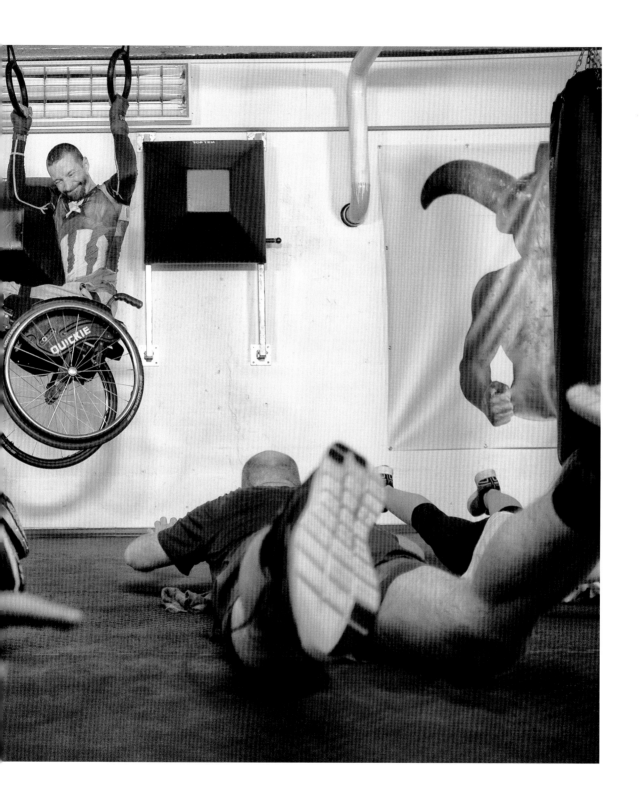

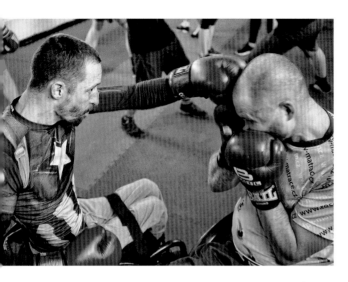

Zdeněk Šafránek is the captain of the Czech Republic Para Ice Hockey team, and has participated in three Paralympic Games. He has been in a wheelchair since an accident at work in an auto repair shop in 2003. He also represents his country in mountain biking and handcycling, and in 2017–18 was the Czech Republic's champion paraboxer. Šafránek lives in the town of Pátek, near Poděbrady, in the Czech Republic, with his partner and three children. *Previous spread*: Šafránek finishes a gym practice session with pull-ups. *Above*: Šafránek spars with his friend Jan Matoušek. *Below*: He says goodbye to his daughter at preschool. *Facing page, top*: Šafránek gets dressed at home in Pátek. *Middle*: He was injured when a car-carrying platform weighing 1.5 tonnes fell on top of him at work. *Below*: Matoušek helps Šafránek down the stairs to the gym for practice.

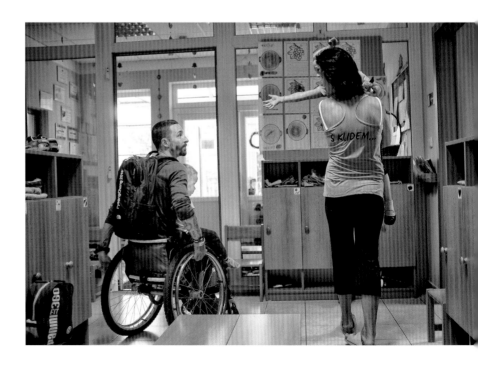

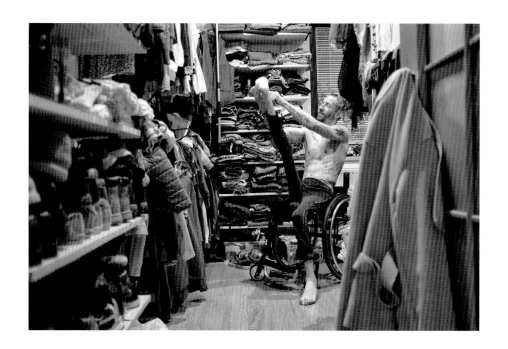

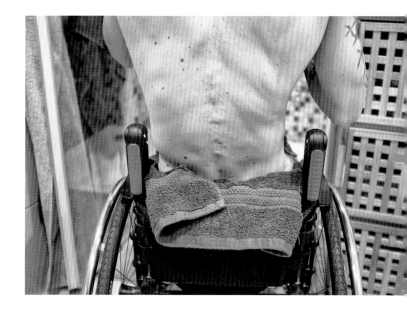

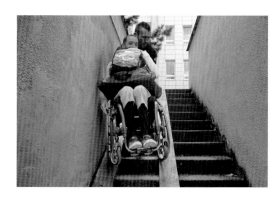

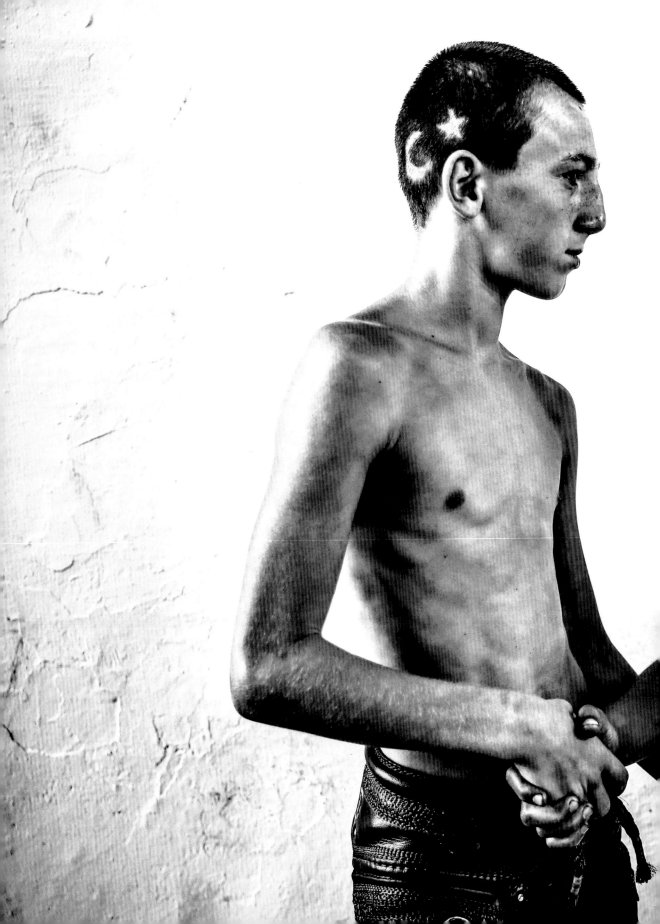

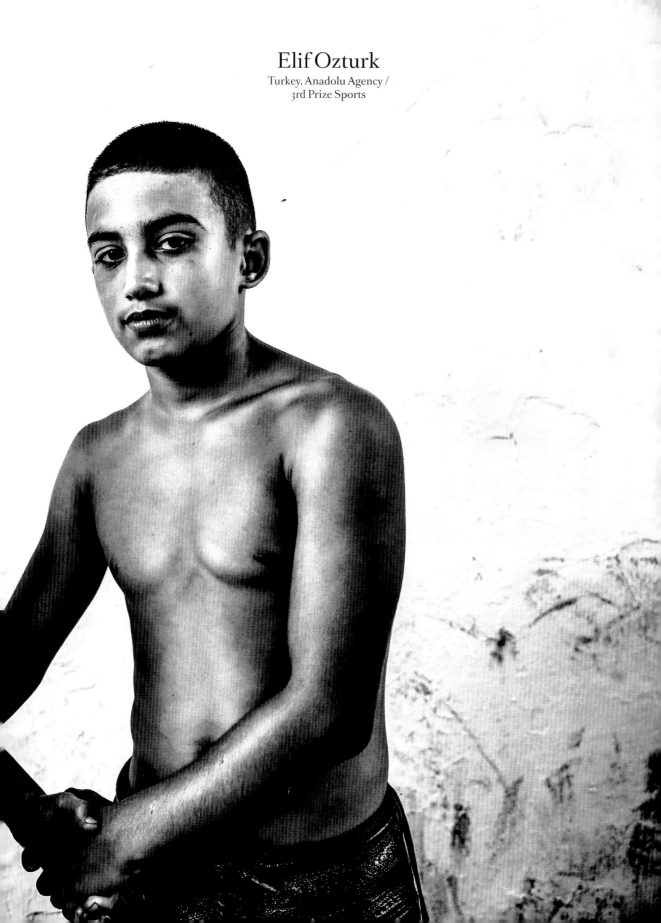

Elif Ozturk

Turkey, Anadolu Agency /
3rd Prize Sports

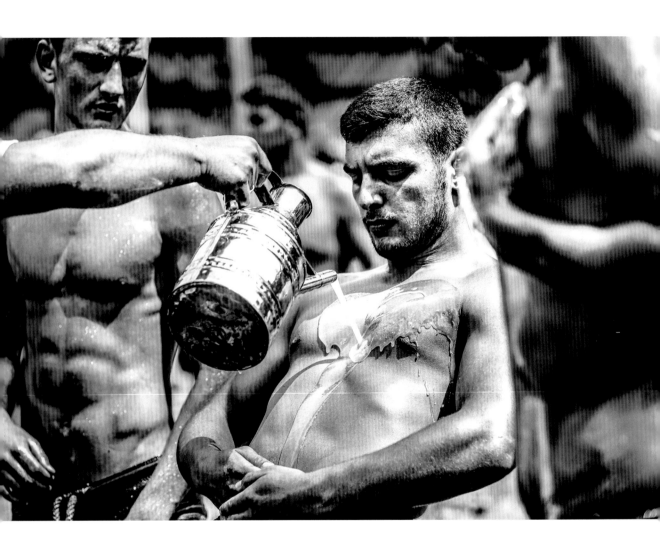

Kirkpinar is a Turkish oil-wrestling tournament dating back over 660 years. It is held annually over three days, usually in July, near Edirne, a city in the northwest of the country. Wrestlers ('*pehlivan*') wearing leather breeches ('*kispet*') compete on grass, after being covered with oil. They fight for the title of Chief Pehlivan and a belt made of 1,450 grams of gold. Matches can sometimes last several hours and are won when a wrestler pins another to the ground, or lifts him over his head. *Previous spread*: Junior wrestlers shake hands. *Above*: Wrestlers get covered in oil before a match. *Facing page*: Wrestlers compete on the final day of the tournament. *Following spread*: Competitors wrestle on the first day of the tournament.

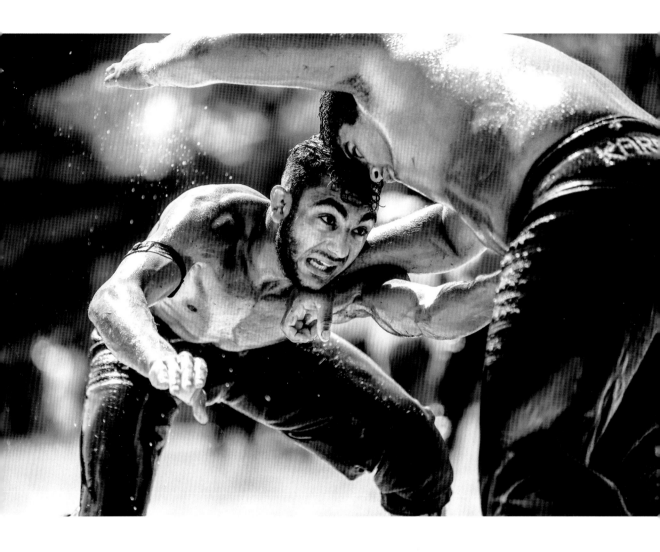

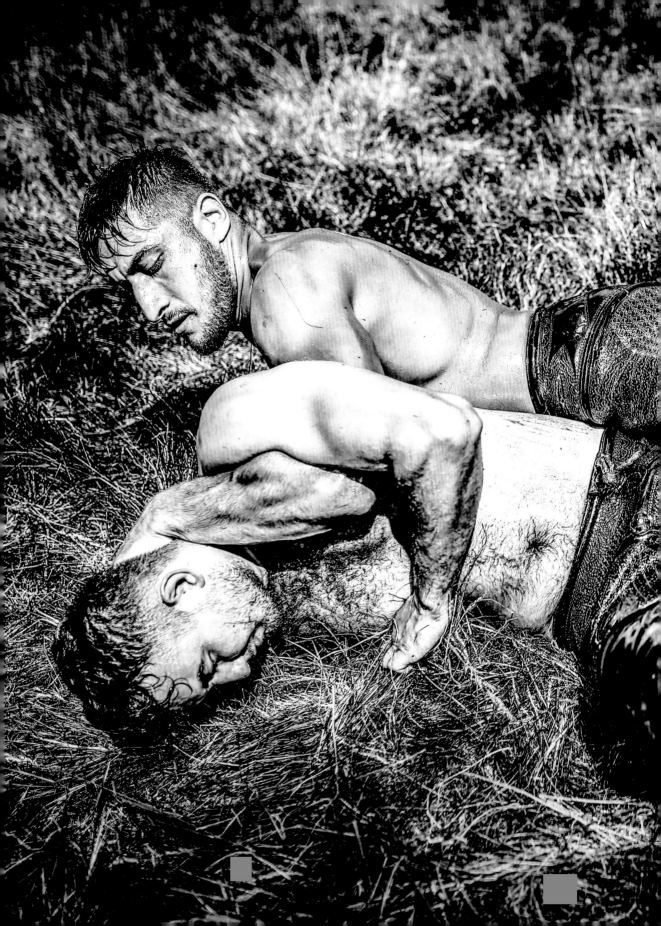

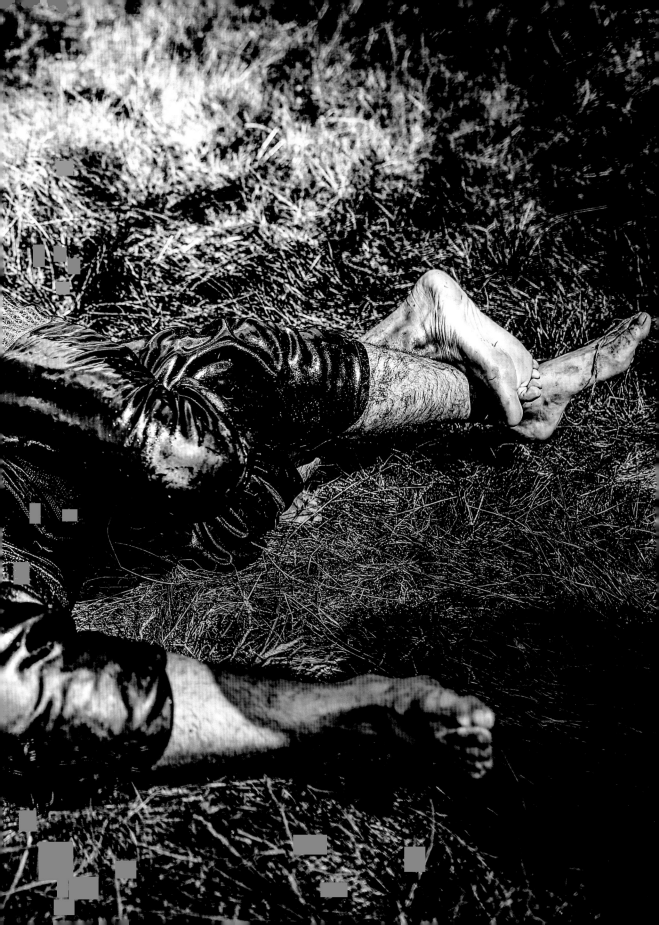

The 2019
Long-Term Projects

Sarah Blesener

United States /
1st Prize

Beckon us from Home

4 April 2016 - 17 November 2018 › Patriotic education, often with a military subtext, forms the mainspring of many youth programs in both Russia and the United States. In America, the dual messages of 'America first' and 'Americanism' can be found not only as a driving force behind adult political movements, but around the country in camps and clubs where young people are taught what it means to be an American. In Russia, patriotic clubs and camps are encouraged by government. In 2015, President Vladimir Putin ordered the creation of a Russian students' movement whose aim was to help form the characters of young people through instruction in ideology, religion and preparedness for war. The 'Patriotic Education of Russian Citizens in 2016–2020' program called for an 8 percent increase in patriotism among youth, and a 10 percent increase in recruits to the armed forces.

The photographer visited ten youth programs in the US, as well as schools and military summer camps in Russia. The aim of the series is to use these young people and their lives as the focal point in an open dialogue around the ideas instilled in future generations, and examine how young people are responding to contemporary society.

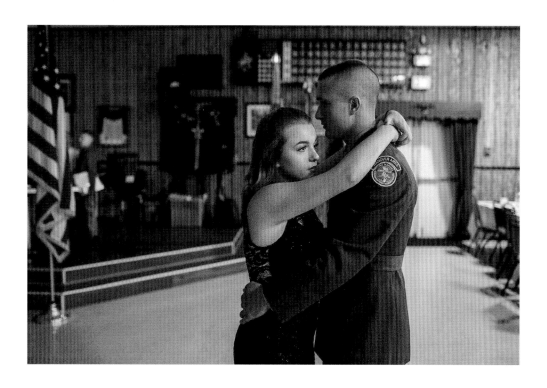

Above: Garett dances with his girlfriend at the Young Marines annual ball, in Hanover, Pennsylvania, USA. Young Marines, a patriotic education program, has 10,000 students nationwide. *Below*: Students escape the heat at a lake during the Orthodox Warrior camp in Diveyevo, Russia. The camp combines combat training with Christian doctrine.

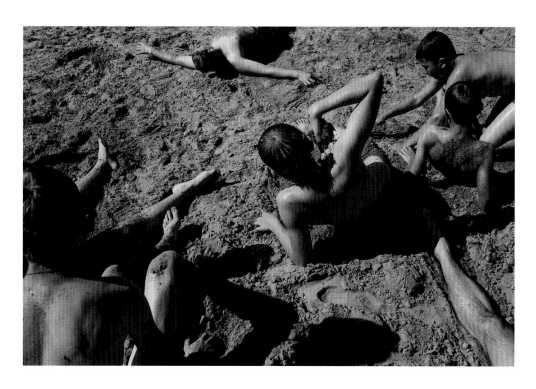

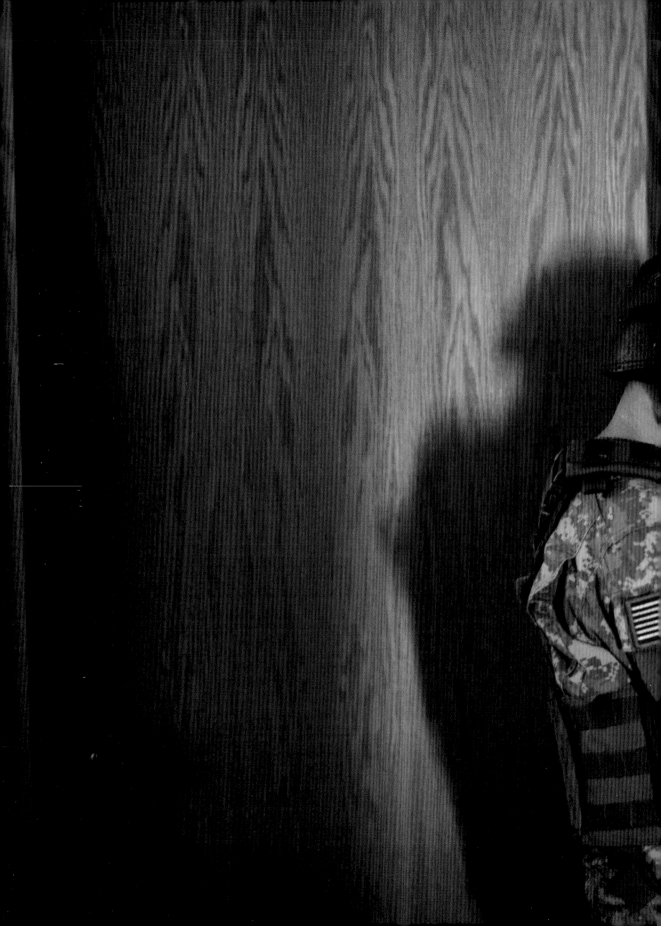

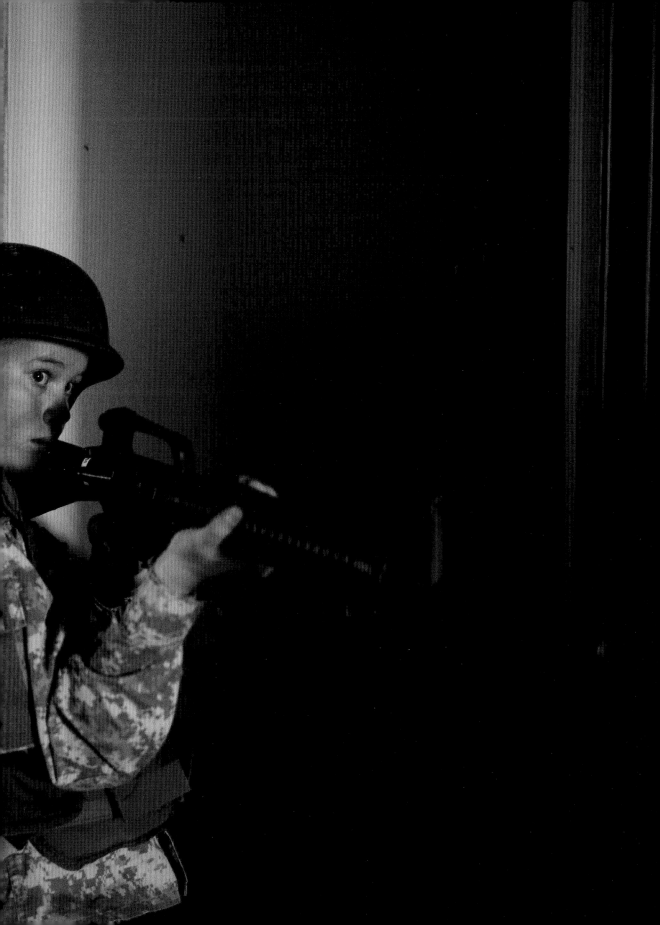

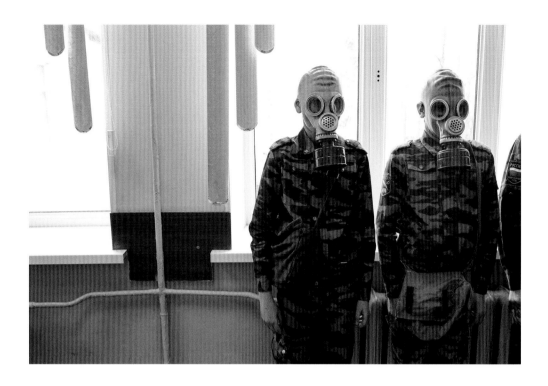

Previous spread: Gilbert (13) practices house-searching drill with the Wisconsin Army Cadets, in Appleton, Wisconsin, USA. *Above*: Students undergo gas-mask training at School #7, Dmitrov, Russia. *Below*: Bailey (11) lines up for a uniform inspection at a weekly Young Marines meeting, in Hanover, Pennsylvania, USA.

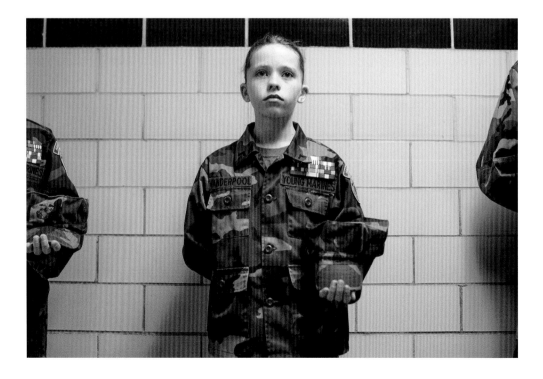

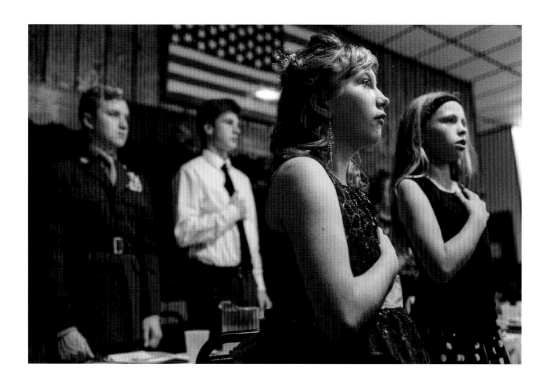

Above: Students stand for the Pledge of Allegiance, at the Young Marines annual ball, in Hanover, Pennsylvania, USA. *Below*: Students from School #18 perform a dance at the local theatre in Sergiyev Posad, Russia. *Next spread*: Students laugh backstage before a singing and marching competition, at School #6 gymnasium, Dmitrov, Russia.

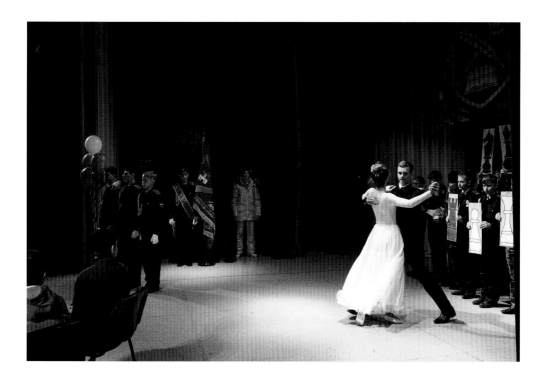

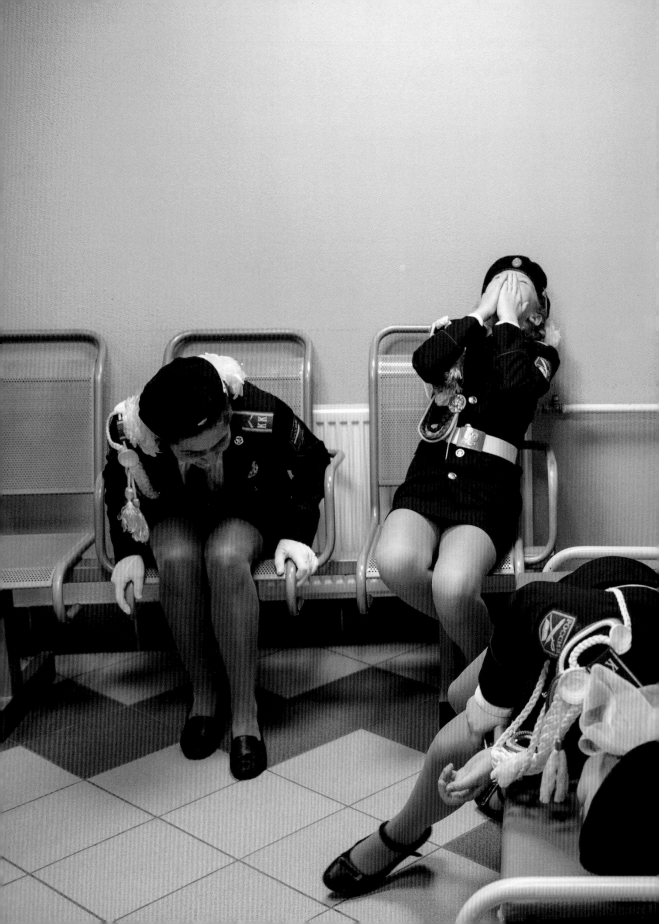

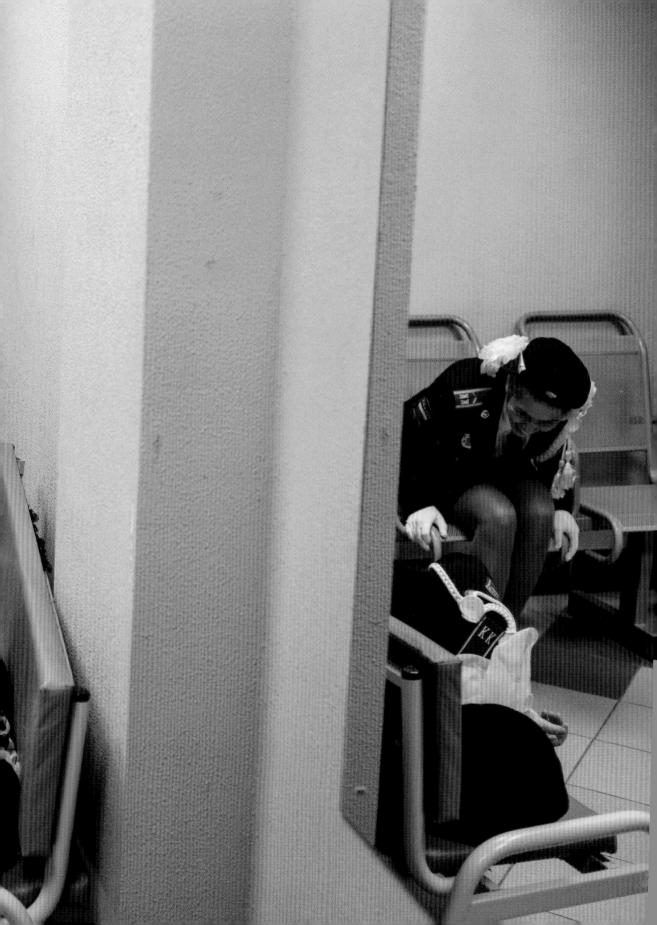

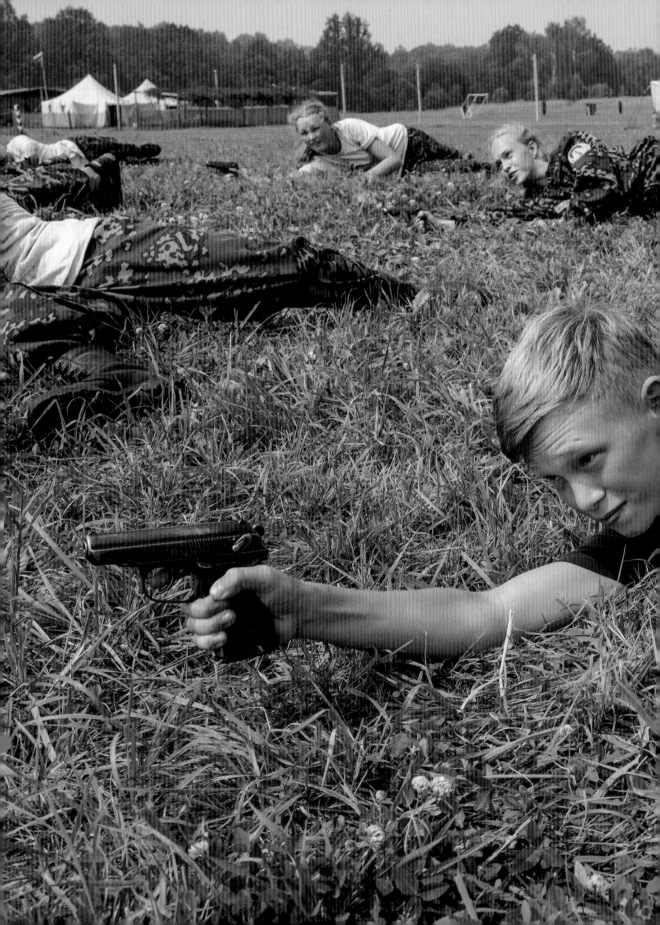

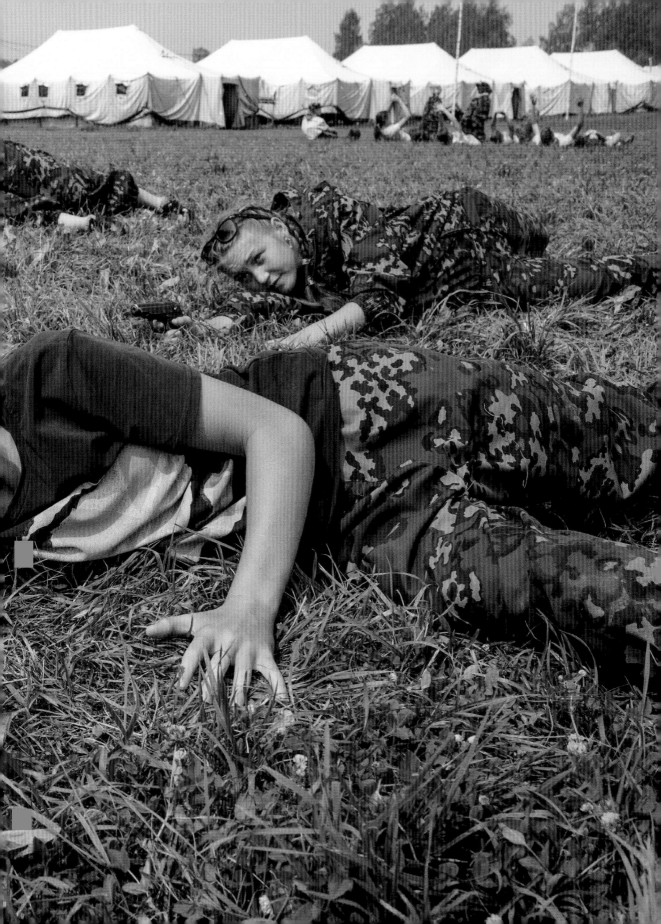

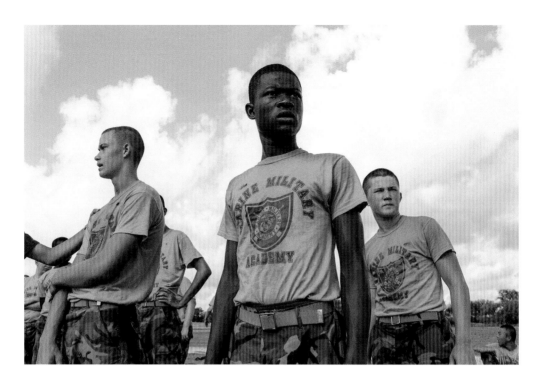

Previous spread: Students undergo firearms training using airguns at Borodino, the battleground where Russia fought Napoleon's forces in 1812. *Above*: Participants wait to begin a relay race, at a Marine Military Academy summer camp, Harlingen, Texas, USA. *Below*: Nerisa, a student from Border Patrol Explorer Program, practices with VR law-enforcement equipment, Kingsville, Texas, USA.

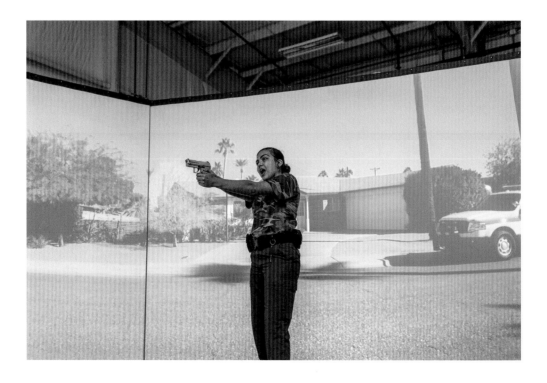

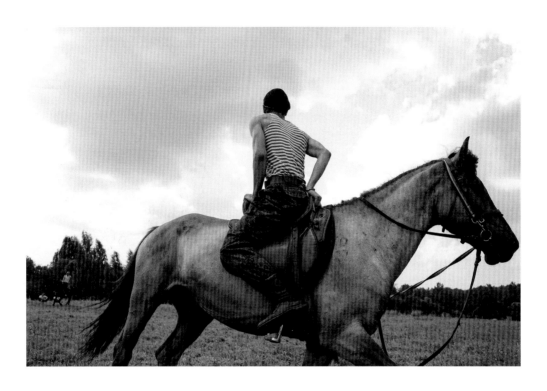

Above: A horse rider trains at the Historical War Camp, Borodino, Russia. Camp activities center on battle reenactments and the use of weapons. *Below*: Cadets line up for drill at School #7, Dmitrov, Russia. *Following spread*: Students from five states around the Midwest attend the week-long Civil Air Patrol Joint Dakota Encampment, in Rapid City, South Dakota, USA.

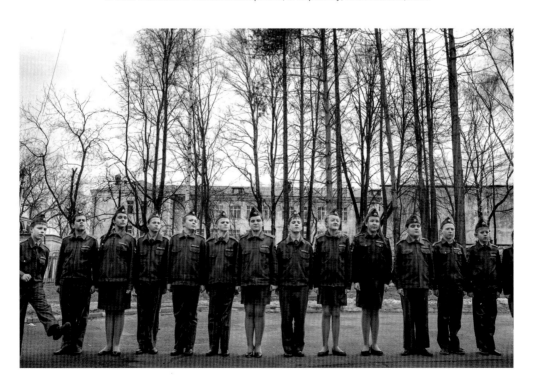

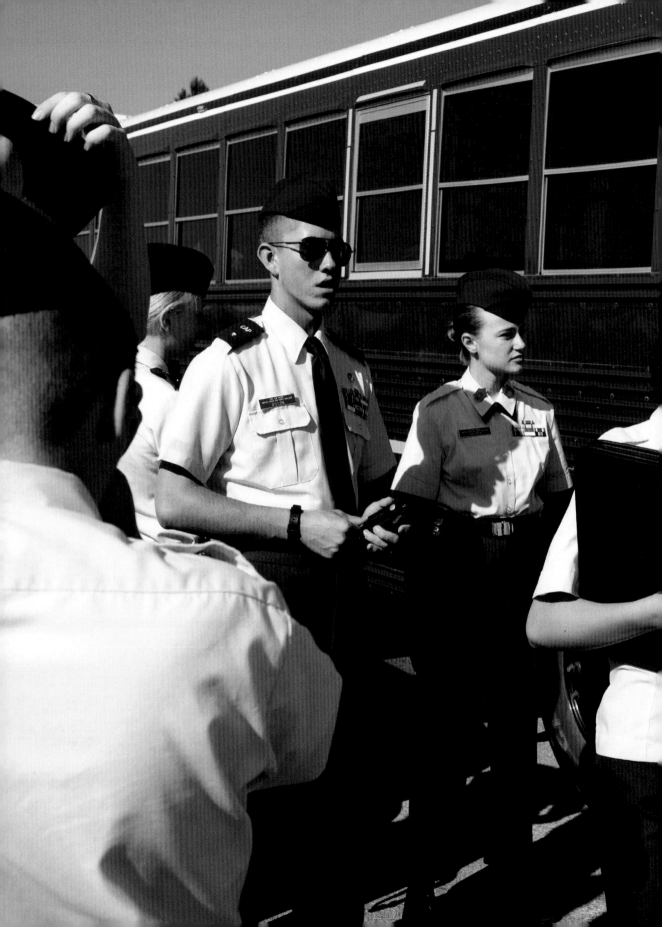

Yael Martínez

Mexico /
2nd Prize

The House that Bleeds

8 October 2013 - 4 November 2018 › Across Mexico, more than 37,400 people have been categorized as 'missing' by official sources. The vast majority of those are believed to be dead—victims of ongoing violence that has claimed more than 250,000 lives since 2006. These disappearances are the source of lasting psychological trauma for families left behind.

The violence has its roots in the war on Mexico's powerful drug cartels instigated by President Felipe Calderón during his 2006–2012 term of office, and continued by his successor, Enrique Peña Nieto. The ensuing violence has led to a catastrophic rise in murder rates and in the number of unsolved disappearances, which is aided by corruption and impunity. President Nieto promised an end to violence, but although homicides declined, authorities seemed unable to restore the rule of law or make much progress in the struggle against cartels. Among the states most affected is Guerrero, which was included in a list of no-travel zones by the US government in 2018.

In 2013, one of the photographer's brothers-in-law was killed and another two disappeared. This led him to begin documenting the resultant psychological and emotional fracture in his own family and in the families of other missing people, to give a personal account of the despair and sense of absence that accrues over time.

Above: Digno Cruz cries at home in Taxco, Guerrero, while talking about his missing grandsons.
Below: A derelict house in Santiago Temixco, Guerrero. After the photographer's brothers-in-law
disappeared, the family searched abandoned locations in the hope of finding their bodies.

Following spread: Dried cactus roots on a wall in Tixtla, Guerrero. In 2014, municipal police ambushed a
convoy of buses carrying students from Tixtla's Ayotzinapa teachers' training college. Five people were killed,
another student's body was later found showing signs of torture, and 43 others disappeared without trace.

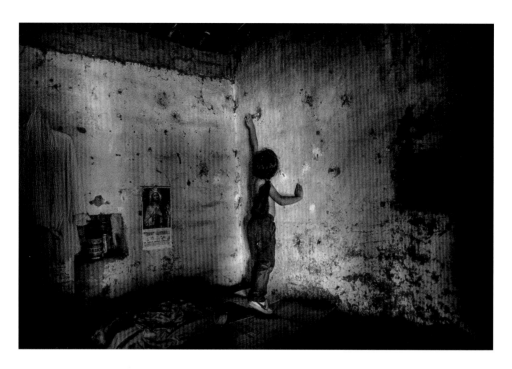

Itzel Martínez, the photographer's daughter, plays at her grandparents' house
in Santiago Temixco, Guerrero. Three of her uncles disappeared in 2013.

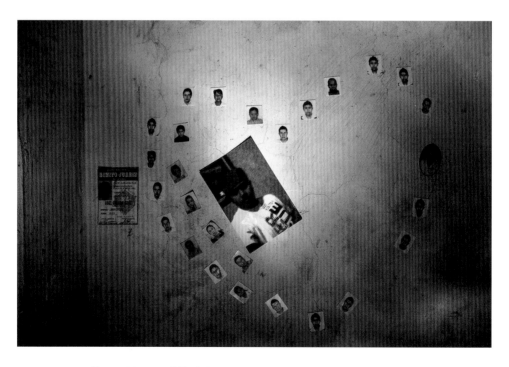

Photos of 14-year-old Perla Granda's missing brothers adorn her bedroom wall.
The photographer's sister-in-law lives with her mother and surviving sister.

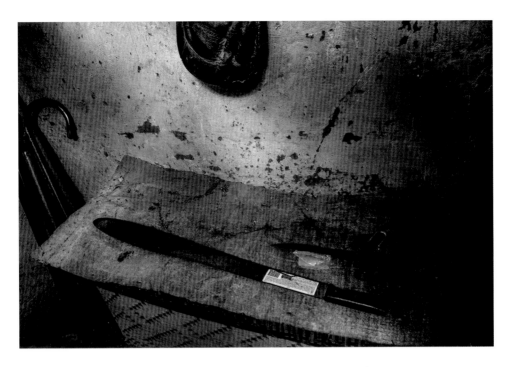

A machete lies in the bedroom of Digno Cruz, whose grandsons
are missing, in Santiago Temixco, Guerrero.

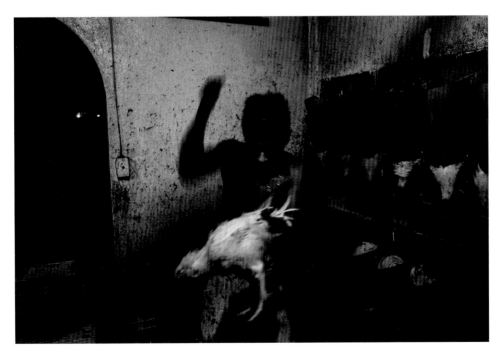

Above: A man kills a chicken at a slaughterhouse in Acapulco, Guerrero. His brother is missing,
but the family have not filed the case with officials. *Following spread*: Alin Granda at her father's
home in Taxco, Guerrero. She was one year old when her father went missing.

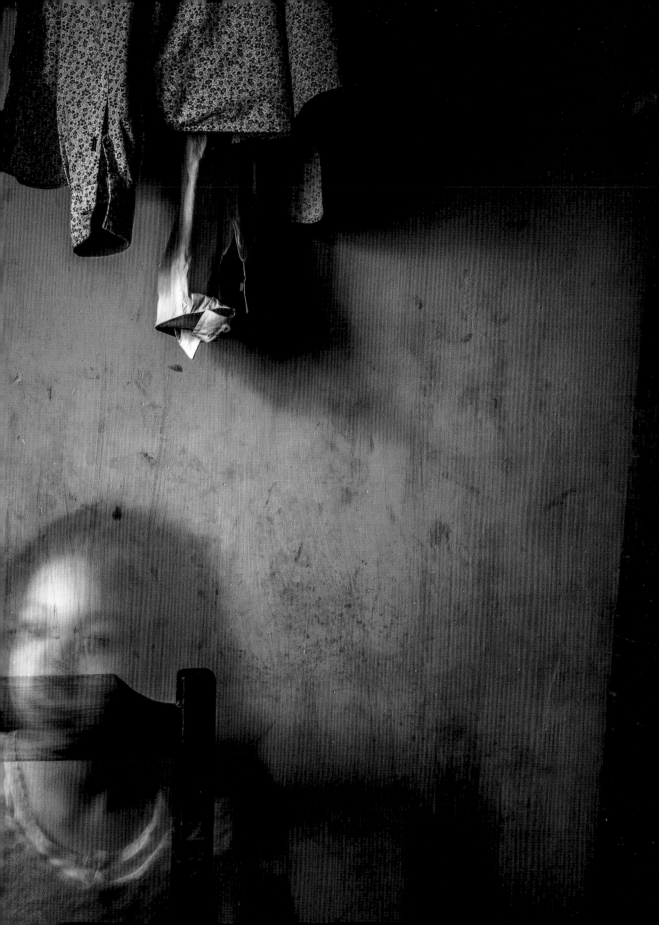

Previous spread: A shadow on the wall of a house in Metlatónoc, Guerrero. *Above*: President Nieto arrives to deliver his state-of-the-union address in Mexico City, on 2 September 2017.

Clothes hang up in the home of the Campos family. They are still looking for José Ángel Campos Cantor, twenty months after he disappeared along with other students when buses from the Ayotzinapa college were ambushed.

A bedroom in the Cruz family home, in Santiago Temixco, Guerrero. Three family members—the photographer's brothers-in-law—are missing.

Above: Lucero Granda, the photographer's wife, showers at home in Taxco, Guerrero. *Following spread*: Photographs of people hang pinned to an image of the Virgin at the Basilica of Guadalupe in Mexico City. Pilgrims come annually on 12 December to ask for miracles for their loved ones.

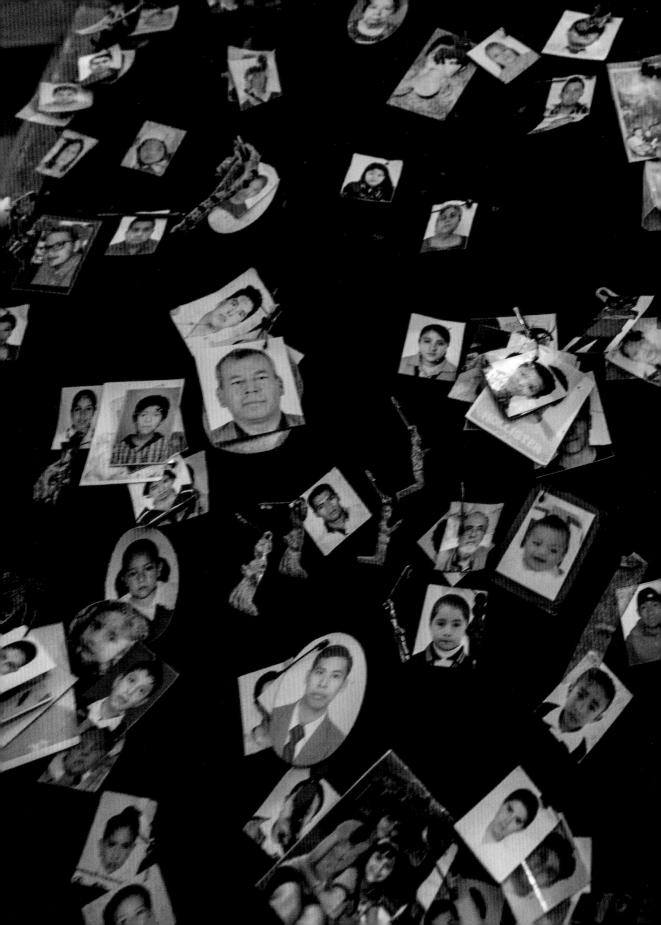

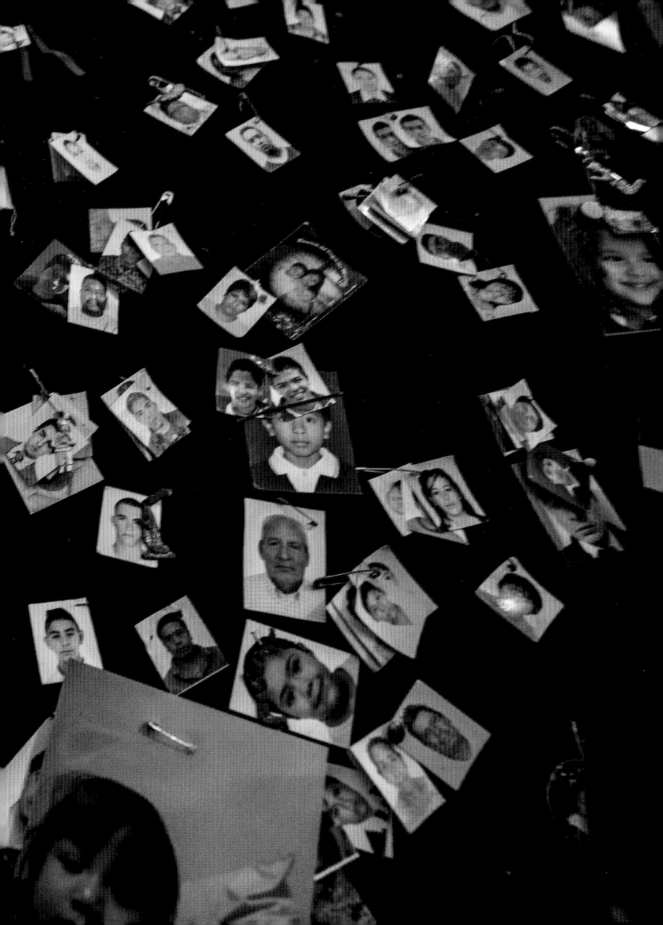

Alejandro Cegarra

Venezuela /
3rd Prize

State of Decay

31 March 2013 - 19 March 2018 › Under Hugo Chávez, president of Venezuela from 1999 to 2013, the country experienced the biggest economic boom in its history. Venezuela has the highest proven oil reserves in the world, and Chávez took office as oil prices soared in the 2000s. He channeled revenues into welfare programs and building houses for the poor. His successor, Nicolás Maduro, has overseen a country in spectacular decline. Oil prices crashed in 2014, and Maduro's attempts to continue welfare programs led to government over-expenditure and ultimately hyperinflation, a situation compounded by US sanctions. Political tensions have escalated with increasing shortages of food, medicine and other essential items. Protests are widespread, and according to the Venezuelan NGO Observatorio de Violencia, the predicted rate of 81.4 violent deaths per 100,000 inhabitants in 2018 makes Venezuela the most violent country in Latin America.

 The photographer picks up the story in 2013, starting with Chavez's death, and aims to tell the story of a crumbling country from the inside.

Facing page, top: The 43rd Field Artillery brigade pass by during an Independence Day parade in Los Proceres, on 5 July 2015. *Below*: A demonstrator puts a rosary over his head before clashing with the Bolivarian National Guard during anti-government protests in Caracas, on 14 March 2014. *Following spread*: People line the streets as President Chávez's coffin is taken to a military base in Caracas, 6 March 2013.

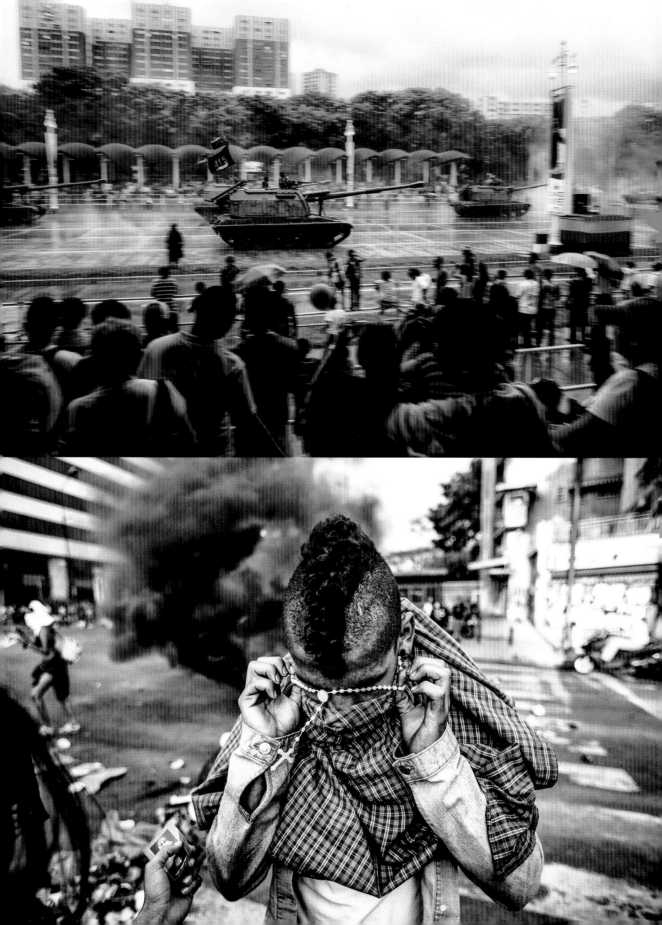

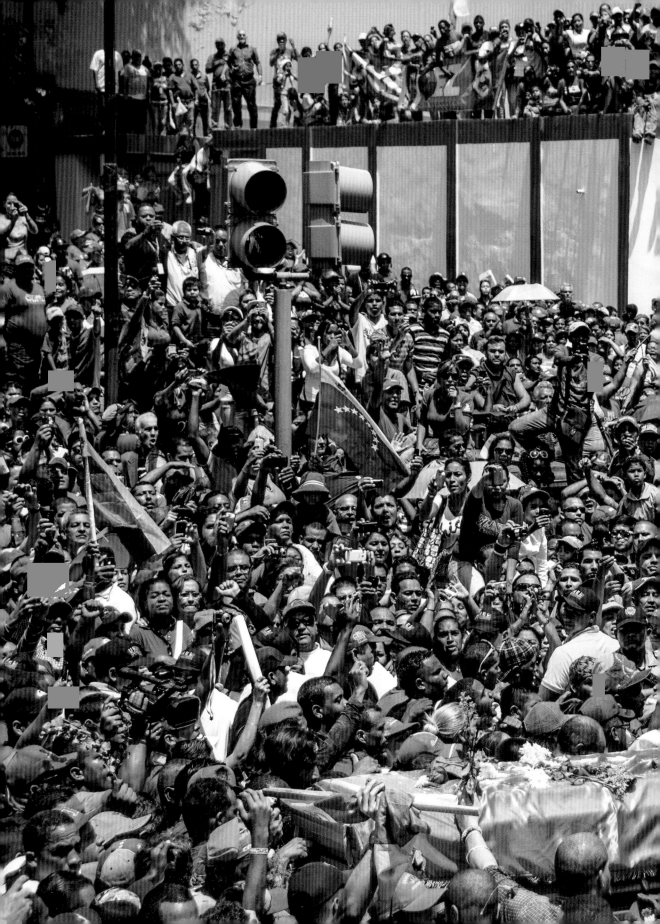

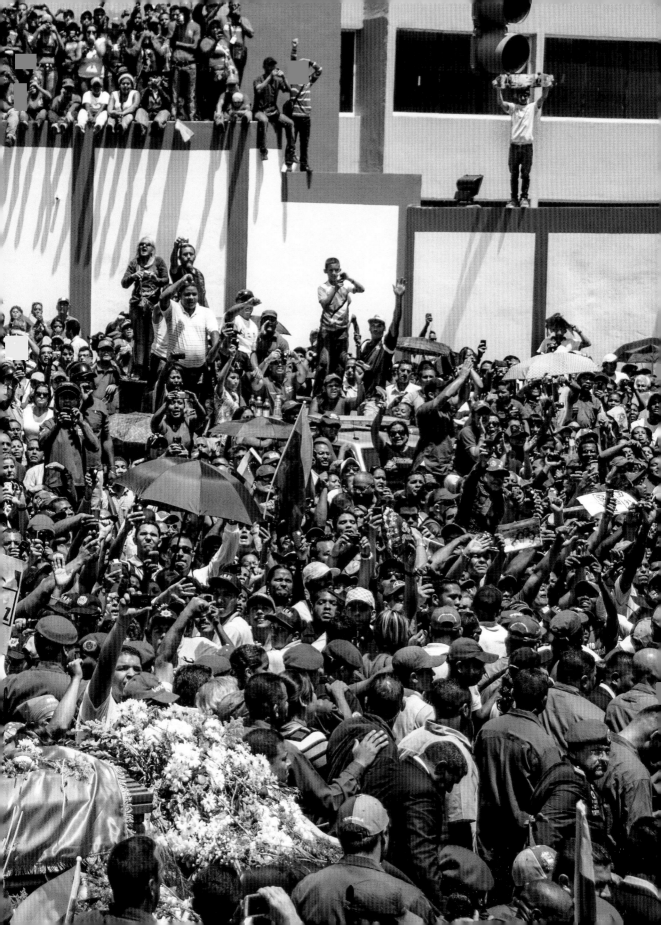

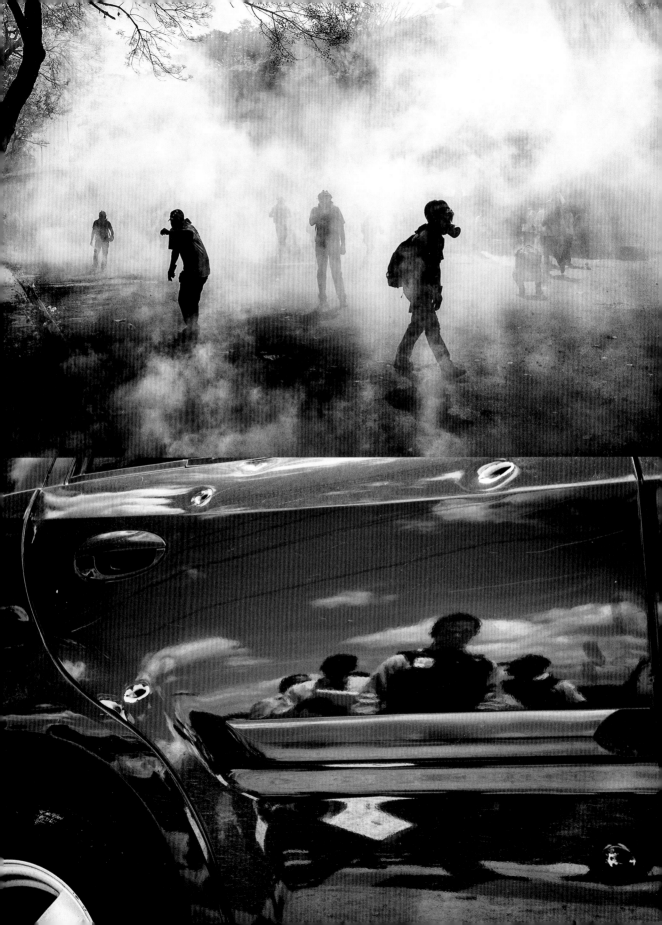

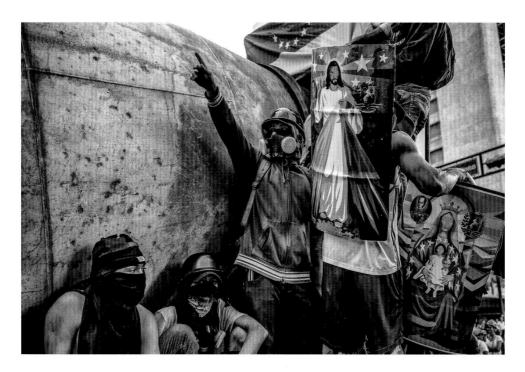

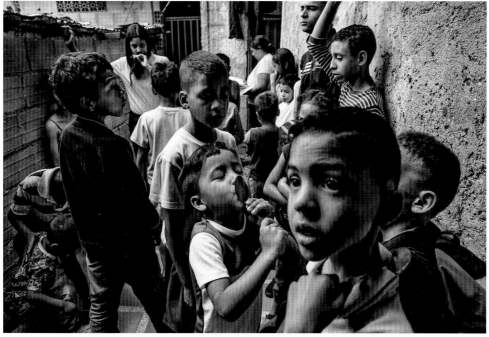

Previous spread: A protestor holds a Venezuelan flag during a demonstration demanding President Maduro's resignation, Caracas, 21 April 2017. *Facing page, top*: Demonstrators walk through teargas during anti-government protests, Caracas, 12 March 2014. *Below*: Officers examine the scene where three people were killed in a police car chase, La Guaira, 15 August 2015. *This page, top*: Demonstrators with homemade shields at an anti-Maduro protest, Caracas, 7 July 2017. *Below*: Children gather outside a community dining room in Caracas, 12 March 2018.

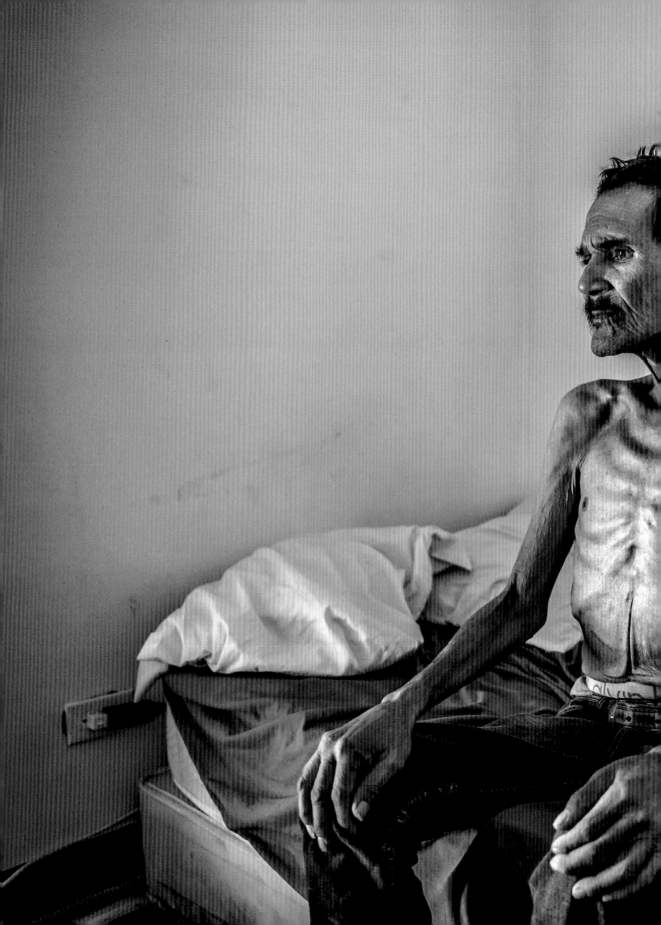

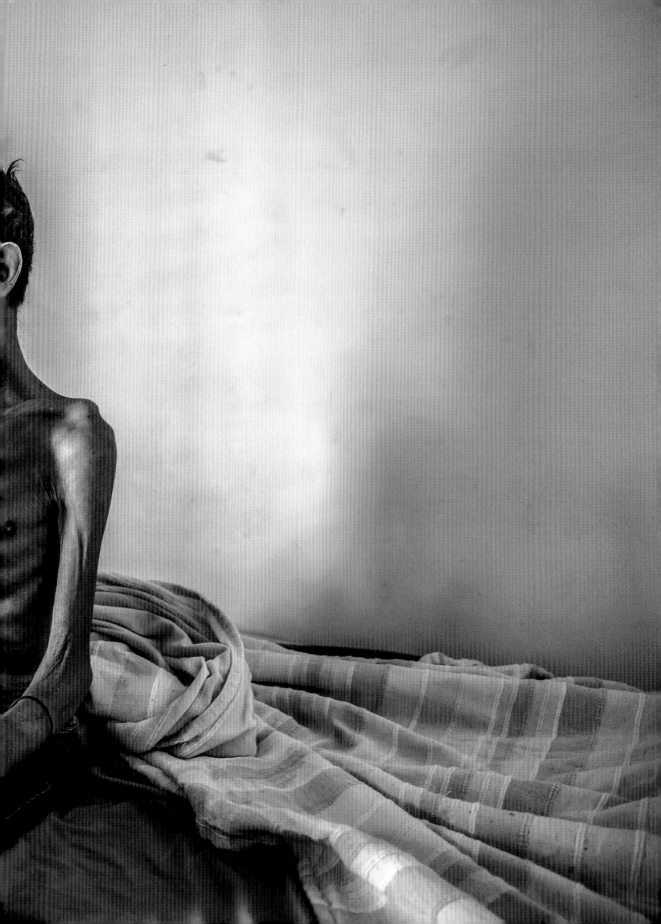

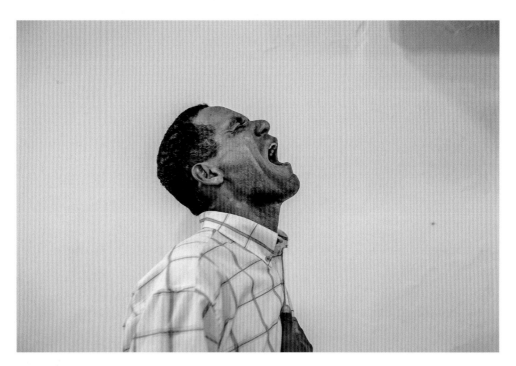

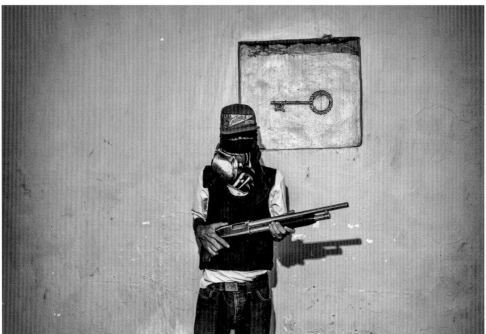

Previous spread: Ruben Zamora sits on his bed having lost 20 kg in three months when the homeless center he was staying in ran out of food. He died two days after the photograph. *This page, top*: Ex-convict Saul sings in church. *Below*: A gang member poses with a gun in Carapita slum, Caracas. *Facing page, top*: Blood lies on the road after three people were shot in a police car chase, La Guaira, 15 August 2015. *Below*: Children play beside the Pan-American Highway after their homes were destroyed by the National Guard, supposedly looking for Colombian paramilitaries.

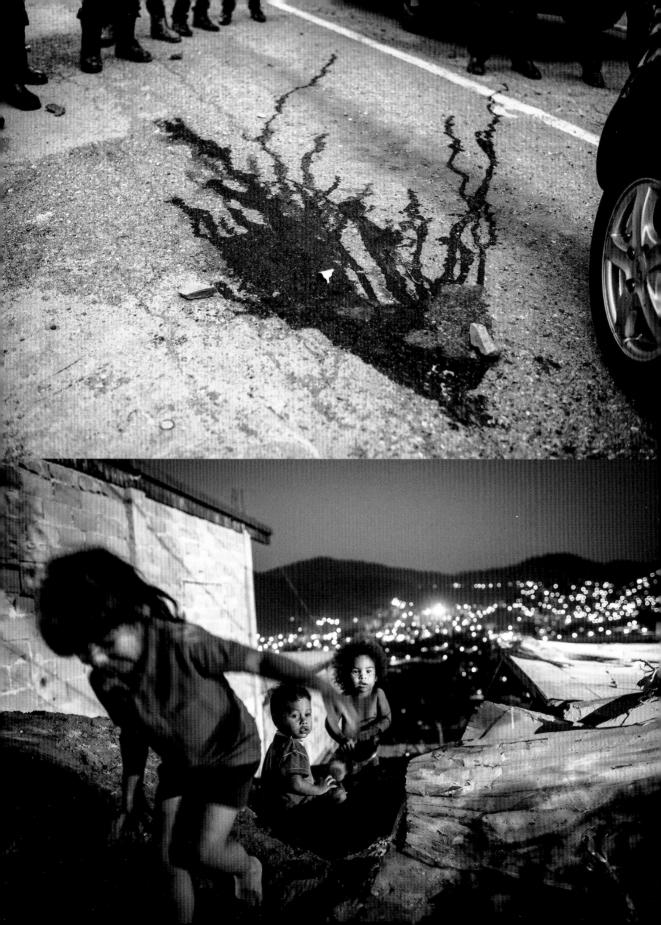

The 2019
Digital Storytelling Contest

The 2019 World Press Photo
Interactive of the Year Nominees

Flint is a Place
Zackary Canepari
→ page 227

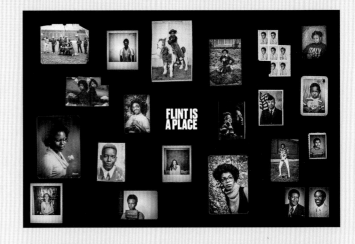

The Last Generation
FRONTLINE/The
GroundTruth Project
→ page 227

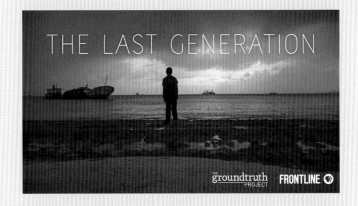

Notes from Aleppo
Paradox
→ page 227

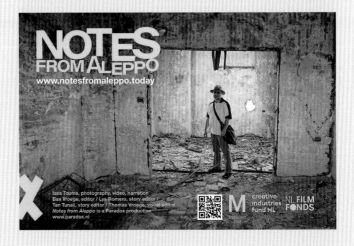

The 2019 World Press Photo
Online Video of the Year Nominees

Unprotected
ProPublica/BBC News
→ page 228

In the Absence
Field of Vision
→ page 228

The Legacy
of the 'Zero
Tolerance'
Policy
Univision News Digital
→ page 229

The Digital Storytelling Contest

With the rise of digital technologies, there are now numerous ways, in addition to photography, of telling high-quality visual stories. The World Press Photo Foundation launched its Digital Storytelling Contest in 2011 as a way to honor new forms of visual storytelling evolving out of the changing media economy.

In the early years of the contest, winners presented their stories through videos and basic web pages hosting a selection of imagery, whereas content is now seamlessly presented in myriad ways: as webdocs within highly interactive interfaces, in apps for mobile phones, or even experienced in augmented and virtual reality.

The 2019 Digital Storytelling Contest reflected the ever-changing domain of visual journalism with three categories: Interactive, Long and Short. Whilst the Long and Short categories reward winners with first, second, and third prizes, recognition in the Interactive category is achieved differently. The constant development in technology is celebrated through three equally weighted awards, and given the diversity of interactive formats, the jury chooses the approaches they wish to acknowledge as outstanding.

This year sees two new major awards—the World Press Photo Interactive of the Year and World Press Photo Online Video of the Year—to put this multimedia work on a par with the World Press Photo of the Year and the World Press Photo Story of the Year.

Zahra Rasool, chair of the 2019 Digital Storytelling Contest jury says:

"It is important to have this contest, because today we consume information and news through social media and online platforms and so we want to recognize that stories are made for these channels and in new, innovative ways. We chose those productions that will have an impact, that create more awareness of and draw attention to the politics of our times."

The awarded productions are on our website: worldpressphoto.org

The 2019 Digital Storytelling Contest Jury

Chair: Zahra Rasool, head of Contrast VR—Al Jazeera, India
Gema Juárez Allen, film producer, Argentina
Sara Kolster, interactive director and designer, the Netherlands
Zoeann Murphy, video journalist, United States
Muyi Xiao, visual editor ChinaFile, China

Secretary:
Henrik Kastenskov, production director and photojournalist, Denmark

Interactive

**World Press Photo
Interactive of the Year 2018**

The Last Generation
FRONTLINE/The GroundTruth Project
Outstanding Multimedia Narrative

What is it like to grow up in a country that is disappearing? This question lies at the heart of *The Last Generation*, a cinematic, seamlessly interactive story that brings audiences into the lives of three children who face losing not just their homes but their entire nation to rising seas. The Marshall Islands is a chain of low-lying coral uplifts halfway between Hawaii and Australia that is home to more than 50,000 people, with nearly half of them under the age of eighteen. Scientists predict that if the global temperature rise is not contained, the islands could become uninhabitable within the lifetime of the children living there today. Through intimate moments and compelling stories, the film's young protagonists—9-year-old Izerman, 14-year-old Julia and 12-year-old Wilmer—draw us into the importance and urgency of what is at stake.

Notes from Aleppo
Paradox
Nominee for World Press Photo Interactive of the Year
Outstanding Immersive Journey

Notes from Aleppo follows photographer Issa Touma's rediscovery of his home city. Forced to leave in 2012, Issa traveled back and forth to Syria until East Aleppo was retaken by the regime in December 2016. *Notes from Aleppo* shows the people who are returning and those who never left. In a sincere, insightful way, Issa reveals the struggles of Aleppo's citizens in their attempt to restore normality in their day-to-day lives and recover from the destruction of war. He uncovers who is behind the reconstruction of the city—neither the regime nor foreign powers, but the citizens themselves. Their stories have gone largely unnoticed by international media. Yet the war has created an independent new generation of Aleppans, who no longer take traditional structures for granted.

Flint is a Place
Zackary Canepari
Nominee for World Press Photo Interactive of the Year
Outstanding Long-Term Project with Experimental Approaches

Flint is a Place is a cross-platform documentary series about Flint, Michigan. It explores a specific moment within this American city in an intimate, character-driven way. Using a variety of media, each of the episodes in the project focuses on a character or a systematic issue and engages with a different community within the city. There are a lot of issues in Flint, MI, including contaminated water, high crime and chronic blight. Flint can be portrayed as a dysfunctional place. And in many ways, it is. But that's not all it is.

In the Absence

Field of Vision
Nominee for World Press Photo Online Video of the Year
1st Prize Long

In the Absence is an unflinching look at the *Sewol* ferry disaster in South Korea. Employing extensive archival material and in-depth historical research, it tells the story of the *Sewol*, a ferry that capsized and sank in the Yellow Sea on 16 April 2014, killing more than 300 people, mostly high school students on a field trip. Visual and audio material gathered at the time is integrated with new footage to create what is both a compelling narrative and a valuable historical document.

Unprotected

ProPublica/BBC News
Nominee for World Press Photo Online Video of the Year
2nd Prize Long

More than Me, an American charity founded by Katie Meyler in Monrovia in the aftermath of the Second Liberian Civil War, set out to protect and empower girls and young women through education. But, far from being protected, many of the girls in More than Me's care were made to endure the same abuses of power inflicted on them during the conflict, specifically sexual exploitation. *Unprotected* tells a searing story, turning a critical lens on the charity and its board, and on the lack of oversight by government institutions, the aid community, and the press. An impressive piece of investigative journalism, it exposes the problem of accountability, not only within Liberia, but the whole system of philanthropy-funded international aid.

Marielle and Monica

Fábio Erdos/*The Guardian*
3rd Prize Long

Marielle Franco, a Brazilian politician and LGBTQI and human-rights activist, was killed in March 2018. While coming to terms with the death of her partner, Monica Benicio continues the fight to give a voice to those who are deemed disposable in Brazil: women, the poor, the LGBTQI community, and black Brazilians. Marielle's murder has still not been solved and, as the police investigation drifts, Monica is plunged into a new crisis because of the right-wing anti-LGBTQI politician Jair Bolsonaro's campaign to become Brazilian president. *Marielle and Monica* tells a personal story of loss, bringing into focus the challenges that lie ahead for LGBTQI rights and progressive politics in Brazil.

Short

World Press Photo
Online Video of the Year 2018

The Legacy of the 'Zero Tolerance' Policy:
Traumatized Children With No Access to Treatment

Univision News Digital
1st Prize Short

Adayanci Pérez is one of more than 2,500 children who were separated from their parents at the US-Mexico border as part of Donald Trump's 'Zero Tolerance' policy. The six-year-old Guatemalan girl was away from her family for three-and-a-half months, and before being allowed to return to her family in Guatemala she was diagnosed with acute trauma and post-traumatic stress disorder. This film shows the reality of the policy's legacy, and gives a voice to those who are not always heard.

I Just Simply Did What He Wanted

Emily Kassie/*The New York Times*
2nd Prize Short

Maria and E.D. are among thousands of women who have reported sexual abuse while held in immigrant detention in the United States. Under the Trump administration, the detention system in America continues to expand rapidly, now holding over 48,000 immigrants daily, including thousands of women and children. *I Just Simply Did What He Wanted* brings together personal accounts, data analysis, court records and insider interviews to illuminate an overwrought system riddled with abuse.

Ghadeer

Chiara Avesani/Matteo Delbò
3rd Prize Short

A young journalist from Mosul returns to his war-devastated city in order to be a part of its future. Having fled to Europe to escape the conflict in Iraq, Ghadeer finds hope for Mosul's recovery in recent European history and the post-war effort. Through Radio One FM—which is self-financed and with no political support—Ghadeer spreads positive messages. He represents the energy of a young civil society that is emerging from the rubble. This short film challenges mainstream narratives of refugees, showing the importance of self-determination and emphasizing that communication is central to cultural transformation.

The 2019 Photo Contest Jury

News and Documentary Specialist Jury
Chair: Whitney Johnson, vice president, Visuals and Immersive Experiences, *National Geographic*, United States
Christoph Bangert, photographer and teacher, Germany
Denise Camargo, photographer, professor, researcher and cultural project manager, Brazil
Davina Jogi, photographer and co-director, Zimbabwe Association of Female Photographers, Zimbabwe
Ahmed Najm, managing director of Metrography Agency, Iraq

Portraits Jury
Chair: Paul Moakley, editor-at-large, Special Projects, TIME, United States
Lekgetho Makola, head of Market Photo Workshop, South Africa
Adriana Zehbrauskas, independent documentary photographer, Brazil

Nature and Environment Jury
Chair: Neil Aldridge, conservation photographer, South Africa
Barbara Stauss, photo director and founding member of *Mare*, Switzerland
Xi Zhinong, wildlife photographer, China

Sports Jury
Chair: Maye-E Wong, photojournalist at Associated Press, Singapore
Olivier Michon, managing director of Presse Sports / L'Equipe, France
Marguerite Schropp Lucarelli, director of photography *Sports Illustrated*, United States

General Jury
In the second week of judging, an independent general jury consisting of the chairs of the specialist juries, plus three new members, chooses the nominees:

Chair: Whitney Johnson, vice president, Visuals and Immersive Experiences, *National Geographic*, United States
Neil Aldridge, photographer, South Africa
Yumi Goto, independent photography curator, Japan
Nana Kofi Acquah, photographer at Getty Images, Ghana
Paul Moakley, editor-at-large, Special Projects, TIME, United States
Alice Martins, photojournalist, Brazil
Maye-E Wong, photojournalist and editor, Singapore

Secretaries:
Kaat Celis, managing director of Sluitertijd and director of AntwerpPhoto, Belgium
David Griffin, owner of DGriffinStudio, United States

Participants Photo Contest

In 2019, 4,738 photographers from 129 countries submitted 78,801 images in the photo contest. The participants are listed here alphabetically by first name according to nationality, as filled in by them in the entry registration system.

Afghanistan
Mohammad Ismail / Mostafa Rezaei Mazari / Omar Sobhani / Rahmat Gul

Albania
Aggelos Barai / Gentian Shkullaku

Algeria
Arslane Bestaoui / Fethi Sahraoui / Zohra Bensemra

Argentina
Analia Cid / Andres Horacio Larrovere / Andres Kudacki / Angel Ricardo Ramirez / Koral Carballo & Anita Pouchard Serra / Atilio Orellana / Bruno Cerimele / Calvo Dino / Carlos Barria / Caro Pierri / Daniel Jayo / Emiliano Lasalvia / Fabián Mattiazzi / Facundo Arrizabalaga / Franco Fafasuli / Gabriel Luque / Gisela Volá / Guillermo Prat / Gustavo Cherro / Hernan Zenteno / Hugo Passarello Luna / Ignacio Colo / Juan Medina / Juan Ignacio Aréchaga / Juanma Baialardo / Juano Tesone / Lara Otero / Laura Lago / Lucho Casalla / Luján Agusti / Marcos Gomez / Mario Sayes / Mario De Fina / Martin Acosta / Martin Arias Feijoo / Maximiliano Vernazza / Natacha Pisarenko / Nicolás Borojovich / Nicolas Bravo / Nicolas Pousthomis / Oscar Fridman / Nestor García / Pablo Aharonian / Pablo Barrera Calo / Rodrigo Abd / Santiago Filipuzzi / Sebastian Gil Miranda / Silvana Ines Boemo / Soledad Quiroga / Tony Valdez / Walter Astrada / Walter Diaz

Armenia
Anush Babajanyan / Artem Geodakyan / Asatur Yesayants / Eric Grigorian / Hrant Khachatryan / Karen Mirzoyan / Nazik Armenakyan / Piruza Khalapyan / Yulya Grigoryants

Australia
Adam Ferguson / Adam Pretty / Alana Holmberg / Alex Ellinghausen / Andrea Francolini / Andrew Kelly / Andrew Quilty / Angus Mordant / Asanka Ratnayake / Ashley Gilbertson / Barry O'Brien / Ben Cooke / Blair Horgan / Bradley Kanaris / Brendan Esposito / Brett Costello / Cameron Spencer / Chris McGrath / Chris Hopkins / Craig Golding / Dan Peled / Darrian Traynor / David Gray / David Caird / David Kelly / David Martinelli / Dean Lewins / Dean Saffron / Douglas Gimesy / Jason Edwards / Jenny Evans / Jeremy Piper / Jim Wilson / Juergen Hasenkopf / Julia Wheeler / Justin McManus / Kate Geraghty / Lachie Hinton / Lisa Hogben / Lisa Maree Williams / Lyndal Irons / Marc McCormack / Mark Kolbe / Matthew Abbott / Michael Aw / Michaela Skovranova / Nick Moir / Nyani Quarmyne / Palani Mohan / Patrick Brown / Paul Hilton / Phil Hillyard / Philip Brown / Quinn Rooney / Raphaela Rosella / Richard Wainwright / Rohan Kelly / Russell Shakespeare / Ryan Pierse / Stephanie Simcox / Stephen Dupont / Steve Christo / Sylvia Liber / Tim Clayton / Toni Greaves / Tracey Nearmy / Trent Mitchell / Trevor Collens / Vanessa Mignon / Virginia Star / Warren Richardson

Austria
Armin Walcher / Christian Bruna / Christian Fischer / Elisabeth Niesner / Erwin Scheriau / Eugenia Maximova / Gregor Kallina / Gregor Kuntscher / Heimo Aga / Heinz-Peter Bader / Helmut Graf / Johann Groder / Josef Timar / Lukas Beck / Mario Marino / Martin Zinggl / Robert Krasser / Rudolf Klaffenböck / Tobias Steinmaurer

Azerbaijan
Emil Khalilov / Rena Effendi

Bahrain
Hamad Mohammed

Bangladesh
A.N.M Zia / Abdul Goni / Abir Abdullah / Abutaher Khokon / Alamin Leon / Apu Jaman / Azim Khan Ronnie / Fabeha Monir / Faiham Ebna Sharif / Habibur Rahman / Hasan Raja / Ismail Ferdous / Jashim Salam / Joyeeta Roy / K.M. Asad / Kamol Das / Kazi Md. Jahirul Islam / Kazi Riasat Alve / Khaled Hasan / Mamunur Rashid / Md Abu Sufian Jewel / Md Maruf Hasan / Md Rafayat Haque Khan / Md. Rahat Kabir / Mohammad Rakibul Hasan / Mohammad Shahnewaz Khan / Monirul Alam / Mushfiqul Alam / Naman Protick Sarker / Nasif Imtiaz / Piyas Biswas / Probal Rashid / Rahat Karim / Rahul Talukder / Rajesh Chakraborty / Rayhan Ahmed / Rehman Asad / Ripon Barua / Saikat Mojumder / Salahuddin Ahmed / Samiul Hamim Tuhin / Shafayet Hossain Apollo / Shafiqul Alam Kiron / Shorave Das / Sony Ramany / Sowrav Das / Sudeepto Salam / Suman Paul / Suvra Kanti Das / Syed Amil Batul Musa Reza / Syed Ashraful Alam / Turjoy Chowdhury / Yousuf Tushar / Zabed Hasnain Chowdhury / Zakir Hossain Chowdhury

Belarus
Alexander Vasukovich / Andrei Liankevich / Anton Dotsenko / Eugene Tihanovich / Irina Dainakova / Julia Shablovskaya / Maxim Sarychau / Sergei Gapon / Siarhei Balai / Siarhei Lysenko / Tatsiana Tkachova / Uladzimir Hrydzin

Belgium
Alain Schroeder / Alexander Dumarey / Anthony Dehez / Arne Gillis / Bart Lenoir / Caroline Thirion / Christophe Ketels / Colin Delfosse / Filip Van Roe / Francois Lenoir / Frederik Buyckx / Gael Turine / Heleen Peeters / JC Guillaume / Jean-Michel Clajot / Julien De Wilde / Katrijn Van Giel / Kevin Faingnaert / Kristof Vadino / Lieven Engelen / Lil Steinberg / Liza Van der Stock / Martine De Flander / Mashid Mohadjerin / Nick Hannes / Olivier Matthys / Oscar Dhooge / Patrick De Roo / Peter De Voecht / Rebecca Fertinel / Rob Walbers / Robbe Vandegehuchte / Roger Job / Saar Ingelbert / Sanne De Wilde / Sébastien Van Malleghem / Thomas Freteur / Tomas Van Houtryve / Valentin Bianchi / Virginie Nguyen / Wanda Tuerlinckx / Yorick Jansens

Bolivia
David Mercado / Manuel Seoane / Marcelo Perez del Carpio / Patricio Crooker / Wara Vargas

Bosnia and Herzegovina
Ahmed Hadrovic / Haris Memija / Husein Sljivo / Midhat Poturovic / Vedad Ceric

Brazil
Adriano Choque / Albari Rosa Silva / Alberto César Araújo / Alexandre Guzanshe / Alexandre Meneghini / Alinne Rezende / Amanda Martinez Nero / Amanda Perobelli / Ana Sabiá / André Borges / André Câmara / André Durão / André Liohn / Andre Penner / André Porto / André Vieira / Ariel Subirá / Arthur Menescal / Avener Prado / Bruna Prado / Bruno Kelly / Camila Falcão / Carlos Ambioris Almonte / Cassia Tabatini / Cesar Greco / Christian Braga / Cristiane Mattos / Daniel Marenco / Daniel Moreira / Daniel Teixeira / Danilo Verpa / Diorgenes Pandini / Edmar Barros / Eduardo Lima / Ellan Lustosa / Eugênio Sávio / Fabio Teixeira / Felipe Dana / Felipe Fittipaldi / Fernando Frazão / Fernando Martinho / Fernando Souza / Flavio Forner / Francisco Proner / Gabi Di Bella / Gabriel Chaim / Guilherme Dionizio / Guilherme Santos / Guito Moreto / Henry Milleo / Humberto Araujo / Humberto Lemos De Carvalho / Ilana Bar / João Velozo / Joédson Alves / Joey Rosa / José Carlos Alexandre / Junio Matos / Lalo de Almeida / Leonardo Carrato / Leonardo Correa / Lilo Clareto / Lucas Landau / Luciano Candisani / Luisa Dörr / Luiz Carlos Gomes / Marcelo Carneiro Silva / Marcio Esteves Cabral / Marcio Isensee E Sá / Marcio Pimenta / Marcos Ramos / Markus Bruno / Marta Nascimento / Mateus Bruxel / Mauricio Lima / Mauro Pimentel / Nacho Doce / Nailana Thiely Salomão Pereira / Natalia Alves / Nelson Almeida / Nelson Antoine / Pablo De Luca / Paula Mariane Silva Da Costa / Paulo Amorim / Paulo Mumia / Paulo Pampolin / Paulo Pinto / Pedrosa Neto / Raphael Alves / Ricardo Moraes / Ricardo Moreira / Ricardo Teles / Rodolfo Buhrer / Rodrigo Soares Pires / Rogerio Stella / Sebastiao Moreira / Sergio Ranalli / Sylvia Izquierdo / Teresa Maia / Thiago Bernardes / Thiago Dezan / Ueslei Marcelino Silva / Valda Nogueira / Victor Venco Moriyama / Werther Santana Santos / Wilson Soares / Yan Boechat Rocha / Yanahin Waurá / Yolanda Mêne

Bulgaria
Anastas Tarpanov / Boris Voynarovitch / Dimitar Dilkoff / Dimitar Kyosemarliev / Hristo Rusev / Ivo Danchev / Julia Lazarova / Mehmed Aziz / Mladen Antonov / Valery Poshtarov / Victor Troyanov / Vlado Trifonov

Cameroon
Zacharie Ngnogue

Canada
Aaron Vincent Elkaïm / Aaron Lynett / Adrienne Surprenant / Alana Paterson / Alexa Vachon / Allen McInnis / Andre Pichette / Andrej Ivanov / Andrew Vaughan / Anne-Marie Jackson / Anne-Sophie Beaudoin / Barbara Davidson / Ben Nelms / Benedict Moran / Brett Gundlock / Carlos Osorio / Caroline Hayeur / Chris Donovan / Chris Wattie / Christopher Katsarov / Cody Punter / Cole Burston / Daniel Charbonneau / Darren Calabrese / Darryl Dyck / Edouard Plante-Fréchette / Emiliano Joanes / Eric Demers / Etienne De Malglaive / Genevieve Thibault / Ian Willms / Iva Zimova / Jack Simpson / Jackie Dives / Jason Franson / Jean-François / Jeff LeBlanc McIntosh / Jen Osborne / Jo-Anne McArthur / Jody Rogac / Johnny C. Y. Lam / Juozas Cernius / Kiana Hayeri / Kieran Oudshoorn / Kitra Cahana / Lance McMillan / Larry Wong / Leah Hennel / Louie Palu / Mark Lehn / Mathieu Belanger / Michael Wheatley / Michel Tremblay / Michelle Siu / Muse Mohammed / Nathalie Daoust / Neil Ever Osborne / Nick Kozak / Norman Y Lono / Olivier Staub / Olivier Jean / Patrick Price / Patrick Woodbury / Paul Nicklen / Pieter de Vos / Pooyan Taba / Renaud Philippe / Rick Madonik / Roger Lemoyne / Ryan Koopmans / Sara Hylton / Shehzad Noorani / Shlomi Amiga / Stephanie Foden / Tamara Abdul Hadi / Tanya Bindra / Tim Smith / Valerie Blum

Chile
Alvaro Riveros / Bruno Gallardo / Carlos Newman / Carlos Villalon / Cristobal Olivares / Edgard Garrido / Ernesto Zelada / Fernando Lavoz / Hector Retamal / Ivan Alvarado / Luis Hidalgo / Marcos Zegers / Marcos González Valdés / Matias Delacroix / Oscar Muñoz Badilla / Pedro Mora / Tamara Merino / Tomas Munita

China

Dai Teng Fei Jia / Jie Wu / Pengwei Yang / Shiyan Xia / Xianming Luo / Aly Song / Amy Luo / Baidi Wang / Bailiang Yan / Baocheng Lin / Baoguo Cui / Baoxi Tian / Baoying Lu / Bin Xu / Bing Zhou / Bingcheng Wang / Bingsheng Liu / Binhao Luo / Bo Wen / Boqian Cui / Bossa Song / Cangna Yan / Cao Zongwen / Changchun Liu / Changlong Wang / Changming Liu / Changshu Wang / Changsong Liu / Changzai Lu Chao Li / Chaohai Zheng / Chen Gang / Chen Jian / Chengbin Zhang / Chenglin Zhang / Chengzhou Zhou / Chuanbin Chen / Chuanjun Jia / Chuannian Li / Chuanzhong Li / Chun Meng / Chun Qiang Li / Chunshui Yu / Cong Hu / Cui Jun / Cui Li / Cuncheng Zhang / Da Xue / Dan Liu / Dan Zhu / Debiao Fan / Debin Liu / Quanke Deng / Di Wu / Di Zhao / Diankui Xu / Ding Gang / Dong Yao / Dongfeng Deng / Dongjun Zhang / Duanhong Wu / Ella Guo / Fan Li / Fangbin Fan / Fei Wang / Feifei Hu / Feng Li / Feng Sun / Feng Wang / Feng Zhang / Fengchao Wang / Fengning Chen / Fengrui Liu / Fule Xie / Ga Li / Gang Lei / Gang Li / Gang Yin / Gangfeng Zhou / Gao Peng / Gao Wei / Gengga Suonan / Gengsheng Chen / Genhuo Lin / Guangfeng Chen / Guanghui Mu / Guangjin Li / Guangqi Zhang / Guanguan Liu / Guiyan Lin / Gukai Zhou / Guo Jin / Guohua Zheng / Guoji Dong / Guoji Jiang / Guoman Liao / Guoqiang Wu / Guoqiang Zhou / Guoqing Hu / Guorong Jia / Guorong Wang / Guotao Xiong / Guoxiang Sun / Guoyong Wu / Haibo Chi / Haifeng Qian / Haiguang Tian / Haisong Pan / Haiyan Zong / Haiyang He / Haiyong Feng / Haizhen Lin / Han Luo / Hanan Wang / Hanlin Wang / Hao Wu / Hong Lei / Hong Li / Hong Tao / Hongwei Zhang / Hong Wu / Hongbo Yun / Hongbo Zhu / Hongjie Ma / Hongjun Yue / Houyu Liu / Hu Li / Huage Shang / Huaifeng Li / Huaming Wu / Huang Qiqing / Huanxin Ding / Hui Li / Hui Qi / Hui Wang / Huimin Kuang / Huiqiao Man / Huoyan Wang / Jia Gu / Jialei Zhou / Jiaming Chen / Jian Li / Jian Liu / Jian Luo / Jian Tian / Jian Wang / Jianyu Chen / Jian Zhai / Jianan Liu / Jiancheng Zhao / Jianfeng Shen / Jiang Yue / Jiang Liu / Jiangang Li / Jiangchuan Tong / Jiangsong Li / Jiangtao Guo / Jianguo Wang / Jiangxin He / Jianhua Yan / Jianjun Ma / Jianming Wang / Jianqiang Chen / Jiansheng Zhou / Jianshu Li / Jianyong Chen / Jianyuan Chen / Jianzhong Zhang / Jiaxiang Wu / Jidong Li / Jie Chen / Jie Hao / Jie Liu / Jie Ma / Jie Wang / Jiemin Tian / Jijian Yu / Jimei Liu / Jin Chen / Jin Li / Jin Wu / Jinbing Liu / Jing Li / Jing Wang / Jing Yan / Jingdong Zhao / Jingguo Zhang / Jingwei Zhao / Jingyu Guo / Jinhui Bi / Jinqi Zhang / Jinxing Du / Jinyan Wang / Jipeng Zhu / Jitao Qin / Jiujiang Xie / Jun Cao / Jun Wang / Jun Wang / Jun Ye / Jun Zhao / Junshang Zeng / Justin Jin / Kelin Bai / Kuiwu Zhang / Kun Fu / Lei Jia / Lei Wang / Lei Zhang / Li Jiang / Li Junhui / Li Feng / Li Liu / Li Song / Li Wei / Li Yong / Lian Huang / Liang Jin / Liangkuai Jin / Lianhua Zhang / Liao Xiong / Lichun Zhou / Lide Zhang / Lihe Zhou / Like Zhu / Lili Wang / Liliang Guo / Liming Cao / Liming Zhong / Lin Li / Lin Lu / Lin Qi / Lin Yan / Lin Zeng / Lindong Zheng / Lingling Qiu / Lingluo Cui / Lingzhi Chen / Linhong Wu / Linji Song / Linlin Li / Lintao Zhang / Liping He / Lui Lei / Liu Song / Liu Xunqi / Liwang Jin / Liwei Zhang / Liyan Yu / Liyang Yuan / Liyong Fan / Longxiang Xie / Lu Xu / Luo Rui / Mang Wan / Maohua Fei / Maojun Ning / Marc Yang / Meng Yan / Mia (Tianqi) Song / Min Wan / Min Ying / Ming Li / Ming Liang / Ming Xi / Mingdeng Jiang / Mingjie Lu / Mingjun Jiang / Minhao Xu / Minqiang Lu / Muzi Li / Na Zhou / Nan Cui / Nan Suo / Nanhua Xie / Ni Dong / Nian Liu / Ou He / Pan Liao / Pan Wang / Peijian Zhang / Peng Yuan / Pin Li / Ping Shi / Ping Xu / Ping Yu / Pingfan Ye / Pingfan Zeng / Pinglang Zhou / Qi An / Qian Lubin / Qianchuan Zhan / Qianfu Yang / Qiang Han / Qiang Feng / Qiang Li / Qiang Zhang / Qianjin Li / Qianli Ma / Qiaojiang Su / Qin Wang / Qing Xu / Qingsheng Sun / Qituo Chen / Qiu Yan / Qiumin Tan / Qixuan Mai / Qizheng Li / Renzi Li / Risheng Liu / Riying Wei / Roban Wang / Rongqin Liu / Rongrong Yan / Rui Li / Rui Zhang / Ruiyang Liu / Ruohao Zhang / Sanfeng Lan / Shangtong Zhou /

Shangzhen Fan / Shangzhi Xia / Shanhong Gu / Shaofeng Zhang / Shaohua Chen / Shaolong Su / Shaoxi Zeng / Shen Wang / Shen Yue / Sheng Jiapeng / Shengjie Luan / Shengli Zhou / Shi Tao / Shibo Wang / Shihui Liu / Shijia Ni / Shijin Zhao / Shijun Wang / Shilong Wang / Shiquan Li / Shixiang Wang / Shouguo Zhang / Shuailiang Liu / Shuangyin Dong / Shuchen Lang / Shuhua Zhang / Shujie Jin / Shulian Xiao / Shuran Huang / Shuzhen Bai / Sihang You / Songgang Pan / Songge Cui / Songqing Liu / Sun Hai / Sun Huajin / Sun Yunhe / Taiheng Wang / Tao Huan / Tao Liu / Tao Luo / Tao Lv / Tao Zhang / Tao Zheng / Tianming Zhang / Tiejun Wang / Tieqiang Li / Tingmei Hu / Tom Zhao / Tong Cao / Tong Yu / Wang Bing / Wang He / Wang Xiao / Wang Xueya / Wang Zhao / Wang Zhuo / Wangzhen Zhen / Wei Han / Wei Long / Wei Tan / Wei Xu / Wei Ye / Wei Zeng / Wei Zhang / Wei Zhou / Wei Zhu / Weiguang Li / Weiguo Hu / Weimin Zhao / Weirong Qiu / Weiwei Wang / Weiwen Ou / Weixi Chen / Weizhong Qian / Wen Ran / Wenbin Gong / Wenbin Yao / Wendong Tan / Wenjian Zhao / Wenjin Chen / Wenlong Hu / Wenlong Lu / Wentao Zhang / Wenwei Chen / Wo Shu / Wu Fang / Wu Huang / Wuwang Lin / Xian Qian / Xiang Fang / Xiang Li / Xiangbo Li / Xiangyang Wang / Xiangyang Yuan / Xianzhang Zeng / Xiao Guo / Xiao Langping / Xiao Min Chen / Xiao Xia / Xiaodong Liu / Xiaodong Liu / Xiaofa Wang / Xiaofeng Chen / Xiaohui Zhou / Xiaoke Wang / Xiaolong Guo / Xiaomei Zheng / Xiaoming Ge / Xiaoming Qiu / Xiaoqing Chen / Xiaoqun Zheng / Xiaoxian Wang / Xiaoxu Pu / Xiaoyu Wu / Xin Su / Xin Yang / Xingang Xu / Xingxin Zhu / Xingzhi Chen / Xinke Wang / Xinmin Zhang / Xiuting Ren / Xiyong Zhu / Xizhi Zhang / Xu Liu / Xu Wang / Xue Bai / Xueqi Bai / Yalin Dong / Yalin Shao / Yan Chen / Yan Han / Yan Zhan / Yanan Zhang / Yang Bo / Yang Du / Yang Hua / Yang Kejia / Yang Xu / Yang Yang / Yangkun Shi / Yanhua Lu / Yanping Ma / Yao Wang / Yaoquan Huang / Yaoye Yang / Yi He / Yi Hong Zhang / Yi Jun Zhao / Yi Shi / Yi Wang / Yi Xiao / Yi Yuan / Yi Zhang / Yicen Che / Yijiang Guo / Yijun Yang / Yilan Song / Yilong Liang / Yiming Dou / Yiming Yang / Yin Ba / Yin A / Ying Li / Yingchang Zhuang / Yingcheng Hai / Yingdong Fu / Yingfei Liang / Yingli Cai / Yingnan Zhang / Yingting Li / Yong Wang / Yong Jun Fu / Yong Li / Yong Lin / Yong Min / Yong Zhao / Yongen Zhou / Yongguang Wei / Yonghong Jin / Yonghong Yin / Yongkang Li / Yongqing Bao / Yongsheng Wang / Yongzhong Xu / Youde Yang / Youdong Deng / Youqiong Zhang / Yu Hou / Yu Shen / Yu Zhan / Yuan Chen / Yuan Zhang / Yuan Zhang / Yuanran Zheng / Yuejian Hu / Yuesheng Yu / Yufei Xiong / Yufeng Li Yuguo Wang / Yuhua Yuan / Yujie Liu / Yujie Zhang / Yulei Fan / Yunhong Li / Yunhua Yu / Yunsheng Geng / Yunzhi Xu / Yuqiang Zhou / Yuqing Dong / Yuqing Han / Yushan Li / Yuting Lei / Yuyan Zhou / Yuyang Liu / Yuze Li / Yvqing Guo / Zhaijian Huang / Zhang Jie / Zhang Jin / Zhang Jing / Zhang Lei / Zhang Mao / Zhangjie Wu / Zhannan Zhao / Zhao Kang / Zhaoxu Xia / Zhaozeng Zhang / Zhe Huang / Zhedong Li / Zhenbin Zhong / Zheng Ji / Zheng Wei / Zhenhua Fan / Zhi Zuo / Zhibin Jiang / Zhibo Zheng / Zhifeng Xu / Zhigang Wang / Zhihui Shi / Zhijun Sun / Zhijun Tan / Zhiming Han / Zhiming Jin / Zhiquan Liu / Zhitang Zhong / Zhixian Chen / Zhixian Yang / Zhiyou Zhang / Zhonghua Yang / Zhongju Wang / Zhonglin Wu / Zhongqiu Chen / Zhongyang Cao / Zhou Shiju / Zhou Wei / Zhuang Wu / Zhulin Zuo / Zijie Gong / Zhang Wei / Zilin Wang / Ziyang Peng / Zongqi Wu / Zuo Wang / Zuoquan Ge

Colombia

Alejandro Osses Saenz / Andrés Cardona / Angie Milena Espinel / Ariel Arango / Christian Escobar Mora / Diego Pérez / Eliana Aponte / Esteban Vega La-Rotta / Federico Rios / Felipe Caicedo / Fernando Vergara / Gillmar Said Villamil Lemus / Henry Agudelo / Henry Romero / Iván Herrera / Ivan Valencia / Jaime Pérez Munevar / Jair Fernando Coll Rubiano / Joana Toro / Joaquin Sarmiento / Jonathan Carvajal Borja / Jose Miguel Gomez / Juan Antonio Sánchez Ocampo / Juan Arredondo /

Juan Diego Buitrago Cano / Juan Diego Pinzon / Juan Giraldo / Juanita Escobar / Luis Acosta / Luis Ramirez / Luis Robayo / Manuel Saldarriaga / Marco Valencia / Mario Franco / Mauricio Morales / Miguel Medina / Nelson Cardenas / Nelson Sierra / Raul Arboleda / Roberto Orru / Salym Fayad / Santiago Escobar-Jaramillo / Santiago Mesa / Sebastián Villegas / Valentina Encalada / Vanessa Romero / Verónica Giraldo Canal / Victoria Holguin

Congo

Michael Kalamo

Costa Rica

Alonso Tenorio / Jose Diaz / Mayela López / Melvin Molina / Rafael Pacheco Granados

Croatia

Borna Vincek / Dragan Matić / Igor Kralj / Paul Lukin / Petar Kurschner / Vlado Kos

Cuba

Alejandro Ernesto Perez Estrada / Ismael Francisco Gonzalez Arceo / Juan Aristides Otamendiz / Ricardo Tamayo

Czech Republic

Katia Christodoulou / Dan Materna / David Tesinsky / Eduard Erben / Hynek Glos / Ivan Vetvicka / Jan Wünsch / Jana Andert / Jarmila Štuková / Jaromir Hanzlik / Jiří Královec / Jiri Nykodym / Klára Vaculíková / Lukas Biba / Lukáš Mach / Martin Studený / Martin Divíšek / Martin Kozák / Martina Houdek / Matěj Hard / Michael Hanke / Michal Novotný / Miroslav Pavlík / Pavel Hrančík / Petr Topič / Renka Hasilová / Roman Vondrouš / Šárka Vancurova / Stanislav Krupař / Tom Junek / Tomáš Vocelka / Vendula Fantova / Vladimír Čech Jr.

Denmark

Andreas Beck / Andreas Hagemann Bro / Andreas Haubjerg / Anthon Unger / Asger Ladefoged / Casper Dalhoff / Charlotte Pardorf / Corneliu L Cazacu / Flemming Olsen / Gregers Tycho / Jacob Buchard / Jacob Ehrbahn / Jakob Carlsen / Jan Grarup / Jens Astrup / Jens Juul / Jeppe Bøje Nielsen / Jeppe Carlsen / Jeppe Gudmundsen-Holmgreen / Jesper Houborg / Joakim Eskildsen / Jon Spangsvig / Jorgen Hildebrandt / Ken Hermann / Klaus Holsting / Klaus Bo Christensen / Klaus Thymann / Kristian Buus / Lars Moeller / Lasse Kofod / Lene Esthave / Linda Kastrup / Louise Herrche Serup / Mads Nissen / Marcus Trappaud Bjørn / Marie Hald / Michael Dropt-Hansen / Mikkel Hørlyck / Miriam Dalsgaard / Mogens Laier / Morten Pape / Nanna Kreutzmann / Nanna Navntoft / Niels Ahlmann Olesen / Nikolai Linares / Rasmus Flindt Pedersen / Sigrid Nygaard / Søren Bidstrup / Steven Achiam / Thomas Nielsen / Thomas Sjørup / Tine Harden / Tobias Nicolai / Tom Svensson / Tor Birk Trads / Torben Raun

Ecuador

Dolores Ochoa / Emilia Lloret / Felipe Jacome / Jonathan Miranda Vanegas / Karen Toro / Karla Gachet / Lucas Bustamante / Marcos Pin / Martin Jaramillo / Santiago Borja

Egypt

Ahmed Abd El-Gawad / Aly Fahim / Amr Alfiky / Asmaa Gamal / Asmaa Waguih / Ayman Aref / Fayed El-Geziry / Galal Elmissary / Hadeer Mahmoud / Heba Khamis / Khaled Basyouny / Mahmoud Khaled / Mohamed Hesham / Mostafa Darwish Mohamed Fawaz / Nariman El-Mofty / Nour El Refai / Racha Rachad / Rodina Abdeldaim / Roger Anis / Samer Abdallah

El Salvador

Camilo Roque Alvarenga Freedman / Frederick Meza / Lissette Lemus / Marvin Recinos / Oscar Rivera / Yuri Cortez

Estonia

Eero Vabamägi / Joosep Martinson / Tairo Lutter

Ethiopia

Naod Lemma

Faroe Islands

Benjamin Rasmussen

Finland

Ahti Kannisto / Akseli Valmunen / Arttu Laitala / Emmi Korhonen / Janne Körkkö / Janne Riikonen / Joel Karppanen / Jukka Gröndahl / Kaisa Rautaheimo / Markus Jokela / Markus Varesvuo / Meeri Koutaniemi / Miikka Pirinen / Mikko Vähäniitty / Niklas Meltio / Petteri Kokkonen / Sakari Piippo / Sami Kero / Tatu Blomqvist / Tatu Lertola / Timo Hartikainen / Ville Rinne

France

Abdesslam Mohamed Mirdas / Adeline Praud / Adlan Mansri / Adnan Farzat / Adrien Vautier / Agnes Dherbeys / Alain Laboile / Alain Mounic / Alexandre Marchi / Alexis Berg / Alexis Huguet / Alexis Pazoumian / Alexis Rosenfeld / Ania Freindorf / Anita Pouchard Serra / Anne Laure Camilleri / Anne-Christine Poujoulat / Antonin Burat / Antonin Ménagé / Antonin Thuillier / Arno Vittet / Augustin Le Gall / Axelle de Russé / Bastien Pascal / Beatrice de Gea / Benedicte Kurzen / Benjamin Cremel / Benjamin Decoin / Benjamin Girette / Benoit Tessier / Boris Allin / Brice Portolano / Bruno Arbesú / Bruno Bade / Bruno Fert / Catalina Martin-Chico / Charbonnier Nathanael / Charles Xelot / Christian Brun / Christian Hartmann / Christophe Ena / Christophe Huby / Christophe Le Petit / Claire Delfino / Claire-Lise Havet / Claude Puquet / Collanges Guillaume / Corentin Fohlen / Corinne Mariaud / Corsan Olivier / Cyril Abad / Daniel Karmann / David Bignolet / David Himbert / David Mareuil / Delphine Bedel / Denis Allard / Denis Meyer / Dessons Eric / Didier Bizet / Didier Sylvestre / Dominique Secher / Emeric Fohlen / Emilie Buzyn / Emilien Urbano / Emilienne Malfatto / Emmanuel Dunand / Emmanuel Rondeau / Eric Baledent / Eric Dubost / Eric Gaillard / Eric Garault / Eric Travers / Erik Sampers / Ernoult Alain / Erwan Rogard / Estelle Ruiz / Fabrice Dimier / Flavien Moras / Florence At / Florence Moncenix / Florent Gooden / Francis (Max) Rousseau / Franck Boutonnet / Franck Fife / Franck Paubel / Franck Vogel / Francois-Olivier Dommergues / François-Xavier Marit / Fred Dufour / Frédéric Marie / Frederic Noy / Frederique Cifuentes / Gabriel Bouys / Gael Cloarec / Gaëlle Girbes / Gaillarde Raphael / Garcia Michel / Gerard Robert Gratadour / Gia To / Gladieu Stephan / Gregory Lecoeur / Guilhem Alandry / Guillaume Binet / Guillaume Herbaut / Guillaume Holzer / Guillaume Squinazi / Hervé Lequeux / Isabelle Merminod / Jacques Pion / Jan Schmidt-Whitley / Jean Pierre Sageot / Jean-Claude Moschetti / Jean-François Mutzig / Jean-Jérôme Destouches / Jeanne Taris / Jeff Pachoud / Jeoffrey Guillemard / Jérémie Jung / Jérôme Bonnet / Jerome Gence / Jonathan Fontaine / Jonk / Julia Druelle / Julie Franchet / Julien Blanc / Julien Daniel / Julien Faure / Julien Goldstein / Kamil Zihnioglu / Keyser France / Laetitia Vancon / Latreille Francis / Laura Ponchel / Laure d'Utruy / Laurence Geai / Laurent Ballesta / Laurent Weyl / Leon Quijano Camilo / Lewis Joly / Livia Saavedra / Loïc Mazalrey / Loïc Venance / Ludovic Marin / Magali Cohen / Mamelle Florent / Marc Dozier / Marc Roussel / Marin Driguez / Martin Bertrand / Martin Bureau / Martin Colombet / Mathias Depardon / Mathias Zwick / Matthieu de Martignac / Matthieu Paley / Maud Bernos / Mehdi Chebil / Mehdi Taamallah / Mélanie Rey / Melanie Wenger / Michael Bunel / Moland Fengkov / Myriam Meloni / Myriam Tangi / Nadège Mazars / Nicolas Dumoulin / Nicolas LeBlanc / Nicolas Seurot / Olivier Boëls / Olivier Coret / Olivier Grunewald / Olivier Morin / Olivier Touron / Pascal Aimar / Pascal Beaudenon / Pascal Kobeh / Pascal Maitre / Patrick Aventurier / Patrick Blanche / Patrick Chapuis / Patrick Desgraupes / Patrick Tourneboeuf / Paul Béjannin / Philippe de Poulpiquet / Philippe Henry / Pierre Adenis / Pierre Crom / Pierre Mohamed-Petit / Pierre Terdjman / Pierre Teyssot / Rafael Yaghobzadeh / Romain Laurendeau / Romain Sellier / Rose Lecat / Salomé Hévin / Samuel Gratacap / Sattler Alexandre / Sébastien Boué / Sébastien Le Clézio / Sébastien Leban / Sébastien Lebègue / Sébastien Salom-Gomis / Sidney Léa Le Bour / Sophie Garcia / Stéphane Lagoutte / Stephane Mahe / Sylvain Demange / Tadeusz Paczula / Thibault Vandermersch / Thomas Coex / Thomas Morel-Fort / Thomas Nicolon / Tim Franco / Valérie Savary / Valery Hache / Veronique de Viguerie / Véronique Roux Voloir / Victoire Mandonnaud / Vincent Tremeau / Viviane Dalles / William Keo / Xavier Desmier / Yann Castanier / Yoan Valat / Yves Gellie / Zannettacci Cyril / Zen Lefort

Georgia

Ana Kacheishvili / Mariam Amurvelashvili / Natia Rekhviashvili

Germany

Alexander Hassenstein / Alireza Parvin / Anke Waelischmillerann-Christine Woehrl / Anne Ackermann / Annette Hauschild / Annette Schreyer / Arnd Wiegmann / Bernd Lauter / Bettina Meister / Björn Kietzmann / Bo Van Wyk / Britta Jaschinski / Carsten Kalaschnikow / Carsten Peter / Christian Werner / Christian Ziegler / Christof Wolf / Christoph Löffler / Christoph Gerigk / Claudio Verbano / Corinna Kern / Dagmar Kielhorn / Daniel Chatard / Daniel Etter / Daniel Pilar / Daniel Reiter / David Baltzer / David Klammer / Dieter Leistner / Dietmar Scherf / Dmitrij Leltschuk / Dominik Butzmann / Emine Akbaba / Enno Kapitza / Enrico Fabian / Erik Hinz / Eva-Maria Horstick / Fabian Matzerath / Fabian Weiss / Fabrizio Bensch / Florian Bachmeier / Florian Manz / Florian Müller / Florian Ulrich / Frank Lehmann / Frank Schultze / Franziska Stünkel / Fredrik Von Erichsen / Friedrich Stark / Gerard Saitner / Hansjürgen Britsch / Harald Hauswald / Harald Keller / Harald Schmitt / Hartmut Reeh / Hartmut Schwarzbach / Hendrik Schmidt / Hermann Bredehorst / Holger Maass / Horst Friedrichs / Hubert Brand / Ingo Arndt / Ingo Otto / Jakob Schnetz / Jan Michalko / Jan Woitas / Jana Bauch / Jens Büttner / Jens Meyer / Jens Rosbach / Jens Schwarz / Jesco Denzel / Joerg Boethling / Jörg Friedrich / Jörg Modrow / Johannes Eisele / Jon Andoni Juarez Garcia / Jonas Opperskalski / Judith Jockel / Julia Gunther / Julius Schrank / Jürgen Fromme / Jürgen Veits / Kai Pfaffenbach / Kai Löffelbein / Kai Oliver Pfaffenbach / Kai Schwörer / Kai Wiedenhöfer / Karl-Josef Hildenbrand / Karsten Moran / Karsten Thielker / Kati Jurischka / Kirstin Schmitt / Klaus H. Daams / Kristina Steiner / Laci Perenyi / Lars Baron / Lars Berg / Lena Mucha / Louise Amelie Aljaž Fuis / Lucas Wahl / Luise Aedtner / Lukas Kreibig / Lukas Schulze / Magdalena Possert / Manuela Braunmüller / Marcel Koepper / Marcus Simaitis / Marcus Wiechmann / Maren Krings / Mark Muehlhaus / Markus Georg Reintgen / Marlena Waldthausen / Marlis Meergans / Martin Meissner / Martin Rose / Martin Specht / Matthias Schrader / Maximo Musielik / Melanka Helms / Michael Dalder / Michael Harker / Michael Jostmeier / Michael Nguyen / Michael Schwartz / Mika Volkmann / Moritz Mueller / Morris Mac Matzen / Murat Türemis / Nanna Heitmann / Nathalie Bertrams / Nick Jaussi / Noel Tovia Matoff / Norbert Schmidt / Olaf Schuelke / Oliver Görnandt-Schade / Oliver Weiken / Oliver Wolff / Patricia Kühfuss / Patrick Haar / Patrick Junker / Patrick Stollarz / Peter Schatz / Philipp Von Ditfurth / Ralf Hirschberger / Ralf Lienert / René Ruprecht / Reto Klar / Richard Thieler / Roberto Schmidt / Robin Hinsch / Roland Breitschuh / Roman Pawlowski / Rudi Meisel / Ruwen Möller / Sandra Hoyn / Sarah Pabst / Sascha Fromm / Sascha Rheker / Sebastian Backhaus / Sebastian Hofer / Sebastian Kahnert / Sebastian Wells / Sebastian Widmann / Sebi Berens / Selina Pfrüner / Soenke Christian Weiss / Solvin Zankl / Stefan Boness / Stefan Dauth / Stefan Richter / Stefanie Glinski / Stefanie Loos / Stephan Rabold / Stephanie Wunderl / Sven Zellner / Sven Creutzmann / Tamina-Florentine Zuch / Tanja Major / Thilo Schmülgen / Thomas P. Peschak / Thomas Pflaum / Thomas Rabsch / Thomas Schmidt / Till Rimmele / Tim Wagner / Tobias Gottschaldt / Toby Binder / Tom Krausz / Tom Vierus / Ulla Lohmann / Uwe Mann / Valeska Achenbach / Walter Fogel / Walter Schmitz / Wolfgang Borm / Wolfgang Noack / Xiomara Bender / Yvonne Seidel

Ghana

Dennis Akuoku-Frimpong / Geoffrey Buta / Selorm Attikpo

Greece

Alexandros Avramidis / Alexandros Katsis / Alexandros Maragkos / Alkis Konstantinidis / Angelos Tzortzinis / Anna Pantelia / Aris Messinis / Aristidis Vafeiadakis / Ayhan Mehmet / Costas Baltas / Costas Lakafossis / Daphne Tolis / Dimitri Mellos / Dimitris Michalakis / George Vitsaras / Georgios Makkas / Gerasimos Koilakos / Giorgos Moutafis / Giorgos Zachos / Kostas Argyris / Kostas Mantziaris / Louise Nylen / Nikolia Apostolou / Pinelopi Thomaidi / Savvas Karmaniolas / Socrates Baltagiannis / Stelios Misinas / Vangelis Bougiotis / Vassilis Makris / Yannis Behrakis / Yannis Kolesidis / Yannis Kontos

Guatemala

Alan Lima / Anyelo García / Carlos Paredes / Danilo Ramírez / Deccio Serrano / Edwin Bercian / Erick Sor / Esteban Biba / Gabriel Herrera / Johan Ordonez / Luis Echeverria / Moises Castillo / Sergio Izquierdo

Haiti

Homère Cardichon

Hong Kong

Billy H.C. Kwok / Chung Ming Ko / Geovien So / Hoi Kin Fung / Keith Chung / Kevin On Man Lee / Long Hei Chan / Siu Wai Lui / Yunxiang Xu / Yik Fei Lam

Honduras

Délmer Membreño / Elias Assaf / Esteban Felix / Orlando Sierra

Hungary

Adam Urban / Ákos Hegedűs / Akos Stiller / András Bánkuti / András Polgár / Arpad Kurucz / Attila Kisbenedek / Attila Németh / Balazs Beli / Balazs Gardi / Balazs Somorjai / Bence Mate / Daniel Kovalovszky / Esther Horvath / Géza Hernád / István András Juhász / Istvan Bielik / Istvan Csaba Santa / István Huszti / Janos Bodey / János Török / Joe Petersburger / Lajos Soós / Laszlo Szirtesi / László Végh / Márton Merész / Marton Monus / Milan Radisics / Norbert Hartyányi / Peter Komka / Peter Szalmas / Robert Szaniszló / Simon Móricz-Sabján / Tamas Paczai / Tamás Sóki / Zoltan Balogh / Zoltán Molnár / Zsolt Balázs / Zsolt Szigetvary

Iceland

Gísli Svendsen / Ólafur Steinar Gestsson / Vilhelm Gunnarsson

India

Aarti Singh / Abhijit Alka Anil / Abhijith Pulparambath / Aditya Ghosh / Aditya Kapoor / Adnan Abidi / Ajay Kumar / Altaf Qadri / Anand Bakshi / Anand Singh / Anirban Mandal / Ankit Mudgal / Aravind Venugopal / Arjit Sen / Arko Datto /

Arnab Chakraborty / Arun Chandrabose / Arvin Singh Uzunov Dang / Ashima Narain / Ashish Shankar Gupta / Avishek Das / Azhar Khan / Bhagirath Basnet / Bhanu Prakash Chandra / Bhupendra Rana / Biju Boro / C. Suresh Kumar / Chandan Khanna / Chirag Waakkar / C K Thanseer / Danish Siddiqui / Dave Nirav / Debajyoti Chakraborty / Debarchan Chatterjee / Debarshi Mukherjee / Debomit Chakraborty / Debsuddha Banerjee / Deepak Turbhekar / Deepesh Dixit / Dev Gogoi / Dhruba Jyoti Dutta / Dipankar Majumdar / Divyakant Solanki / Eshwar Shivanna / Faisal Bhat / Faisal Khan / Gajjela Sai Kumar / Goutam Roy / Harish Tyagi / Hemant Padalkar / Himanshu Vyas / Hitesh Harisinghani / Idrees Abbas / Indranil Bhoumik / Indranil Mukherjee / Irfan Dar / Jaipal Singh / Javed Dar / Javed Sultan / Jayesh P / Jitendra Prakash / Joydip Mitra / Kailashh Hirdode / Kunal Patil / Manoj Chemancheri / Mijannur Rahaman Gazi / Mohammed Favas K / Murali Krishnan / Muzamil Bhat / Nagesh Panathale / Nayan Khanolkar / Neeraj Priyadarshi / Neha Hirve / Nidhish Krishnan / Nikhil Raj / Pablo Bartholomew / Pattabi Raman / Prashanth Vishwanathan / Pratik Dutta / Praveen Khanna / Qasim Bazaz / Rajat Gupta / Rajib De / Rajivmalu / Raju Shinde / Raminder Pal Singh / Ranita Roy / Rashi Arora / Ravi Posavanike / Ravi Choudhary / Renuka Puri / Rijo Joseph / Ritesh Shukla / Rk Bhat / Robert Vinod / Rohit Jain / RS Gopan / Rupak De Chowdhuri / Sagar Shriskar / Sahiba Chawdhary / Sajeesh Sankar / Sampa Guha Majumdar / Samsul Huda Patgiri / Sandipan Chatterjee / Sanjay Ahlawat / Sanjoy Ghosh / Santosh Sharma / Sarang Sena / Sasi K. / Satya Thakur / Satyaki Ghosh / Saumya Khandelwal / Sayan Hazra / Shihab Pallikkal / Shivang Mehta / Showkat Shafi / Shrikant Singh / Shrirang Swarge / Siddharth Jain / Sivaram Venkitasubramanian / Subin Cheruthuruthy / Sudharmads Nr / Sudipto Das / Syed Muzaffar / Tanvi Sharma / Umar Ganie / Varun Kumar Mukhia / Vicky Roy / Vikramjit Kakati / Vishnu V Nair / Yashpal Rathore Singh / Yawar Nazir / Zafar Dar / Zhayynn James

Indonesia
Afriadi Hikmal / Agoes Rudianto / Agung Parameswara / Agung Rahmadiansyah / Ali Lutfi / Andika Wahyu / Anton Gautama / Arif Hidayah / Arimacs Wilander / Chaideer Mahyuddin / D Wisnu Widiantoro / Dhana Kencana / Donal Husni / Endra Rizaldi / Evi Aryati Arbay / Feri Latief / Fernando Randy / Gholib / Hafidz Mubarak Ahmad / Hariandi Hafid / Hendra Eka / Herka Yanis Pangaribowo / Iggoy El Fitra / Ignas Inyas Kunda / Iqbal Lubis / Irene Barlian / Jurnas Sukarno / Kuncoro Widyo Rumpoko / Made Nagi / Mas Agung Wilis Baskoro / Muhammad Adimaja / Muhammad Awaluddin Fajri / Nuktoh Kafrawi Kurdi / Nurul Hidayat / Poriaman Sitanggang / Putu Sayoga / Qodrat Al Qadri / Raditya Helabumi / Riza Fathoni / Rosa Panggabean / Seto Wardhana / Sutanta Aditya / Sutanto Nurhadi Permana / Suwandi Chandra / Tarko Sudiarno / Tatan Syuflana / Taufan Wijaya / Theo Aji / Ulet Ifansasti / Wisnu Agung Prasetyo / Yoppy Pieter / Yosua Marunduh / Yuli Seperi / Yuniadhi Agung / Yusni Aziz / Zulkifli

Iran
Abbas Mohammadi / Abdollah Heidari / Abdollah Safa / Abolfazl Neasei / Adel Pazyar / Ahmad Zohrabi Jamkarani / Ali Hamed Haghdoust / Ali Asaei / Ali Farshadmehr / Ali Khara / Ali Mohammadi / Ali Reza Goudarzi / Amin Mohammad Jamali / Amir Aslan Arfa Kaboudvand / Amir Hakimi / Amir Narimani / Arash Mollahasani / Arez Ghaderi / Aryadokht Jahanbakhshan / Asghar Khamseh / Ashkan Pordel / Ata Ranjbar Zeydanlou / Atefeh Motehayer Arani / Azad Amin Rashti / Azadeh Besharati / Azam Hasan Larijani / Azin Anvar Haghighi / Behrad Ghasemi / Behrouz Mehri / Borna Ghasemi / Enayat Asadi / Eshagh Aghaei /

Farshid Tighehsaz / Farzam Saleh / Forough Alaei / Galavizh Ahmadi / Hadi Zand / Hashem Shakeri / Hasti Kasraei / Hossein Fatemi / Hossein Kazemi / Hossein Sadri Nobarzad / Iman Jannati / Jalal Shamsazaran / Jamal Mortazavi / Javad Erfanian Aalimanesh / Javad Parsa / Javid Nikpour / Javid Tafazoli / Kaveh Rostamkhani / Keyvan Jafari / Khashayar Javanmardi / Kimiya Nik / Mahdi Barchian / Mahya Rastegar / Majid Asgaripour / Majid Ghohroodi / Majid Hojati / Mari Sayari / Marjan Yazdi / Maryam Kamyab / Maryam Rahmanian / Masoome Bahrami / Mehdi Nazeri / Mehrali Razaghmanesh / Mehrvarz Ahmadi / Mikaeel Bayazidi / Milad Rafat / Mina Noei Noshahr / Mohammad Ali Najib / Mohammad Babaei / Mohammad Barzegar / Mohammad Harooni / Mohammad Javad Abjoushak / Mohammad Reza Akhoondi / Mohammad Saffari / Mojtaba Esmaeilzad / Mona Hoobehfekr / Morteza Aminoroayayi / Morteza Jaberian / Nazanin Tabatabaee / Parisa Feyzollahi / Ramin Adl / Reza Ghasemi Zarnousheh / Rouzbeh Fouladi / Sadegh Souri / Sajad Safari / Sara Lalkamalian / Seyed Madyar Shojaeifar / Shahab Naseri / Shayan Hajinajaf / Shermin Nasiri / Sina Yaghoobpoor / Sina Taheri / Soheil Zandazar / Soran Qurbani / Tahmineh Godazgar / Vali Mohseni / Younes Khani / Zohre Sabagh Nejad

Iraq
Abdullah Dhiaa Al-Deen / Ahmed Al-Rubaye / Akam Shex Hady / Ari Jalal / Azad Lashkari / Gailan Haji / Hawre Khalid / Khaled Al-Mousily / Safa Alwan / Shvan Harki / Taisir Mahdi / Thaer Al-Sudani / Wissm Al-Okili / Younes Mohammad Abdolrahman

Ireland
Andrew McConnell / Brendan Moran / Bryan O'Brien / Caroline Quinn / Charles McQuillan / Clodagh Kilcoyne / Conor Horgan / David Fitzgerald / Deirdre Brennan / Denis Minihane / Douglas O'Connor / Eamon Ward / Eoin Noonan / Gary Carr / Ivor Prickett / Jacques Piraprez Nutan / James Crombie / John Kelly / Kieran Doherty / Mark Duffy / Morgan Treacy / Padraig O'Reilly / Paulo Nunes Dos Santos / Piaras Ó Mídheach / Ray McManus / Ray Ryan / Simon Roughneen / Stephen McCarthy / Steve Humphreys / Tommy Dickson

Israel
Abir Sultan / Alex Farfuri / Amir Cohen / Amir Levy / Amit Shaal / Ammar Awad / Ariel Tagar / Avishag Shaar-Yashuv / Dan Bar Dov / Daniel Elior / David Silverman / Denis Buchel / Eddie Gerald / Emil Salman / Eyal Yassky / Gil Cohen Magen / Gili Yaari / Guy Fattal / Hadas Itzkovitch / Hadas Parush / Jasmine Kayouf / Jorge Novominsky / Kobi Wolf / Lior Mizrahi / Marc Israel Sellem / Mati Milstein / Meged Gozani / Menahem Kahana / Michael Shvadron / Michel Braunstein / Nir Alon / Nir Gal-On / Nir Keidar / Oded Baililty / Ohad Zwigenberg / Oren Ben Hakoon / Oren Ziv / Oz Moalem / Pavel Wolberg / Rina Castelnuovo / Roie Galitz / Ronen Zvulun / Roni Ben Ari / Roy Rochlin / Shay Mehalel / Tomer Ifrah / Vardit Goldner / Yuval Chen / Ziv Koren

Italy
Agnese Morganti / Alberto Buzzola / Alberto Maretti / Alberto Pizzoli / Alessandro Annunziata / Alessandro Cinque / Alessandro D'Angelo / Alessandro Falco / Alessandro Gandolfi / Alessandro Grassani / Alessandro Penso / Alessandro Rota / Alessandro Trovati / Alessio Cupelli / Alessio Mamo / Alessio Paduano / Alessio Perboni / Alessio Romenzi / Alex Coghe / Alfredo Bini / Alfredo Bosco / Andrea Santese / Andrea Alai / Andrea Carboni / Andrea Falcon / Andrea Fantini / Andrea Frazzetta / Andrea Provenzano / Andrea Rizzi / Andrea Signori / Andrea Staccioli / Andreas Trenker / Angelo Calianno / Annalisa Marchionna / Annalisa Natali Murri / Annamaria Bruni / Antonella Marchini Antonello Nusca / Antonello

Veneri / Antonietta Baldassarre / Antonino Condorelli / Antonio Baiano / Antonio Busiello / Antonio Faccilongo / Antonio Gibotta / Attilio Solzi / Barbara Zanon / Beniamino Pisati / Bruno D'Amicis / Bruno Zanzottera / Camillo Pasquarelli / Carlo Bevilacqua / Carlo Gianferro / Carlo Pellegrini / Carolina Munzi / Carolina Paltrinieri / Chiara Dazi / Chiara Diomede / Chiara Goia / Chiara Tesser / Christian Mantuano / Christian Sinibaldi / Cinzia Canneri / Cinzia D'Ambrosi / Clara Vannucci / Claudia Gori / Claudia Manzo / Claudio Giovannini / Cristian Umili / Cristiano Minichiello / Cristina Cosmano / Daniela Sala / Daniele Badolato / Daniele Calisesi / Daniele Castellani / Daniele Vita / Daniele Volpe / Danilo Balducci / Danilo Campailla / Danilo Garcia Di Meo / Dario De Dominicis / David Brunetti / Davide Bertuccio / Davide Casella / Davide Monteleone / Diana Bagnoli / Diego Mayon / Diego Mola / Edoardo Agresti / Elena Perlino / Elisabetta Zavoli / Emanuele Camerini / Emanuele Satolli / Emiliano Grillotti / Emiliano Pinnizzotto / Enrico Genovesi / Enrico Mascheroni / Enzo Mistretta / Erberto Zani / Erik Messori / Fabian Albertini / Fabio Bucciarelli / Fabio Cuttica / Fabio Muzzi / Fabio Sasso / Fabrizio Annibali / Fabrizio Giraldi / Fabrizio Villa / Fausto Podavini / Federica Valabrega / Federico Vespignani / Federico Barattini / Federico Borella / Federico Caponi / Federico Serra / Filippo Trojano / Filippo Venturi / Francesca Ferrara / Francesca Leonardi / Francesca Magnani / Francesca Pompei / Francesca Semerano / Francesca Vieceli / Francesca Volpi / Francesco Anselmi / Francesco Bellina / Francesco Cilli / Francesco Pistilli / Francesco Rossi / Francesco Zizola / Fulvio Bugani / Gabriele Cecconi / Gabriele Duchi / Gabriele Galimberti / Gabriele Micalizzi / Gabriele Sciotto / Gaia Squarci / Gerardo Filocamo / Giacomo D'Orlando / Giacomo Palermo / Giampiero Assumma / Giancarlo Malandra / Gianluca Cecere / Gianmarco Maraviglia / Giorgio Palmera / Giorgio Scala / Giovanni Ambrosio / Giovanni Attalmi / Giovanni Capriotti / Giovanni Cipriano / Giovanni Del Brenna / Giovanni Di Cecca / Giovanni Diffidenti / Giovanni Lo Curto / Giovanni Mereghetti / Giovanni Minozzi / Giulia Lacolutti / Giulia Marchi / Giuliano Berti / Giuliano Koren / Giulio Di Sturco / Giulio Lelardi / Giulio Piscitelli / Giuseppe Chiantera / Giuseppe Chiucchiù / Giuseppe Fama / Giuseppe Nucci / Graziano Perotti / Guillermo Luna / Igor Petyx / Isabella De Maddalena / Isabella Franceschini / Italo Rondinella / Jacob Balzani Lööv / Jean-Marc Valentina Caimi / Piccinni / Karl Mancini / Laura Liverani / Laura Salvinelli / Laura Venezia / Lavinia Parlamenti & Manfredi Pantanella / Leonardo Brogioni / Linda Dorigo / Livio Mancini / Lombezzi Martino / Lorenzo Grifantini / Lorenzo Moscia / Lorenzo Poli / Lorenzo Tugnoli / Losan Piatti / Luca Bracali / Luca Catalano Gonzaga / Luca Fontana / Luca Locatelli / Luca Neve / Luca Nizzoli / Luca Santese / Luca Venturi / Luciano del Castillo / Luigi Avantaggiato / Manfredi Pantanella / Manuel Goria / Manuela Schirra / Marcello Bonfanti / Marco Albertini / Marco Cantile / Marco Carmignan / Marco Casino / Marco Erba / Marco Garofalo / Marco Gualazzini / Marco Longari / Marco Massai / Marco P. Valli / Marco Panzetti / Marco Sacco / Marco Valle / Marco Zorzanello / Maria Laura Antonelli / Marika Bertoni / Mario Bucolo / Mario Laporta / Massimiliano Donati / Massimo Barberio / Massimo Paolone / Massimo Pellone / Massimo Podio / Massimo S. Volonte / Massimo Sciacca / Massimo Spinolo / Matteo Bastianelli / Matteo Chinellato / Matteo Franchi / Mattia Passarini / Mattia Vacca / Mattia Velati / Mattia Zoppellaro / Maurizio Di Pietro / Mauro De Bettio / Mauro Donato / Max Rossi / Max Rum / Michele Cattani / Michele Lapini / Michele Piscitelli / Michele Amoruso / Michele Pavana / Michele Spatari / Monika Bulaj / Nanni Fontana / Nicola Zolin / Nicolo Filippo Rosso / Nicoló Lanfranchi / Oskar Landi / Paolo Patrizi / Paolo Verzone / Paolo Bona / Paolo Manzo / Paolo Marchetti / Paolo Vezzoli / Patrick Russo / Pierluigi

Giorgi / Pierpaolo Mittica / Pietro Di Giambattista / Pietro Masturzo / Pio De Rose / Raffaele Petralla / Renatore Magnoli / Riccardo Dalle Luche / Riccardo Pareggiani / Roberto Brancolini / Roberto Colacioppo / Roberto Fumagalli / Roberto Isotti / Roberto Nistri / Rocco Rorandelli / Romano Antonio Maniglia / Rosa Mariniello / Roselena Ramistella / Salvatore Allegra / Salvatore Cavalli / Salvatore Esposito / Sandro Maddalena / Sara Casna / Sara Mignogna / Savino Paolella / Sergio Pitamitz / Sestino Letizia / Siegfried Modola / Silvia Alessi / Silvia Dogliani / Silvia Landi / Simona Bonanno / Simone Dalmasso / Simone Cerio / Simone Migliaro / Simone Padovani / Simone Perolari / Simone Tramonte / Stefano Butturini / Stefano Gerardi / Stefano Guidi / Stefano Lemon / Stefano Miliffi / Stefano Montesi / Stefano Morelli / Stefano Schirato / Stefano Spaziani / Stephanie Gengotti / Sulejman Bijedic / Tiziana Fabi / Tommaso Protti / Tommaso Rada / Turi Calafato / Valentina Piccinni / Valentina Sinis / Valentina Tamborra / Valeria Scrilatti / Valerio Bispuri / Valerio Nicolosi / Victor Serri / Villani Laura / Vincenzo Bruno / Vincenzo Floramo / Vincenzo Massimiani / Vincenzo Metodo / Vincenzo Montefinese / Vito Finocchiaro / Vito Fusco / Vittore Buzzi / Vittorio Daniele / Vittorio Zunino Celotto / Viviana Peretti

Ivory Coast
David Ehl / Ina Fassbender / Markus Schreiber / Stefan Gregor

Jamaica
Ruddy Roye

Japan
Akira Suemori / Atsushi Taketazu / Dai Kurokawa / Daisuke Wada / Hiroko Masuike / Hiroto Sekiguchi / Hiroyuki Taira / Hiroyuki Watanabe / Hisato Kawashima / I. Mattigo / Jun Yasukawa / Kazuhiko Matsumura / Kazuhiro Nagashima / Kenichi Unaki / Kenji Konoha / Kentaro Ikushima / Koji Aoki / Kyo Shimizu / Masayuki Terazawa / Nadezda Melikhova / Naoko Kawamura / Noriko Hayashi / Rei Kubo / Rei Shiva / Ryuzo Suzuki / Satoshi Takahashi / Shigetaka Kodama / Shiho Fukada / Shiro Nishihata / Shohei Miyano / Suo Takekuma / Taichi Kaizuka / Takaaki Iwabu / Takao Ochi / Takashi Aoyama / Takashi Nakagawa / Takashi Ozaki / Takuma Nakamura / Teruo Kashiyama / Tetsuro Takehana / Tomoko Yasuda / Toru Hanai / Tsuyoshi Matsumoto / Tsuyoshi Yamamoto / Yasuhiro Sugimoto / Yasuyoshi Chiba / Yohei Koide / Yoshi Shimizu / Yosuke Fukudome / Yosuke Kashiwakura / Yuki Miyatake

Jordan
Muhammed Muheisen / Tanya Habjouqa

Kazakhstan
Grigoriy Bedenko

Kenya
Brian Otieno / Daniel Irungu / Don Wilson Odhiambo / Emily Rosa Lerosion / Georgina Goodwin / Gordwin Odhiambo / Joseph Kipsang / Louis Nderi / Phoebe Okall / Shalet Mkamzungu / Thomas Mukoya / Zollo Nyambu

Kuwait
Khalil Hamra

Kyrgyzstan
Artur Bolzhurov / Erkin Bolzhurov

Latvia
Natalija Gormalova

Lebanon
Fadi El Binni / Hassan Ammar / Marwan Naamani / Saër Karam

Libya
Hani Amara

Liechtenstein
Peter Klaunzer

Lithuania
Alfredas Pliadis / Andrius Repsys / Marius Mork / Paulius Peleckis / Ramunas Danisevicius / Tadas Kazakevicius / Valentinas Pecininas

Luxembourg
Jonas Staselis

Macedonia
Boris Grdanoski / Georgi Licovski / Marija Dang

Madagascar
Rija Emadisson

Malaysia
Adi Safri / Ahmad Yusni / Aizuddin Saad / Art Chen / Chen Wei / Chong Voon Chung / David ST Loh / Firdaus Latif / Glenn Guan / Jeffry Lim / Kah Meng Lek / Mohd Samsul Mohd Said / Muhamed Fathil Asri / Nick Ng / Rasfan Mohd / Riduan Rizal Ahmad / Sengeelong Tan / Sengsin Lai / Stefen Chow / Tuck Mun / Vivian Lo Sook Mun

Mali
Hadama Diakite / Hamdia Traoré / John Kalapo / Souleymane Ag Anara

Malta
Darrin Zammit Lupi

Mauritius
Kadrewvel Pillay Vythilingum / Sunita Beezadhur

Mayotte
Gabriel Barathieu

Mexico
Adam Wiseman / Adriana Escamilla / Alan Rodríguez / Alejandro Cossio / Alejandro Gutierrez / Alejandro Prieto / Alfredo Estrella / Alicia Vera / Angel Hernandez / Angel Omar Saucedo García / Antonio Busqueta / Anuar Patjane Floriuk / Armando Santibáñez Romellón / Armando Solís / Bénédicte Desrus / Carlos Jasso / Carlos Cazalis / Carlos González / Carlos Santiago / Christian Vizl / Christopher Vanegas / Claudia Guadarrama / Claudio Contreras Koob / Cristopher Rogel Blanquet Chavez / David Guzmán González / David Polo / Demian Chávez / Diego Uriarte / Duilio Rodríguez / Eduardo Jaramillo Castro / Eliud Gil Samaniego / Elizabeth Dalziel / Emilio Espejel / Enrique Castro Sánchez / Esteban González de León Y León / Felipe Luna / Felix Marquez / Fernando Gutierrez Juarez / Flor Castañeda / Gabriela Olmedo / Genaro Limon / Gerardo Flores / Guillermo Arias / Guillermo de Avila / Hector Guerrero / Isaac Esquivel Monroy / Jair Cabrera / James Rodriguez / Javier Rojas / Joaquín Sanluis Farfán / Joel Sampayo Climaco / Johana Kim / Jorge Silva / Jorge Villalpando / José Luna / Jose Jimenez / Jose Luis Magana / Jose Velasco / Jozef Ibarr / JP Ampudia / Karina Tejada / Koral Carballo / Luis Antonio Rojas / Luis Villalobos / Marcos Moreno / Massiel Hernández / Mauricio Palos / Monica Gonzalez / Narciso Contreras / Octavio Aburto / Oliver de Ros / Pablo Salazar / Pedro Pardo / Rafael del Río / Roberto Hernandez / Rodrigo Jardón Gal / Santiago Billy / Ulises Martinez / Verónica G. Cárdenas / Victor Medina / Victoria Razo / Yael Martínez

Monaco
Nick Danziger

Mongolia
Rentsendorj Bazarsukh

Morocco
Elbakri Abdellah / Hind Bouqartacha / Karim Achalhi / Mosa'ab Elshamy / Seif Kousmate

Mozambique
David Aguacheiro / Yiannis Kourtoglou

Myanmar
Hkun Lat / Ko Myo / Minzayar Oo / Nyein Chan Naing / Soe Zeya Tun / Thet Htoo / Ye Aung Thu / Zarni Phyo

Namibia
Karel Prinsloo / Robert Gongoll

Nepal
Barsha Shah / Bijaya Rai / Deepak Tolange / Gagan Thapa Magar / Nabin Baral / Narayan Maharjan / Navesh Chitrakar / Suresh Mukhiya / Susheel Shrestha / Tripty Tamang Pakhrin / Uma Bista

The Netherlands
A.M. van der Heijden / Adrie Mouthaan / Alex Kemman / Alexander Schippers / Alice de Kruijs / Alice Wielinga / Amit Bar / Andreas Terlaak / Annabel Oosteweeghel / Annie van Gemert / Arie Kievit / Arjan Bronkhorst / Bart Hoogveld / Bas de Meijer / Bert Wieringa / Bianca Sistermans / Birgit Schuch / C.J.J.M. Sparidaens / Carla Kogelman / Carla van de Puttelaar / Cees Glastra van Loon / Chantal Heijnen / Chris Keulen / Cigdem Yuksel / Cris Toala Olivares / Cynthia Boll / Daniel Maissan / David van Dam / Dirk-Jan Visser / Eline van Nes / Ellis Doeven / Elsbeth Tijssen / Emile Luider / Eran Oppenheimer / Eric Brinkhorst / Erik Hijweege / Erik van 't Woud / Flip Franssen / Friso Spoelstra / Gerdien Wolthaus Paauw / Guillaume Groen / Hadas Itzkovitch & Anya van Lit / Hans Gerritsen / Hans Kemp / Harry Heuts / Henk Bothof / Hossein Fardinfard / Humberto Tan / Huub Keulers / Ilvy Njiokiktjien / Inge van Mill / Ingrid Koedood / Irene van Nispen Kress / Jan Everhard / Jan Janssen / Jan Mulders / Jasper Doest / Jasper Juinen / Jeroen Toirkens / Jeroen van Loon / Jildiz Kaptein / Johan Hahn / John Gundlach / Joris Knapen / Joris van Gennip / Kadir van Lohuizen / Kees van de Veen / Kjeld Duits / Louise Honée / Lukas Göbel / Maartje Brockernd / Marieke van der Velden / Marielle van Uitert / Marinka Masséus / Marlies Wessels / Merlin Daleman / Michael Rhebergen / Michiel van Noppen / Milan Gies / Mona van den Berg / Nick Gammon / Nico Bastens / Olaf Kraak / Patrick Post / Patrick van Gemert / Peter Lous / Petra van Velzen / Piet Hermans / Pieter Ten Hoopen / Pim Ras / Rachel Corner / Ramon Mangold / René Clement / Robbert Wijtman / Robin Utrecht / Roger Waleson / Ronnie Dankelman / Ruben Hamelink / Sander de Wilde / Sandra Minten / Saskia Aukema / Sinaya Wolfert / Susan Leurs / Theo Bosboom / Theo Captein / Vincent Riemersma / Willeke Duijvekam

New Zealand
Amos Chapple / Braden Fastier / Charlotte Anderson / Cornell Tukiri / Hannah Peters / Iain McGregor / Jiongxin Peng / John G. Cosgrove / Joseph Harrison / Kent Blechynden / Martin de Ruyter / Martyn Aim / Max Reeves / Richard Robinson / Robin Hammond / Scott Barbour / Staton Winter / Stephen Jaquiery

Nicaragua
Alfredo Zuniga / Carlos Herrera / Inti Ocon / Oscar Navarrete / Oscar Sánchez / Oswaldo Rivas

Nigeria
Etinosa Yvonne Osayimwen / Adetona Omokanye / Afolabi Sotunde / Andrew Esiebo / Benson Ibeabuchi / Cletus Nwadike / Fati Abubakar / Ismail Folaranmi Odetola / Kene Nwatu / Kingston Daniel / Kunle Ajayi / Mayor Otu / Nguveren Ahua / Obasola Bamigbola / Odutayo Odusanya / Okeoghene Onogbo / Ovinuchi Ejiohuo / Sir Inyene / Yagazie Emezi

Norway
Aleksander Nordahl / Andrea Gjestvang / Christian Belgaux / Eirik Grønningsæter / Espen Rasmussen / Gøran Bohlin / Helge Skodvin / Jarle Aasland / John

T. Pedersen / Johnny Haglund / Jon Olav Nesvold / Katinka Hustad / Ken Opprann / Linda Bournane Engelberth / Mariann Dybdahl / Monica Strømdahl / Odd Andersen / Paal Audestad / Pål Hansen / Pål Hermansen / Patrick Da Silva Sæther / Paul S. Amundsen / Sigurd Fandango / Sølvi Iren Wessel-Berg / Terje Bringedal / Therese Alice Sanne / Tine Poppe / Tomm Wilgaard Christiansen / Vegard Wivestad Grøtt

North Korea
Hee Moon

Pakistan
Mariam Magsi / Saeed Khan / Saiyna Bashir / Syed Murtaza Ali / Yasir Mehmood

Palestine
Abed Al Hashlamoun / Adel Hana / Ahmad Gharabli / Ahmad Hasaballah / Ahmed Jadallah / Ahmed Zakot / Ali Jadallah / Ashraf Amra / Eman Mohammed / Ibraheem Abu Mustafa / Issam Rimawi / Laura Boushnak / Mahmoud Issa / Mahmud Hams / Mohammed Asad / Mohammed Salem / Mohammed Talatene / Mustafa Hassona / Mustafa M.B. Hassouna / Saber Nureldine / Said Khatib / Suhaib Salem / Wissam Nassar

Panama
Adriano Duff

Peru
Alexis Huaccho / Angela Ponce / Carlos García Granthon / César Fernando Garcia Lanfranco / Edson Flores / Eitan Abramovich / Francesca Florian / Gihan Tubbeh / Hector Emanuel / Hugo Curotto / Liz Tasa / Máx Cabello Orcasitas / Miriam Moreno / Moises Saman / Pilar Pedraza / Rochi León / Sebastian Montalvo / Silvia Izquierdo / Wilfredo Fernandez

The Philippines
Aaron Favila / Alexis Carlo Corpuz / Claro Cortes IV / Czar Dancel / Ezra Acayan / Francis Malasig / George Calvelo / Hannah Maria Carmina Reyes / Jerome Ascaño / Jes Aznar / Jun Ryan Arañas / Kimberly dela Cruz / KJ Rosales / Linus Escandor II / Lynzy Billing / Mark Balmores / Martin Jhudiel San Diego / Raffy Lerma / Ritchie B. Tongo / Veejay Villafranca / Victor Kintanar / Xyza Cruz Bacani

Poland
Magdalena Chodownik / Adam Guz / Adam Jankowski / Adam Warżawa / Aleksandra Dynas / Aleksandra Szmigiel / Andrzej Banaś / Andrzej Bocheński / Andrzej Grygiel / Anna Gondek-Grodkiewicz / Anna Liminowicz / Arkadiusz Kubisiak / Arkadiusz Ławrywianiec / Artur Widak / Bartłomiej Jurecki / Bartłomiej Muszyński / Bartosz Hołoszkiewicz / Bartosz Mateńko / Bartosz Rozalski / Beata Zawrzel / Daniel Frymark / Darek Delmanowicz / Dawid Stube / Dawid Zieliński / Dominik Gajda / Dominik Śmiałowski / Dominika Drabik / Filip Błażejowski / Grażyna Makara / Grzegorz Banaszak / Grzegorz Celejewski / Grzegorz Wójcik / Hanna Jarząbek / Igor Szokalski / Jacek Fota / Jacek Kusz / Jacek Labedzki / Jacek Szydłowski / Jacek Turczyk / Jadwiga Figula / Jakub Gadek / Jakub Porzycki / Jakub Włodek / Jan Klos / Jędrzej Nowicki / Joanna Kosowska / Joanna Mrówka / Joanna Nowicka / Józef Skrzeczkowski / Julia Zabrodzka / Kacper Kowalski / Kamil Szumotalski / Karina Krystosiak / Karolina Jonderko / Katarzyna Idźkowska / Katarzyna Mrugała / Krystian Dobuszyński / Krzysztof Gołuch / Leszek Pilichowski / Łukasz Cynalewski / Łukasz Szelag / Maciej Luczniewski / Maciej Mężczyźni / Maciej Nabrdalik / Maciek Iwaniszewski / Maciek Jazwiecki / Magdalena Wosińska / Maksymilian Rigamonti / Marcin Bielecki / Marcin Kadziolka / Marcin Karczewski / Marcin Zaborowski / Marek M. Berezowski / Marek Maliszewski / Marek Zakrzewski / Mariusz Smiejek / Martyna Bec /

Marzena Wystrach / Mateusz Baj / Mateusz Grochocki / Mateusz Ochocki / Mateusz Skwarczek / Michał Adamski / Michał Korta / Michal Kosc / Michal Obrycki / Michał Ryniak / Michal Siarek / Michał Sita / Michal Solarski / Mikolaj Nowacki / Mirosław Pieślak / Monik Stolarska / Natalia Fedorczenko / Pawel Laczny / Paweł Piotrowski / Paweł Starzec / Piotr Bieniek / Piotr Jaruga / Piotr Nowak / Piotr Wittman / Piotr Zwarycz / Radek Pietruszka / Rafał Klimkiewicz / Sebastian Szwajkowski / Selim Korycki / Sławomir Olzacki / Sławomir Rzewuski / Stanislaw Kusiak / Szymon Barylski / Tomasz Czechowski / Tomasz Gzell / Tomasz Lazar / Tomek Deko / Tomek Kozłowski / Tytus Kondracki / Waldemar Stube / Weronika Murray / Wojciech Grzędziński / Wojciech Matusik / Wojciech Pacewicz

Portugal
Adelino Meireles / André Alves / Armindo Cerqueira / Beatriz Pereira / Bruno Colaço / Bruno Ribeiro / Carlos Alberto Santos Costa / Carlos Pimentel / César Lomba / Eduardo Leal / Francisco Antunes / Gonçalo Delgado / Gonçalo Fonseca / Gonçalo Lobo Pinheiro / Janeth Tavares / Jose Fragozo / Jose Sergio / Luis Barbosa / Luís Godinho / Marcos Sobral / Mário Cruz / Pedro Fiuza / Pedro Narra / Pedro Noel Da Guerreiro / Pedro Nunes / Raquel Wise / Reinaldo Rodrigues / Ricardo Ramos / Rodrigo Cabrita / Rui Caria / Rui Duarte Silva / Rui Oliveira / Zed Jameson

Puerto Rico
Christopher Gregory / David 'Dee' Delgado / Erika P. Rodriguez / Gabi Perez-Silver

Romania
Alecsandra Raluca Dragoi / Amnon Gutman / Andreea Campeanu / Andrei Pungovschi / Dan Giurca / Dragos Lumpan / Ganea Octov / Ioana Moldovan / Iulian Pascaluta / Maria Sturm / Mircea Restea / Mugur Varzariu / Petrut Calinescu / Raul Stef / Tudor Martalogu / Vadim Ghirda

Russia
Aleksandr Miridonov / Aleksandra Komova (Polukeeva) / Aleksey Maishev / Alex Kudenko / Alexander Aksakov / Alexander Isaev / Alexander Ulianenko / Alexander Vedernikov / Alexandr Kryazhev / Alexey Nikolsky / Alexey Filippov / Alexey Kompaniychenko / Alexey Kunilov / Alexey Malgavko / Alexey Vasilyev / Alyona Kochetkova / Anastasia Rudenko / Anastasia Shpilko / Andrey Arkhipov / Andrey Chepakin / Andrey Rudakov / Andrey Zadorojny / Anna Ivantsova / Anna Sadovnikova / Anna Zekria / Anton Unitsyn / Anton Vaganov / Artem Dergunov / Artemiy Ivanov / Artur Novositsev / Daria Isaeva / Daria Klimasheva / Daria Nazarova / Denis Sinyakov / Dmitrii Lebedev / Dmitriy Chelyapin / Dmitry Azarov / Dmitry Berkut / Dmitry Kostyukov / Dmitry Serebryakov / Donat Sorokin / Eduard Korniyenko / Ekaterina Soloviea / Elena Chernyshova / Elena Khovanskaya / Elena Oskina / Eugenia Bakunova / Evgeni Epanchintsev / Evgeniya Zhulanova / Evgeny Andreev / Evgeny Evgeny / Evgeny Stetsko / Filippo Valoti Alebardi / Fyodor Savintsev / Fyodor Telkov / Gennadiy Gulyaev / Georgiy Orlov / Gleb Shchelkunov / Grebnev Dmitriy / Grigory Sysoev / Igor Gruzdev / Igor Ivanko / Igor Maleev / Igor Tereshkov / Ilya Naymushin / Ilya Pitalev / Irina Kalashnikova / Irina Motina / Julia Galushina / Julia Lisnyak / Kamil Aysin / Katerina Savina / Kirill Gorelov / Kirill Kudryavtsev / Kirill Umrikhin / Konstantin Zavrazhin / Kristina Brazhnikova / Kristina Shakht / Kristina Syrchikova / Ksenia Leksakova / Kseniia Ivanova / Kseniia Kuleshova / Leonid Shcheglov / Ludmila Kovaleva / Maria Plotnikova / Maria Tikhonova / Marina Kruglyakova / Mary Gelman / Max Avdeev / Maxim Babenko / Maxim Korotchenko / Maxim Shemetov / Maxim Zmeyev / Mike Kolesnikov / Mikhail Grebenshchikov / Mikhail Sinitsyn / Nadezhda Ermakova / Natalia

Gorshkova / Natalia Volvach / Nataliya Makarova / Nigina Beroeva / Nikita Teryoshin / Nina Padalko / Oksana Yushko / Oleg Kargapolov / Oleg Konstantinov / Oleg Lastochkin / Olga Maltseva / Pavel Bednyakov / Pavel Volkov / Raisa Mikhaylova / Roman Balaev / Roman Demyanenko / Roman Kruchinin / Sasha Arutyunova / Sergei Gazetov / Sergei Ilnitsky / Sergei Kivrin / Sergey Bobylev / Sergey Golovach / Sergey Maximishin / Sergey Mikheev / Sergey Nazarov / Sergey Novikov / Sergey Parshukov / Sergey Ponomarev / Sergey Schcekotov / Sergey Shakuto / Sergey Vdovin / Stanislava Novgorodtseva / Svetlana Bulatova / Tatiana Malysheva / Tatiana Valko / Vadim Elistratov / Valentin Ilyushin / Valery Melnikov / Valery Sharifulin / Valya Egorshin / Varya Kozhevnikova / Victor Berezkin / Viktor Lyagushkin / Vladimir Astapkovich / Vladimir Vyatkin / Vladimir Finogenov / Vladimir Lamzin / Vladimir Pesnya / Vladimir Tereshkov / Vladimir Velengurin / Vladislav Aznaurov / Yulia Nevskaya / Yuliya Gaysina / Yuliya Skorobogatova / Yuri Smityuk / Yuri Kozyrev / Yuri Strelets / Yuri Tutov / Yury Kochetkov / Yury Soldatov / Zhannet Shershitskaya

Rwanda
Jean Luc Habimana

Saudi Arabia
Iman Al-Dabbagh / Tasneem Alsultan

Serbia
Aleksandar Dimitrijevic / Aleksandar Plavevski / Dusko Despotovic / Goran Tomasevic / Igor Pavicevic / Jelena Jankovic / Jelena Žigić / Marko Djurica / Marko Drobnjakovic / Marko Risovic / Nemanja Pancic / Predrag Dedijer / Saša Čolić / Sava Radovanovic / Tanja Valic / Vladimir Zivojinovic

Sierra Leone
Ngadi Smart / Sierra Nallo

Singapore
Charmaine Poh / Chih Wey Then / Daniel Neo / Gavin Foo / How Hwee Young / Huiying Ore / Hwee Young How / Jonathan Yeap / Joseph Nair / Kelvin Chng / Kevin Lim / Laurence Tan / Lionel Ng / Marissa Chen / Matthew Aslett / Mindy Tan / Ranjan Ramchandani / Suhaimi Abdullah / Weejin Ong / Yaohui Lim / Zann Huizhen Huang

Slovakia
Andrea Zvadova / Ján Husár / Jana Rajcova / Joe Klamar / Jozef Jakubčo / Matus Zajac / Michal Svítok / Rene Fabini / Tomáš Halász / Vladimír Šimíček

Slovenia
Andrej Tarfila / Dejan Mijović / Jaka Gasar / Luka Dakskobler / Maja Hitij / Matic Zorman / Matjaž Krivic / Matko Mioč / Samo Vidic / Simon Plestenjak / Tadej Znidarcic / Tina Dokl / Voranc Vogel

Somalia
Feisal Omar / Ismail Taxta

South Africa
Adrian de Kock / Angus Begg / Brent Stirton / Brenton Geach / Graham De Lacy / Gulshan Khan / Iga Motylska / James Oatway / John Wessels / Joy Meyer / Julian Goldswain / Justin Sullivan / Karabo Mooki / Kim Ludbrook / Lee-Ann Olwage / Leon Lestrade / Lulama Zenzile / Marc Shoul / Michel Bega / Mpumelelo Buthelezi / Mujahid Safodien / Nardus Engelbrecht / Nic Bothma / Pieter Bauermeister / Reatile Moalusi / Rodger Bosch / Samuel Shivambu / Shayne Robinson / Siphiwe Sibeko / Tebogo Letsie / Werner Hills

South Korea
Byeongsik Lim / Choi Dong Jun / Chris Jung / Chung Sungjun / Heonkyun Jeon / Hongji Kim / Hongji Kim /

Jaeho Kim / Jewon Lee / Jiyun Jeong / Jinsub Cho / Joonhee Shin / Jun Michael Park / Jung Hanjo / Kyungjoon Kim / Sangyun Ha / Seongjoon Cho / Sol Hong / Sungbong Cho / Woohae Cho / Woongjae Shin / Yoojin Choi

Spain

Abargues Abargues / Abel Ruiz de León / Agustín Iglesias Otero / Aitor Garmendia / Aitor Lara / Albert Busquets Plaja / Alberto Cob / Alberto del Hoyo Mora / Alberto Di Lolli / Alberto Estévez / Alberto Hugo Rojas Luque / Alcorta Hernández / Alejandro Martinez Velez / Álex Cámara / Alexander Cabeza Trigg / Alvaro Ybarra Zavala / Alvaro Barrientos / Alvaro Fuente / Álvaro Hurtado Molero / Alvaro Laiz / Álvaro Minguito / Amador Guallar / Ana Yturralde / Andoni Lubaki / Andres Martinez Casares / Angel Fitor / Angel Garcia / Ángel López Soto / Angel Luis Navarrete Cuervo / Anna Surinyach Garcia / Antonio Lopez Diaz / Antonio Pérez / Armando Franca / Bernat Armangue / Jesús Blasco de Avellaneda / Bruno A-Thevenin / Carlos de Andrés / Carlos Folgoso Sueiro / Carlos Gil / Carolina Sánchez-Monge Escardó / Celestino Arce / Celia Atset / Cesar Dezfuli / Christelle Enquist / Clara Margais / Claudia Frontino / Cristina de Middel / Cristobal Castro / Dani Gago / Dani Salvà / Daniel Fernandez / Daniel González Acuña / Daniel Ochoa De Olza / David González / David Guillen / David Julià Etxabe / David López Córdoba / David Mudarra / David Oliete Casanova / David Ramos / David Salcedo / Delmi Alvarez / Diego Ibarra / Diego Martínez / Diego Sperani / Dino Geromella / Dune Solanot / Edu Bayer / Eduleón / Eduardo Dieguez San Bernardo / Eduardo Sanz Nieto / Elias Regueira / Eloy Alonso / Emilio Fraile / Emilio Lavandeira / Emilio Morenatti / Encarni Pindado / Enrique Escandell / Erasmo Rafael Fenoy Nuñez / Eva Filgueira / Eva Parey / Felipe Carnotto / Felipe Hernandez Duran / Felipe Trueba / Fermin Rodriguez / Francis Perez / Francisco Seco / Gabriel Tizón / Gonzalo Pérez Mata / Ignacio Marin / Isidre Garcia Puntí / Iván Benítez / Jaime Rojo / Javi Enjuanes / Javier Arcenillas / Javier Aznar González de Rueda / Javier Bauluz / Javier Fergo / Javier Martínez / Javier Teniente / Jesús F. Salvadores / Jesús G. Pastor / JM Lopez / Joan de la Malla / Joan Valls / Joaquín Gómez Sastre / Jon Nazca / Jordi Boixareu / Jordi Cohen / Jordi Play Garcia Coll / Jordi Ruiz Cirera / Jorge Gonzalez / Jorge López Muñoz / Jose Antonio Peral / José Aymá / Jose Luis Mendez Fernandez / Jose Luis Rodriguez / Jose Maria Mercado Montero / Jose Miguel Sierra Arostegui / José Miguel Cerezo Sáez / José Pascual Gil Rubio / Juan Haro Simarro / Juanjo Fernández / Julia Martínez Fernández / Julián Rus / Laia Ros Padullés / Lídia Larrosa Ribell / Lluis Busse / Lluís Salvadó / Lucas Vallecillos Molero / Luis Tato / Manu Brabo / Manu Cecilio / Manuel Lorenzo / Manuel Medir Roca / Marcos Moreno / Maria Contreras Coll / Mario Llorca Loureiro / Mario Valverde / Mariona Giner / Markel Redondo / Marta Pascual Juanola / Martí Albesa Castañer / Martí Fradera / Matías Costa / Maysun Abu-Khdeir Granados / Mdolors G-Luumkab / Miguel Candela / Mikel Ponce / Mikel Prieto / Nacho Hernández / Natalia Sancha Garcia / Nicolás Rodríguez Crespo / Filming For Liberation / Nuria López Torres / Olmo Calvo / Omar Havana / Oriol Segon Torra / Oscar del Pozo / Oscar Dominguez / Pablo Blazquez Dominguez / Pablo Chacón / Pablo Cobos / Pablo Garcia Sacristan / Pablo Lasaosa / Pablo Lorente / Pablo Miranzo Macià / Patricia Esteve / Patrick Meinhardt / Patxi Uriz / Pau Barrena / Pedro Acosta / Pedro Luis Ajuriaguerra Saiz / Pep Escoda / Quintina Valero / Rafael Marchante / Ramon Espinosa / Ramon Costa / Raúl Gallego Abellán / Raul Barbero Carmena / Raúl Belinchón Hueso / Raúl Moreno / Ricardo García Vilanova / Rober Astorgano / Rodrigo Jimenez Torrellas / Roger Grasas / Rubén Salgado Escudero / Samuel Aranda / Samuel de Román / Sandra Balsells / Santi Palacios / Sebastián Liste Vicario / Sergi

Camara / Sergi Escribano / Sergio Basi Alfonso / Sergio Enríquez Nistal / Sergio Rodriguez / Sofia Moro / Sonia Giménez Bellaescusa / Sumy Sadurni / Susana Girón / Susana Romero Fernandez / Susana Vera / Tarek Halabi Alonso / Teófilo Valente / Teresa Palom / Tino Soriano / Tomas Calle / Toni Arnau / Ugo Mellone / Victor Fraile / Xavier Bertral / Xoan A. Soler

Sri Lanka

Ashane Marasinghe / Buddhika Weerasinghe / Lakshitha Karunarathna

Sudan

Mohamed Altoum

Sweden

Åke Ericson / Anders Forngren / Anders Hansson / Andreas Bardell / Anette Nantell / Åsa Sjöström / Axel Öberg / Björn Larsson Rosvall / Carl Sandin / Chris Maluszynski / Christian Åslund / Daniel Malmberg / Daniel Nilsson / David Joakim Wedholm / Elin Berge / Elisabeth Ubbe / Eva Tedesjö / Fredrik Lerneryd / Hanna Brunlöf / Jack Mikrut / Jimmy Wixtröm / Joachim Wall / Joel Marklund / Jonas Lindkvist / Jonathan Näckstrand / Karl Göran Zahedi Fougstedt / Katarina Premfors / Lars Brundin / Lina Larsson / Lola Akinmade Åkerström / Lotta Härdelin / Magnus Sandberg / Magnus Wennman / Martin Edström / Meli Petersson Ellafi / Michael Svensson / Niclas Hammarström / Nils Petter Nilsson / Nora Lorek / Olle Nordell / Olof Jarlbro / Paul Hansen / Pavel Koubek / Peter Holgersson / Petter Arvidson / Pontus Orre / Roger Larsson / Roger Turesson / Simon Johansson / Staffan Widstrand / Stefan Jerrevång / Stig Torbjorn Selander / Thomas Karlsson / Thomas Nilsson / Troy Enekvist / Urban Andersson / Vilhelm Stokstad

Switzerland

Adrian Moser / Alfio Tommasini / Anna Pizzolante / Anthony Anex / Beat Schweizer / Chris Schmid / Christian Bobst / Claudia Bühler / Daniel Auf der Mauer / David Marchon / Dominic Steinmann / Edouard Musy / Fabian Biasio / Fabrice Coffrini / Florian Spring / Franco Banfi / Gerard Berthoud / Klaus Petrus / Kostas Maros / Laurent Gilliéron / Laurianne Aeby / Lorin Messerli / Luca Zanetti / Massimo Pacciorini-Job / Matthieu Zellweger / Michele Crameri / Mischa Christen / Nathalie Taiana / Niels Ackermann / Patrick B. Kraemer / Patrick Rohr / Pavel Cugini / Reto Albertalli / Rolf Neeser / Sébastien Anex / Stefan Wermuth / Stéphanie Buret / Thilo Remini / Valérie Baeriswyl

Syria

Abdulmonam Eassa / Anas Alkharboutli / Bassam Khabieh / Carole Farah / Firas Abdullah / Hamza Al-Ajweh / Khalil Ashawi / Mohamad Abazeed / Mohammed Badra / Nazeer Al Khatib / Omar Sanadiki / Omar Haj Kadour / Sameer Al-Doumy / Sami Karaali

Taiwan

Boheng Chen / Chia-Chang Hsieh / Po-Yuan Wu / Simon Chang / Yen-Yin Chen / Yingting Shih

Thailand

Charles Dharapak / Piyavit Thongsa-Ard / Pongmanat Tasiri / Rungroj Yongrit / Sirachai Arunrugstichai / Sitan Siriwattana / Tanat Chayaphattharitthee / Wasawat Lukharang / Watsamon June Tri-Yasakda

Turkey

Ali Ihsan Öztürk / Ali Ünal / Arif Hudaverdi Yaman / Baran Ozdemir / Bulent Kilic / Cenk Gençdiş / Elif Ozturk Ozgoncu / Emin Ozmen / Emrah Oprukcu / Emrah Yorulmaz / Ercin Top / Ertugrul Kilic / Evrim Aydin / Hakan Burak Altunoz / Halil Sagirkaya / Ilhami Cetin / Levent Kulu / Lokman Kanik / Murat Sengul / Mustafa Bilge Satkın / Nejdet Canaran /

Nicole Tung / Ozan Kose / Özkan Bilgin / Rıza Özel / Sahan Nuhoglu / Sebnem Coskun / Tahsin Engin Gokten / Tara Todras-Whitehill / Tolga Ildun / Ugur Yildirim / Ünal Çam / Vedat Arık

Uganda

Alex Esagala / Esther Oluka / Katende Andrew / Katumba Badru / Martin Kharumwa / Nicholas Bamulanzeki / Stuart Tibaweswa

Ukraine

Alexander Chekmenev / Anatolii Stepanov / Andrii Konontsev / Arthur Bondar / Denys Kopylov / Dimitri Lovetsky / Inga Tokar / Ivan Tykhy / Mykhaylo Palinchak / Oleh Dubyna / Oleksandr Cheban / Oleksandr Rupeta / Oles Kromplias / Olya Morvan / Pavlo Pakhomenko / Roman Vilenskyi / Serhii Nuzhnenko / Stepan Rudik

United Arab Emirates

Christopher Comeso / Vidhyaa Chandramohan

United Kingdom

Adam Dean / Adam Hinton / Alan Crowhurst / Alex Cavendish / Alex Livesey / Alex McBride / Alice Mann / Alice Zoo / Alys Tomlinson / Amiran White / Anastasia Taylor-Lind / Andrew Boyers / Andrew Fox / Andrew Testa / Andy Buchanan / Andy Couldridge / Andy Hall / Andy Parkinson / Andy Scaysbrook / Anna Filipova / Anna Gowthorpe / Anthony Devlin / Antonio Zazueta Olmos / Austin Ferguson / Ben Curtis / Ben Graville / Ben Radford / Bradley Secker / Brian Anderson / Brian Cassey / Brian Cliff Olguin / Brian Harris / Caleb Stein / Carl de Souza / Carl Court / Carl Recine / Caroline Irby / Caton Caton / Celia Bartlett / Charlie Bibby / Charlie Clift / Charlie Gates / Charlotte Robinson / Chris Stowers / Chris Young / Christopher Furlong / Christopher Pillitz / Christopher Pledger / Clive Brunskill / Clive Mason / Costa Corbas / Damon Coulter / Dan Charity / Dan Giannopoulos / Dan Kitwood / Dan Milner / Daniel Mullan / Daniel Wheeler / Danny Lawson / Darran Rees / Dave Charnley / David Chancellor / David Levene / David Maitland / David Pratt / David Shaw / David Shopland / Dolly Clew / Dylan Martinez / Ed Alcock / Ed Thompson / Eddie Keogh / Eddie Mulholland / Edmond Terakopian / Emily Garthwaite / Emma Hardy / Fabio De Paola / Filip Warwick / Finbarr O'Reilly / Francesca Jones / Frank Dias / Frederic Aranda / Gary Calton / Giles Clarke / Giles Price / Graeme Robertson / Greg Blatchford / Guy Martin / Hannah McKay / Hannah Bailey / Harry Borden / Harry Murphy / Haydn Denman / Hugh Kinsella Cunningham / Ian Forsyth / Ian Jacobs / Ian MacNicol / Jack Hill / Jack Losh / Jack Taylor / James Cannon / James Hill / James Patrick / James Robertson / Jane Barlow / Jason Bryant / Jason Hedges / Jason Florio / Jed Leicester / Jeff Gilbert / Jeff Moore / Jill Mead / Jimmy Lee / Joel Redman / John Linton / John Sibley / Jon Davey / Jonathan Goldberg / Joseph Anthony / Joshua Bright / Julian Andrews / Julian Finney / Kay Lockett / Kenny Elrick / Kieran Dodds / Kieran Galvin / Kieron Yates / Kiran Ridley / Laura Pannack / Lauren Forster / Laurence Griffiths / Lee Smith / Leo Mason / Leon Neal / Lorna Roach / Lucy Nicholson / Lucy Piper / Luke David Kellett / Luke Dray / Marc Ellison / Marcus Valance / Margaret Mitchell / Marina Black / Mark Evans / Mark Henley / Mark Leech / Martin Godwin / Mary Turner / Matthew Writtle / Mia Collis / Mike Egerton / Nathan Murrell / Neil Hall / Nick Cobbing / Nicola Muirhead / Nigel Dickinson / Nigel V Roddis / Nik Strangelove / Oli Scarff / Olivia Harris / Owen Humphreys / Paul Cooper / Paul Ellis / Paul Keene / Paul Marriott / Phil Noble / Phil Clarke Hill / Phil Noble / Philip Wolmuth / Ramsey Cardy / Rebecca Cook / Richard Heathcote / Richard Morgan / Rick Findler / Rob Scott / Robbie Shone / Robert Edwards / Robert Gallagher / Roger Allen / Ross Johnston / Sally Hayden / Sam Tarling / Sandra Mailer / Sean Gallagher / Sean Sutton / Sebastian Palmer / Shai Chishty / Simon Dack /

Simon Norfolk / Simon Sharp / Simon Stacpoole / Stefan Jeremiah / Stefan Rousseau / Stephan Jarvis / Stuart Freedman / Suzanne Lori Plunkett / Tariq Zaidi / Ter Ipengilley / Terry Harris / Tessa Bunney / Thabo Jaiyesimi / Thomas Dryden Kelsey / Thomas Lovelock / Toby Maudsley / Toby Melville / Tom Jenkins / Tom Pilston / Tom White / Venetia Menzies / Vicki Couchman / Victoria Jones / Vincent West / Wattie Cheung / Will Oliver / William Burrard-Lucas / William Cherry / Yui Mok

United States

Aaron Ontiveroz / Acacia Johnson / Adam Berry / Adam Glanzman / Adam Reynolds / Adrees Latif / Adriane Ohanesian / Aga Szydlik / Aj Mast / Akasha Rabut / Al Bello / Al Drago / Alan Berner / Alec Soth / Alessandro Bianchi / Alex Basaraba / Alex Brandon / Alex Potter / Alex Welsh / Alex Wroblewski / Alexander Gouletas / Alexandra Wimley / Alexey Yurenev / Alice Gabriner / Alison Wright / Allison Joyce / Alyssa Schukar / Amanda Mustard / Amber Mahoney / Amy Beth Bennett / Amy Gulick / An Rong Xu / Ana Nance / André Chung / Andre D. Wagner / Andre Da Silva / Andre Malerba / Andrea Dicenzo / Andrea Melendez / Andrea Mohin / Andrew Harnik / Andrew Kaufman / Andrew Renneisen / Andrew Rush / Andrew White / Andria Hautamaki / Anna Boyiazis / Annie Risemberg / Anthony Karen / Arash Yaghmaian / Ariana Drehsler / Aristide Economopoulos / Ash Adams / Astrid Riecken / Atilgan Ozdil / Aude Guerrucci / Barry Chin / Ben C. Solomon / Ben McCanna / Ben Solomon / Benjamin Rusnak / Bess Adler / Billy Calzada / Billy Delfs / Bram Janssen / Brendan McDermid / Brendan Hoffman / Brendan Smialowski / Brett Carlsen / Brian Frank / Brian Palmer / Brian Snyder / Brian Sokol / Brian Vanderbrug / Brianna Soukup / Bruce Bennett / Bruce Omori / Bryan Anselm / Bryan Denton / Bryan Thomas / Calla Kessler / Callaghan O'Hare / Carly Geraci / Carol Allen-Storey / Carol Guzy / Caroline Gutman / Caroline Tompkins / Caroline Yang / Carolyn Kaster / Carolyn Cole / Carolyn Van Houten / Cayla Carter Nimmo / Chang W. Lee / Charles Fox / Charles Krupa / Chelsea Purgahn / Chitose Suzuki / Christian Monterrosa / Christina House / Christine Ruddy / Christopher Lee / Christopher Occhicone / Cinthya Santos Briones / Claire Harbage / Cole Barash / Colin Murphey / Cooper Neill / Craig Ruttle / Craig Walker / Cristina Mittermeier / Cristobal Herrera-Ulashkevich / Damon Dahlen / Damon Winter / Dana Ullman / Daniel Beltra / Daniel Brenner / Daniel Carde / Daniel Clarence Britt / Daniel Cole / Daniel Dreifuss / Daniel Kramer / Daniel Marschka / Daniel Tchetchik / Daniella Zalcman / Danish Ismail / Danny Fulgencio / Darya Ryan / Dave Sanders / David Bathgate / David Butow / David E. Klutho / David Goldman / David Gulden / David Guttenfelder / David J. Phillip / David Jaewon Oh / David Liittschwager / David Maialetti / David McIntyre / David Scott Holloway / David Swanson / Delcia Lopez / Denton Simmons / Devin Yalkin / Diana Cervantes / Diana Markosian / Diana Zeyneb Alhindawi / Dina Litovsky / Dominic Bracco / Donald Miralle Jr. / Doug Mills / Dustin Nathaniel Satloff / Ed Kashi / Ed Murray / Edward Hille / Eileen Meslarelias Williams / Elisa Ferrari / Emilie Richardson / Emily Kask / Eric Davidove / Eric Thayer / Erica Price / Erick W. Rasco / Erin Lefevre / Erin Schaff / Fevan Vucci / Ezra Shaw / Francine Orr / Frank Franklin II / Fred Vuich / Gabriella Angotti-Jones / Gabrielle Lurie / Gary Coronado / Gena Steffens / George Etheredge / George Steinmetz / Gerald Herbert / Gerard Burkhart / Gillian Laub / Gina Ferazzi / Gioia Kuss / Glenna Gordon / Go Nakamura / Greg Nelson / Greg Kahn / Gregory Bull / Guillermo Hernandez Martinez / Hailey Sadler / Heidi Levine / Helen Richardson / Hilary Swift / Holly Pickett / Ilana Panich-Linsman / Isadora Kosofsky / Ivan Flores / Ivan Kashinsky / J. Scott Applewhite / J.B. Russell / Jabin Botsford / Jack Platner / Jackie Molloy / Jae C. Hong / Jahi Chikwendiu / Jake Michaels / Jake

Naughton / James Gong / James Mao / James Rajotte / James Whitlow Delano / Jamie Schwaberow / Jane Hahn / Jane Voisard / Jared Haworth / Jason Minto / Jason Andrew / Jason Corning / Jason Patinkin / Jassen Todorov / Jay Clendenin / Jay Janner / Jeff Haynes / Jeffrey Barbee / Jeffrey Stockbridge / Jen Guyton / Jenna Schoenefeld / Jeremy Hogan / Jerry Beard / Jerry Lara / Jessica Dimmock / Jessica L Griffin / Jessica Phelps / Jessica Rinaldi / Jessica Suarez / Jessie K Wardarski / Jetta Hunter Washington / Jewel Samad / Jillian Mitchell / Jim Damaske / Jim Hollander / Jinsong Weeks / Jody Quon / Joe Buglewicz / Joe Raedle / Joe Van Eeckhout / Joel Auerbach / John Angelillo / John Kimmich / John McCall / John Moore / John Stanmeyer / John W. McDonough / John Wendle / Johnny Milano / Johnny Miller / Jonathan Ernst / Jonathan Bachman / Jonathan Ferrey / Jonathan Levinson / Jordan Sirek / Joseph Swide / Josh Estey / Josh Edelson / Josh Haner / Joshua Roberts / Juan Carlos / Julia Robinson / Julie Dermansky / Justin Maxon / Justin Sullivan / Karen Kasmauski / Karen Pulfer Focht / Karsten Moran / Kate Bubacz / Katharine Lotze / Katie Rausch / Keith Birmingham / Keith Ladzinski / Kelley Dallas / Kelly Joann Guerin / Kelsey Kremer / Kenneth Jarecke / Kenneth Lam / Kenneth Song / Kent Nishimura / Kevin Lamarque / Kevin Dietsch / Kevin Rivoli / Kholood Eid / Kirsten Luce / Kohjiro Kinno / Kristen Angelo / Kristen Zeis / Landon Nordeman / Larry C. Price / Latoya Ruby Frazier / Lauren Grabelle / Lauren Crothers / Lauren K. Decicca / Laurence Kesterson / Laurie Skrivan / Lawrence Sumulong / Laylah Amatullah Barrayn / Leah Millis / Linda Troeller / Lipo Ching / Lisa Krantz / Lisa Morales / Lisette Morales / Lonnie Timmons III / Loren Elliott / Loren Holmes / Lori Hawkins / Lucas Jackson / Luis Sinco / Lynn Johnson / Lynsey Addario / M. Scott Brauer / M. Scott Mahaskey / Maan Habib / MacKenzie Knowles-Coursin / Madalyn A. McGarvey / Maggie Steber / Malin Fezehai / Mandel Ngan / Maranie Staab / Marc Lester / Marcus Yam / Mario Tama / Mark Schiefelbein / Mark Zaleski / Mark Edward Harris / Mark Garten / Mark Holtzman / Mark J. Terrill / Mark Kauzlarich / Mark Kelley / Mark L. Wilson / Mark Makela / Mark Peterson / Martin Klimek / Marvin Joseph / Mary F. Calvert / Mason Trinca / Matilde Simas / Matt Eich / Matt Marriott / Matt McClain / Matthew Hatcher / Matthew Hinton / Maya Alleruzzo / Meg Oliphant / Megan Farmer / Megan Jelinger / Meghan Dhaliwal / Melina Mara / Melissa Golden / Melissa Spitz / Meridith Kohut / Michael A. McCoy / Michael Candelori / Michael Ciaglo / Michael Downey / Michael Hanson / Michael Heiman / Michael M. Santiago / Michael Nigro / Michael Patrick O'Neill / Michael Robinson Chávez / Michael Simons / Michelle Gustafson / Miguel Juárez Lugo / Mike Blake / Mike Stocker / Milbert O Brown Jr. / Miranda Barnes / Misha Friedman / Moriah Ratner / Nada Elsayed / Nadia Shira Cohen / Nancy Pastor / Natalie Keyssar / Nichole Sobecki / Nick Oxford / Nick Parisse / Nicky Woo / Nils Nilsen / Nina Robinson / Noah Berger / Nuri Vallbona / Olivier Douliery / Pablo Martínez Monsiváis / Patrick Record / Patrick Smith / Patsy Lynch / Paul Kitagaki Jr. / Pete Kiehart / Pete Marovich / Peter DaSilva / Peter Muller / Peter Van Agtmael / Philip Montgomery / Phillip Walter Wellman / Ping Homeric / Preston Gannaway / Rachel Woolf / Rae Ceretto / Rafe H. Andrews / Randy Olson / Raul R. Rubiera / Raul Roman / Ray Chavez / Rebecca Blackwell / Renée C. Byer / Ric Francis / Ric Tapia / Ricardo Arduengo / Ricci Shryock / Richard Tsong-Taatarii / Richard Vogel / Rick Bowmer / Rick Friedman / Rick Thomawilking / Ricky Carioti / Ringo Chiu / RJ Sangosti / Rob Tringali / Robert Beck / Robert F. Bukaty / Robert Gauthier / Robert Hallinen / Robin Loznak / Robin Rayne / Robyn Beck / Rod Lamkey Jr. / Ronald W. Erdrich / Ronen Tivony / Rory Doyle / Rose Baca / Ross Taylor / Rudolf

Sulgan / Ruth Fremson / Ryan Christopher Jones / Ryan Dorgan / Ryan Garza / Ryan Pfluger / Salwan Georges / Sam Hodgson / Sam Owens / Sam Simmonds / Sandy Kim / Sangsuk Sylvia Kang / Sara Swaty / Sarah Blesener / Sarah Hoffman / Sarah Hoskins / Sarah Voisin / Saul Loeb / Scott Brennan / Scott Dalton / Scott Serio / Scott Strazzante / Sean Gallup / Sean Pitts / Sebastian Meyer / Seth Herald / Shaban Athuman / Shaie William / Shannon Stapleton / Shawn Thew / Shay Olen Horse / Shmuel Thaler / Sima Diab / Simon Bruty / Smiley Pool / Sol Neelman / Spencer Platt / Staton Rabin / Stefan Falke / Stephanie Chambers / Stephanie Keith / Stephen Brashear / Stephen Ferry / Stephen Voss / Stephen Wilkes / Steve Helber / Steve Winter / Steve Apps / Steven Falk / Stuart Palley / Suchat Pederson / Susan Walsh / Susan Schulman / Susan Stava / Sussana Kohm / Suzanne Kreiter / T.J. Kirkpatrick / Tamir Kalifa / Tara Pixley / Teresa Kruszewski / Terray Sylvester / Terrell Groggins / Thomas R. Cordova / Tim Hussin / Tim Laman / Timothy Tai / Tira Khan / Todd Heisler / Tom Fox / Tom Brenner / Tom Gralish / Tomas Karmelo Amaya / Tony Wu / Tracie Williams / Travis Dove / Travis Fox / Trevor Frost / Tristan Spinski / Troilan Sanos / Ty O'Neil / Tyler Hicks / Tyrone Turner / Vernon Bryant / Vic Valbuena Bareng / Victor Blue / Victoria Will / Wally Skalij / Wayne A. Lawrence / Win McNamee / Winslow Townson / Yalonda M. James / Yana Paskova

Uruguay
Christian Rodriguez / Julio Etchart / Matilde Campodónico / Pablo M. Albarenga / Sthef Folgar

Uzbekistan
Aleksandra Bardas

Venezuela
Adriana Loureiro Fernandez / Alejandro Cegarra / Andrea Hernandez / Carlos Garcia Rawlins / Emanuele Sorge / Gil Padrino / Iván Ernesto Reyes / Jacinto Oliveros / Jaime Villalta / Jose Caruci / Juan Barreto / Juan Carlos Hernández Soria / Kathiana Cardona / Leo Alvarez / Lionel Arteaga / Luis Cabrera / Luis Gerardo González Bruzal / Marco A. Bello / Miguel Gutierrez / Orlando Baquero / Raul Martinez / Ronald Pizzoferrato / Wil Riera

Vietnam
Hoang Trung Thuy / James Duong / Khoa Nguyen Dang / Lekima Hung / Linh Pham / Phan Quang / Thanh Nguyen / Vincent Thian

Yemen
Khaled Abdullah / Mohamed Al-Sayaghi

Zambia
Alex Mukuka / Jean Mandela Ndayisenga / Kelvin Kakanku

Zimbabwe
Angela Jimu / Chinula Mandla / Darius Mutamba / Lucky Tshuma

Participants Digital Storytelling Contest

In 2019, 300 productions were submitted to the Digital Storytelling Contest. These productions are listed here alphabetically as filled in by the entrants in the entry platform.

Interactive

#GenderAnd: The Women Bus Conductors of Uttar Pradesh / 150 Minutes of Hell / A Reclusive Nation Cracks Open Its Doors / As War Rages, Yemen's Fathers and Sons Face an Uncertain Future / Banished / Barnacas / Black in Canada: 10 Stories / Burge Victims Speak / Camp Fire Visual Essay / Climate Crisis – On the Trail of Global Warming / Coding Like a Girl / Congo's Gold / Congolese Revival, Stockholm / Crossing the River / Democracy and Footpaths / Destroyed / Diary of Miners Workers of Minya / Digging into the Mining Arc / Displaced Family Returns Home To Mosul / Endangered Elephants Trapped by World's Largest Refugee Camp / Flint is a Place / Gaza: Teargas, Bullets and Burning Tires / Ghosts of Highway 20 / Guns in America / Hanna the Red / Health Matters: Tackling Maternal Mortality in Kenya / Hey Stranger! What's on your phone? / Hiding Behind God / Hirokos Nuclear Capsule / Hotel Dajti, Albania / I Am His Legs and He Is My Heart / Inside America's Hidden Border / Inside the Black Market Hummingbird Love Charm Trade / It's All in My Head / Katie's New Face Interactive / Kidnapped As Schoolgirls By Boko Haram: Here They Are Now / Land of Plenty, Land of But a Few / Last Prom / Last Refuge / Looking? / Melting Away / Mikaela Shiffrin is an Extraordinary Skier. And That's Not Good Enough / Miss Vietnam Florida 2018 / Notes from Aleppo / One Building, One Bomb: How Assad Gassed His Own People / Plomo – Journey of a Bullet / Poppy Interactive – War and Organized Crime Gone Global / Pro-Life Activists Target Rural Nepali Women / Project Greenland / Public Space – At What Cost? / Rohingya Race Against and Rains / Roxham / Scenes From a Migration Crisis – On Both Sides of and Border / She Called Me Red / She Named Her Child "Enough": A Rare Look At Yemen's War, Where Children Starve and Hospitals Are on Life-Support / Step Inside the Thai Cave in Augmented Reality / Stories From Under the Rubble: Inside the Battle of Marawi / Suffer Not a Witch To Live / The Asylum Machine / The Big Meltdown / The Boracay Project: Paradise Reopens / The Case Against the Open Arms: Key Events / The Case of Jane Doe Ponytail / The Hidden / The Immortal Corpse Interactive / The Last Generation / The Legacy of Oscar Grant / The Mahua Story: Modern Times and an Iconic Brew / The Man Behind Notre-Dame / The Migrant / The Opioid Diaries / The Selkups: Save As... / The Top 25 Teams in World Cup History / To The Next 'BBQ Becky': Don't Call 911. Call 1-844-WYT-FEAR / Transition / Warming Planet, Vanishing Heritage / We – About Russia Without Words

Long

¿Donde Están Los Desaparecidos? Where Are the Disappeared? / Bless You, Boys / 2018 Infinity Awards, Critical Research & Writing: Maurice Berger / 44 Messages From Catalonia / A Grim Education / A Man Called Ragnar / Addicted and Left Behind: The Opioid Epidemic Killing African Americans / An Armenian Must / An Israeli Soldier Killed a Medic in Gaza. We Investigated the Fatal Shot / An Unnatural Wonder / Aquarteladas (Prisoners At Headquarters) / Art for Peace / As If We Were Tuna / Ballet and Bullets: Dancing Out of the Favela / Be My Voice / Boxing Shadows / Butoh Dance in the Islamic Republic of Iran / Café Con Leche / Camorra "The Voices of Inside" 1989/2019:

Nothing Has Changed / China's Healthcare Crisis / Creeping Borders / Democracy Anonymous / Disconnected / Fentanyl and the 14th Floor: The Life and Death of Justin Lidstone / Finding Lubo / Flint is a Place / Foroyar / Genésio – A Bird Without Direction: The Only Witness of the Murder of Chico Mendes / Ghosts of Highway 20, Episode 1 – Marlene / Hegira / Journey / In the Absence / Irrigation Scheme: A Drought Adaptation Initiative / Katie's New Face Documentary / Kimberly / La Barkley Sans Pitié / Little Pyongyang / Marawi: Return To Ruins / Mare Amarum / Margillee / Marielle and Monica / Medina's Song / Mind's Eye: Inside an Olympian Mind / My Beautiful Cancer / My Name is Nour / Noodle School / Nuuca / One Building, One Bomb: How Assad Gassed His Own People / Operation Infektion - Russian Disinformation: From Cold War To Kanye / Parenthood Lost / Returning Home / Searching for Saraswati / Surviving in the Valley of Death / Taste in China / The Believers / The Earth Is Humming / The First Hands / The Fishermen and the Sea / The Immortal Corpse Documentary / The Lost Boys / The Mysterious Genius Who Patented the UFO/ The Ninth Circuit / The Opioid Diaries: Born in Withdrawal / The Path To Radicalization / The Rise of Gen Z and China's Plastic Surgery Boom / The Silence of War – Damascus / The Worst Roommate Ever / Theater Without Borders / This Is What they Call Devastation:' Mexico Beach After Hurricane Michael / This Town Says It's Dying of Cancer. Can One Doctor Help Them Get Out? / Tracing Lois Riess' Past, Her Trail of Death and the Collision Course With Her Alleged Victims / Traditional Leaders: Conduits To Development / Unique (Únicas) / Unprotected / Vera / Vika / Walking Backwards / We're Kids, But We're Also Journalists / Welcome To America / When We Meet Again / Where the Gorillas Live: A Journey in the Congo / With Every Breath / Yemen Unveiled / Your Train Is Delayed. Why?

Short

2018 Infinity Awards, Applied: Alexandra Bell / A Conversation with Zahra / A Lifeline for Minnesota Farmers / A Soldier Returns Home / Abalone: As the Sea Swarms With Poachers / Adorable Runway Fall At Kids Fashion Show in China Warms Hearts / After 25 Years of Broken Promises, India Is Counting Its Manual Scavengers Again / Ali / Ancient Greece 101 / Ancient Mesopotamia 101 / Aretha, Queen of Soul / As One: Making the Marjory Stoneman Douglas Yearbook / Atv Foia / Aurelia´s Last 26 Days / Br 319: Welcome To Reality / Caring for Tor / Chhordima – Silent Feature of Women Movement / Chosen [Not] To Be / Counterclockwise / Cycles / Death and Disappearance in Indian Country / Deported! / Diogenes, the Cynic / Disease, Superstition and Poverty Plague India's Bhil Tribe / Elderly Golden Retriever's Final Walk Prompts Owner's Touching Letter / Emergency Afghanistan / Enough | The Story of the Empowered Women of Korogocho / Facing Prejudice / Fighting Child Marriage With Soccer in India's Villages / Fleeing Honduras / Florida School Shooting Survivors Head To Tallahassee To Demand Change / Forbidden Tattoos / Gaza's Karate Kids / Ghadeer / Girls Are Also Strong / Goat Saves His Own Life By Being Greedy in China / Guardians of the Iberá / Hall of Fame Jockey Victor Espinoza's Recovery / Hector Barajas' Long Road Home / Holi Antifa in Barcelona / Homeless in Hong Kong: Life on a Footbridge / Hong Kong Shop Cats / How a Gang Hunted and Killed a 15-Year-Old in the Bronx / How an Elite Nigerian Unit Killed Dozens of Protesters / How Mass Die-Offs and Poaching Threaten Rare Asian Antelopes / How the Las Vegas Gunman

Planned a Massacre, in 7 Days of Video / How Trees Secretly Talk To Each Other in the Forest / How Your Eyes Make Sense of the World / I Have a Home. I Just Don't Have a Flat Or a House To Put It in / I Just Simply Did What He Wanted / Ice and Fire: How Burning Forests Can Melt Ice Sheets / India's Young Tribal Girls Finding Freedom Through Sport / Inside a Suicide Prevention Center After Maria / Inside Deb Haaland's Historic Bid To Become One of The First Native Congresswomen / Inside the Brothel / Inside the Lives of Butterfly Traders / It's All in My Head / Jair Bolsonaro's Been Called a Misogynist and Fascist. Here's Why Women Still Back Him / Killing Khashoggi: How a Brutal Saudi Hit Job Unfolded / Laos Dam Collapse: Survivors Recount the Horror / Last Prom / Leave No Adolescents Girls Behind for Sustainable Future / Let Me In / Local Aid: Kerala's Rescue Fishermen / Louis' Story: Child Soldier To Role Model / Loved and Loathed: Raising a Gay Child in the Former Soviet Union / Maternal Mortality / Medicinal Venom / Moments As Hurricane Michael Made Landfall Panama City Florida / Monk With His Unwanted Babies / More Than a Gun / Near the Breaking Point / Niassa Elephant Defenders Video Series / No Place To Place / No Turning Back / Northern Everglades Key To South Florida Water Health / One Thing in Nothing / Pagans / Paradise Lost: The Town Incinerated By California's Deadliest Wildfire / Parallel Lives / Plastics 101 / Rebels With a Cause / Reborn / Reshaping the Trauma of Refugee Children in Lesbos / Saia's Promise / See How Termites Inspired a Building That Can Cool Itself / Soul of the Playground / State Identity Crisis Rohingya Refugees / Story of a Face / Taller De Esculturas – Sculpture Workshop / Tamo Junto / Tanaca / The Average Dream / The Body Collector / The Bullet Inside My Body / The Continuing Search: Artist Lorcan Walshe / The Drone Delivery Operator in Rwanda / The Gang Rape / The Great Return March / The Guardians Of The Cerrado / The Killer Lung Disease Behind The Human Cost of Shenzhen's Economic Miracle / The Killing Wave / The Last Prom / The Legacy of the 'Zero Tolerance' Policy: Traumatized Children With No Access To Treatment / The Missing: A Father's Wait / The Notebook / The Other Warriors / The Prostitutes and the Priest / The Rape Jokes We Still Laugh At / The Regulars: The Dreamer / The Revolving Door: Women Behind Bars / The Search / The Story of Mrs Kanno / The Telephone / The Voice and Face of Migrant Caravan (Voz Y Rostro Migrante) / The Window / The World's Best Gay Football Team / This Community in the Philippines Converts Plastic Fishing Nets To Carpet / Thomas Fire Architect / Three Comrades / Three Kids Left in the County: How China's Villages Are Emptying / Time-Travel Train / Tinku / Titanic 101 / Touching Wedding Dance with Dying Dad / Victims To Victims / The Faces and Voices of the "Yellow Vests" in France / Visible Human / Walk Or Die: Dangers of the Sahara / Warriors Who Once Feared Elephants, Now Protect Them. / Water Chlorination / We Are the Ones You Locked in / When She Was Ready, the Detox Beds Were Not / When We Sleep / Wild Poppy / Without A Home / Work Riders, the Unsung Heroes of the Horse Racing Industry / Yellow Vests / You're Gorgeous, You're Mad / What Remains From Maspero

WORLD PRESS PHOTO

Copyright © 2019
Stichting World Press Photo, Amsterdam,
the Netherlands
www.worldpressphoto.org
Schilt Publishing, Amsterdam,
the Netherlands
www.schiltpublishing.com

All photography copyrights are held by
the photographers.

Schilt Publishing
Peter Martensstraat 121
1087 NA Amsterdam, the Netherlands
Tel.: +31 (0) 6 51 98 47 47
www.schiltpublishing.com

Managing Editor
David Campbell
Editor
Rodney Bolt
Production Coordinator
Chee Yee Tang
Picture Coordinator
Thera Vermeij
Research Coordinator
Yi Wen Hsia
Research
Suzan van den Berg, Samira Damato,
Juliette Garms, Roosa Hakkarainen,
Carla Vlaun, Babette Warendorf

Art Director
Teun van der Heijden
Design
Heijdens Karwei, Amsterdam,
the Netherlands, www.heijdenskarwei.com

Print & Logistics Management
KOMESO GmbH, Stuttgart, Germany
www.komeso.de
Lithography, printing and binding
F&W Druck- und Mediencenter GmbH,
Kienberg, Germany, www.fw-medien.de
Paper
Maximat Prime, 300 / 150 g
Produced by UPM, distributed by IGEPAgroup

Production Supervisors
Maarten Schilt
Dana Rakhim

ISBN 978 90 5330 920 9

On the front cover:
John Moore (United States),
Getty Images
'Crying Girl on the Border'
World Press Photo of the Year 2018

On the back cover:
Pieter Ten Hoopen (Netherlands/Sweden),
Agence VU/Civilian Act
'The Migrant Caravan'
World Press Photo Story of the Year 2018

MIX
Paper from
responsible sources
FSC
www.fsc.org FSC® C018828